# CELEBRITY

The photographs of TERRY O'NEILL
Introduced by AA GILL

TED SMART

A *Little, Brown* Book

First published in Great Britain in 2003 by Little, Brown

This edition produced for The Book People Ltd,
Hallwood Avenue, Haydock, St Helens, WA11 9UL
by Little, Brown

Copyright © Photographs Firepine Ltd 2003
Copyright © Introduction AA Gill 2003

The moral right of the authors has been asserted.

Designed by John Tennant.
Design assistance by Jack Tennant.

Typeset in Enigma and Shaker.

A CIP catalogue record for this book is
available from the British Library.

ISBN 0 316 72445 9

Printed and bound in Italy

Little, Brown
An imprint of Time Warner Books UK
Brettenham House
Lancaster Place
London WC2E 7EN

www.TimeWarnerBooks.co.uk

For Sarah, Keegan, Liam & Claude

With thanks to John Tennant for his design,
to Robin Bell for his printing, and to Ed Victor, without whom...

**The Stone Age, Bronze Age, Iron Age,** Dark Ages, Age of Reason, Industrial Age, Post-Industrial Age. Where the hell are we now? Smart, glib people who sell mobile phones and those multi-function electronic controls that collect down the side of the sofa would have us believe that we live someplace called the Information Age. While most of the world still exists in a gloaming of rumour and myth, worldwide we produce and consume one thing that has never been used in such profligate quantities before. If there's one universal commodity that can cause instant screaming gold rushes all over the planet – after all, Humphrey Bogart said that you weren't a star until they could spell your name in Karachi – it's celebrity. **The age we live in is the Celebrity Age.**

This is the first time in history that the living have been able to see the dead. That's quite something … a life after death. We can watch them walking and talking. They smile at us, make us laugh. Spookily we can lust after dead people – even love them. We watch films where everyone involved is dust and ashes. And they'll go on forever, repeating themselves. Replicating. Jumping media. From celluloid, to video, to binary digits, to pure light – they sing to us out of the past.

Flick through the pages of this book and see that the living and the dead mingle without an 'excuse me'. Celebrity doesn't exist in a world where the physical laws of mortality pertain. Celebrities are different. And that's why we invented them – to be a race of superbeings, flawed deities that hang tantalisingly above the real, mortal world. They inhabit an Olympus of hotel suites, country seats, beaches, boats and roped-off pavements in *la nuit américaine*, where day is night. The past and the future are all scaffolding, chipboard and back projection. They look like us, but are apart. I'm always amazed at how celebrity mimics the classical myths. In our pantheon of celebrity each character has their super power over us – tough guys and charmers, Lotharios and irresistible seducers, jokers, power brokers, objects of devotion, pity and lust. They have sagas and adventures; live out parables and epics;

come to fearful ends and are reborn. Their lives run in and out of ours, ethereal and aimless, creative and destructive. They interfere, we invoke them. At the turn of the millennium, you and I know more people we've never met than people we have. We have more celebrities than friends – and that's weird.

I can tell you exactly when the Celebrity Age was born – the mid fifties. There had been famous people before then. There had been stars before, but never like this. Now you can look at history as being the story of great people and great feats, or you can see it as being the impetus of things and ideas. Celebrity was created by a thing. The camera. The single-lens reflex camera. It turned fame into celebrity. Cameras went with printing and publishing in the fifties; paper became cheap and colour litho printing expanded into dozens and dozens of magazines which needed people to photograph. Old-time stars came from Hollywood and the aristocracy, but there just weren't enough of them to go round. The market was expanding and insatiable. We couldn't invent pop stars and starlets fast enough. Market forces made celebrity.

If you want a catchy definition of the difference between a star and a celebrity, then here it is. Stars are couture; celebrities are ready to wear. There have always been stars, distant, twinkling, and there's been photography for over a hundred and fifty years. Almost the first thing a camera was pointed at was someone famous. Photographers behaved like astronomers. Cameras were their telescopes, searching distant galaxies. It was only in the fifties that they got the equipment and found the idea that they could be more than cosmic portraitists. Photographers could be anthropologists, psychologists, psychiatrists, sycophants, rent boys, blackmailers, thieves, best friends, sages, prophets and pucks. Tricks of the light.

The first celebrity was Brigitte Bardot. Look, we can argue about this. Maybe there were proto-celebrity folk before her, but she was the one who did it all. Had it all. She was the leitmotif and the template. She marked a moment when everything changed. We can dissect her and the Zeitgeist ad nauseam and we'll always see there was a desperate need for something. A change of tempo. Something lighter and freer and sexy. Please let there be sex again. For two decades the public face of the world had been serious men in uniform and women pushing prams with their belongings in them. Suddenly here was a girl in a bikini, often only the bottom half of a bikini. She was an actress who couldn't act. She couldn't sing. She could barely string an intelligible sentence together, her movies are unwatchable, but we simply couldn't take our eyes off Bardot. She had a thing. And that thing could be distilled and decanted on to light-sensitive paper. The fact that Bardot could do nothing – or nothing very well – confirmed rather than confounded her celebrity. And it set a precedent for thousands who came after her. Celebrity is not necessarily the result of exceptional talent or skill. It is something else. Perhaps it's luck. Perhaps guile. Or just fate. The whimsy of the gods. Bardot had something ethereal. Something mythic.

In 1960 Federico Fellini made a film that hooked the moment. *La Dolce Vita* was a look at empty, decadent, immoral celebrity life, set against the real, harsh street life

of Rome as seen through the eyes of a journalist. This set another rule for the newly roped-off celebrity life which was yet to be awarded. The honorific style. It was to be ardently prayed for by the audience in the anonymous dark. Imitated, copied, followed, yearned after. But it was also – and this is important – simultaneously known to be empty, cruel, phoney and ultimately malign. The sweet life – a place where the sun is hotter, the champagne colder, the towels fluffier, the carpets deeper, the orgasms more sumptuous and the laughter louder; a place where admiration and love oils every moment – is also, like all sweet things, ultimately bad for you. It ends in celebrity diabetes. In *La Dolce Vita* there's a photographer who uses a scooter to chase celebrities. He's a character who's familiar today, but then he was so new he didn't even have a name. Fellini christened him 'paparazzo' and a profession and a term of abuse were born. It seems ironically appropriate that life imitated art, that paparazzi should have stepped out of the flickering screen into real life. Hermes with a Vespa. The messenger of the gods, whose images could circle the globe at the speed of light.

**It so happens that Terry O'Neill's first job** after finishing National Service was to hang around London Airport waiting to snap celebrities who fell to earth.

Now here's the thing. Celebrities are different from the rest of us but the same as each other. At the bottom of all the baggage they carry is a small, plain, locked box. In it are the deeds to their little acre of fame. And the map of how they got there. The thing is, none of them has the key. They don't know if they're owners, renters or squatters. They don't know if they'll be around for a week, a month, a year or perpetuity. Sometimes they have no idea how they got where they are in the first place. Why them? There were others with as much talent, more beauty, better voices, better agents, better connections, more sex to offer. Is it luck or a deserving fate? What's to stop whatever it is running out? If it's timing, when does the clock stop? If it's talent, which bit do they have to repeat? And if they vary it, will it still work? This is the dread at the heart of all celebrity.

The more craft that's involved in the recipe of fame, the more at ease the practitioner is. So the concert pianist or Olympic skater has more confidence than the pop star or romantic lead movie actor. The harder you work at whatever it is you do, the greater the illusion of control. But it's only an illusion. If the tide goes out, there's sod all you can do about it.

All celebrities talk of celebrity as if it were another country. They talk about it like politicians stumping for re-election. And the other awful truth is that they have no control over their destiny. But there are a lot of other people who do. The bloated secretariat of fame, the managers, agents, PRs, directors, producers, studio executives, fortune tellers and impresarios. However, these are just middlemen. Priests whose lives and livelihoods are also at the beck and call of celebrity. It's the public, the audience, the vast hoi polloi who employ and fire, and this can make celebrity seem like life lived in the Colosseum. Fame's relationship with the

audience is complicated and murky. When a star comes to the edge of the stage and blindly shouts into the spotlight, 'I love you, I love you', they mean it. But they mean it in the way that a battered child means it when her father starts pulling off his belt. The relationship of celebrity and fan is not ruled by the rules of commerce. It's not the economic rationale of supply and demand. It's the irrational anarchy of demand. Everybody's demanding, imploring, and no one demands more than a celebrity.

At best celebrities tolerate the press. Most of them hate it. Now, they'll tell you it's because the media intrude into their private lives and make up lies about them. But the truth is, celebrities lie too. They lie about everything from their ages, their hair colour, how happy they are, what they're reading. Invariably a celebrity, when asked, will say that they only want to talk about their work – but it's a lie. It's the last thing they want to talk about. What they do like to talk about is other people's work. So actors eulogise directors, and other actors. Pop stars compliment producers, managers, agents and other musicians. Models worship designers; designers, models and film stars. And the circle of mutual congratulation and lack of confidence spins round and round. Those wraiths, dryads and nymphs of the celebrity pantheon, people who are famous for simply being, will roll off names of other celebrities to confirm their position by association.

Anyway, Terry starts at the airport. He's just been demobbed. He's playing jazz drums in clubs. He joins British Airways as a technical photographic apprentice. He wants to transfer to be a trolley dolly, because that'll get him to New York, where he can become a better drummer. British Airways send him to art school one day a week to learn about cameras. And the art school sends him out to take pictures of human emotion. Terry hangs around the single terminal at Heathrow Airport.

Aeroplanes were an important part in the rise of celebrity. This is the early sixties: few people travelled. The closest most Londoners had ever got to an aeroplane was being bombed by one. The new, sleek, commercial jets were an emblem of sophistication, wealth and modernity. Symbolically the aeroplane brought with it a sense of freedom from reality and drudgery. Radio, television and newspapers ran regular 'In Town Tonight' features, when the affair between celebrity and film was consummated. This was before celebrity became the rambling Olympian, gated community it is today; then it was a collection of sects and gangs, and one of the first was dubbed 'the Jet Set'.

A photograph of a star ascending the steps to an aeroplane was one of the memorable clichés and religious euphemisms of the post-war years. Airports were exciting places. Passengers dressed up to travel by air. So, Terry and his Agfa Silette snapped an old man asleep in the terminal and by chance a passing journalist offered to buy the film. The sleeping gent was Rab Butler – a leading Conservative politician. The newspaper, the now defunct *Despatch*, was so impressed with the film they asked him to stick around the airport at weekends.

And thus Terry became a photojournalist. Quite a polite one, actually. He

always asked permission. The airport was rich in stars and they were happy to smile for a teenager. The truth was that there were very few places where an unflattering photograph could end up. Papers ran small, dainty women's gossip columns and magazines wanted good news. The press was interested in pretty pictures of pretty people, content to maintain the staged gossamer fabrication of pre-war managed stardom. Interest in stars' private lives was limited to respectful beauty hints and the occasional glimpses into inevitably fairytale, elegant homes. The press assumed that their readers were fans and that what fans wanted was fluff.

But the burgeoning phenomenon of celebrity changed all that, and the relationship between photographers and their famous subjects became more intense, dark and interesting. The affair between celebrity and light-sensitive paper was the greatest love story of the last century. Celebrity and photographer are indissolubly joined by one great lie – that the camera never lies. The absolute veracity and incorruptibility of the lens makes it the confessional box for celebrity. But people have an agenda. Agents, friends, family, the public, clothes sizes, scales – they all fib. And there are days when a mirror will just turn on you. But a photograph is physics. And the laws of physics are immutable. Light travels in a straight line, it passes through a clear lens and is recorded on paper. The absolute truth, in a fraction of a second. So cameras can't lie. We all know that. Photographs are honest enough to be evidence in court. Evidence of existence in a passport. But then, if they were nothing but the truth, the photographer would simply be a man who pushed a button, and the results would all be the same. And patently they're not.

One of the most revealing glimpses into celebrity is to watch it confronted by a contact sheet. The concentration is absolute. The eye unswerving. The process cruelly harsh. It's not enough to choose one image over another – the wrong ones, the wicked ones, have to be defaced. Torn up. There is truth, and then there is a better truth. The mantra is always the same. This makes me look fat. Old. Mad. Sad. Drunk. Stupid. No celebrity ever says, 'This shows me to be fat, old, mad.' Something has happened to muck up the physics and that something has to be the photographer. So photographers who manage to squeeze the good truth down their lenses become essential Boswells to celebrity.

In a purely practical sense, photographs are vital to celebrity. It's a truism that it's difficult to be celebrated without being recognised. Celebrity is an image and the first thing kids who want to be famous do is have their pictures taken. The first thing agents and producers and editors ask for when looking for nascent celebrity is a picture. Photographs are the currency of fame. Show us your face. Show us your body. And of course no interview with a celebrity is published without a photograph.

There is nothing else in the world that we can look at with the same fascination over and over again as we do a picture of Marilyn Monroe or Elvis. What do we expect to see that we haven't seen a thousand times before? What are we

looking for? A truth. And if you think that we, mere fans, have a bulimic appetite for these things, try to imagine how celebrities look at pictures of themselves. Imagine what it's like looking for the truth about yourself. Most celebrities have a very Jekyll and Hyde relationship with their own image. Many, maybe most, can't bear to look at photographs of themselves. All are critical to the point of being self-flagellating, but some won't have a single one in the house. Others have rooms that are galleries to themselves. For all of them the power of the captured image is mesmeric. The truth that they look for goes right back to that lost key and what made them a celebrity. What ethereal force yanked them from the chorus, whisked away the apron and tray and created them as semi-deities? Perhaps the physics of the camera will explain, and they'll be able to see what it was that made them. And if they can see it, maybe they can polish, or protect, or improve it.

Photographers get reputations for being particularly good at particular things. They overlay the laws of physics with a sort of modern necromancy. Some are good with women, some with glamour. Others with the simulacrum of naturalism. They are awarded powers of divination, of being able to reveal or hide the truth. Of course, what is revealed is never solely the photographer's vision. It's only what he can extract and what the celebrity allows to be extracted. No photograph is natural. The process is all staged, even when the image appears unguarded. If the photographer fires off a roll in a break over lunch, or in the make-up room, it's still heavy with manipulation. The great lie of photographs is that they are facts; and, more than that, that they are unvarnished facts. A two-dimensional image is instantly a fiction, but fiction can, at its best, be truer than a mere collection of facts. Sometimes, what you work to conceal reveals a deeper truth. Just occasionally, a picture captures something that isn't worth a thousand words, but fills the silence between words.

**Terry soon had enough of newsprint** and hanging round airports, first nights and galas. He took a gamble and became a freelance. I asked him, what do you do when you go to take someone's picture? Is there a thing, a trick – what do you say? 'Compliments,' he said. And? 'More compliments.' You compliment them a lot then? 'That's it, and, well … you could add a few more compliments.'

Naturally, celebrity compliments are of a completely different order from the 'You look nice today' kind most of us trade in. For celebrities, compliments are serious. They're taken seriously and given seriously. They're mulled over. Filed, pulled out and pondered. Sometimes kept for life, close to the heart, as personal mantras. This may seem idiotic and vain beyond reason, but actually it's an attempt to make some sense of their unusual and inexplicable lives. Compliments are reviews. Favourable criticism. And that's what a photograph is. A criticism.

A celebrity will deconstruct a photograph for a bad notice with a concentration and sophistication that would shame a French literature professor. Anyone sitting in on a celebrity shoot for the first time would be amazed at how long it takes. And

at the Machiavellian complexity of the relationship between photographer and subject. Time is the essence of photography, the split second that's caught for ever. For the celebrity too, time is everything, for celebrity is a terminal condition. How long have I got? No one knows. You can explain the frankly bizarre and absurd behaviour of some celebrities as being the desperation of patients looking for an alternative cure for obscurity. If I surround myself with twenty-seven hangers-on, if I keep everyone waiting for three hours, if I insist on only green jelly beans, and a thousand scented candles, a private jet for my hairdresser, a hairdresser for my hairdresser, if I push the boundaries of fame and my allotment of adoration, maybe I'll know how deep it is, how long I've got.

Celebrities don't live in the same time frame as we do. Everything is faster, more intense. They live like dragonflies. That age in the mud at the bottom of the pond as an ugly bug, and then a brief moth, aloft on gossamer wings. So the symbolism of the photograph appeals to them. It is also the thing that marks out celebrity. The process confirms celebrity, the dragonfly moment caught for ever, an image that will defy time and live on into the Norma Desmond years. Untouchable. So celebrity photographs take an extraordinarily long time, even though celebrities will invariably say they only have half an hour to spare.

Of course, celebrities are all different. But they're all as different as children in the same school photograph. They all come from the same institution. There's a very long waiting list and a very difficult entrance procedure. The one thing you can say about all of them with complete certainty is that they will all be excessively controlling. It's almost a definition of celebrity. They want to predict everything, because their lives and prognosis are unpredictable and where they're most controlling is when they come up against posterity – the most ungovernable thing of all. Posterity is the province of gods. And photographs are the calling cards, the CVs for immortality.

For some celebrities there are photographs that say it all, that become famous in their own right. That in one moment propel the subject to Olympus, for ever. When the performances are all forgotten and lost, the photograph will remain. Sitting is a chess game with the future. The sitter tries to project an image of contrived eternal perfection. And the photographer tries to see through it, past it, to some elusive reality. Both are after the same thing, but by different means. And for different reasons. The rigorous organisation of naturalism. There is no reality behind the image. It's like peeling an orange and finding out that after all it's still an orange. Celebrities are celebrities at home, on their own, on the loo, when talking to dogs. But what there might be is a deeper insight, a glimpse into the workings of celebrity.

Terry says that in all his working life he's perhaps taken no more than twenty memorable images. The ones he'd choose and the ones you and I would choose are probably not the same. And they're not necessarily the ones celebrities would choose. But if you look at this collection as a single work of art, an encyclopaedia, a manual of celebrity, you see a simile, a metaphor for humanity. You have to read it

like a puzzle or a poem, for it's more than the sum of its parts.

Let's start where it all started – with Brigitte Bardot. Instantly recognisable, imperviously iconic. Everything you know about the young Bardot is laid out in this image. The photograph simply records a projection. Today it looks almost mundane. Hundreds of photographs of hundreds of momentary supernovas have been photographed like this. It's a picture you look at and think, I could have taken that. And this itself was part of Bardot's attraction. But in its time the shot was fabulously daring and new. First the hair across the face obscuring the eyes. Stars simply didn't let that happen. And the eyes themselves – have you noticed there's no contact? She's not looking at you.

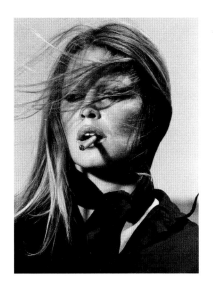

BRIGITTE BARDOT
page 21

Eye contact is the first law of stardom. You look deep into the eye of the camera and on into the eye of the distant, perhaps as yet unborn, viewer. You project your thing. Heroism, love, sex, mystery, comfort, humour. It's a subliminal conversation with the future. Flick through this book, or walk past the newsagents and feel the eyes follow you, all imploring. Eye contact is the great power of the subject in a photograph. The eyes are the first things we look at in an image. Our glance is drawn back to the eyes more than anything else. Next time you're photographed, try staring hard through the lens; try to impart an emotion, just with your eyes. You'll be astonished by how different the picture looks and how difficult it is, how quickly you glaze over and cease to focus.

But Bardot doesn't look at the camera. She's not looking at anything. Her gaze is turned inward, she's thinking. And that's something else stars didn't do. It makes the image look both private and intimate. As if we've caught her in an unguarded moment. But look again at the whole image and you know that this is just not how anyone looks when they're caught in thought. It's a choreographed muse, reminiscent of archly romantic Victorian paintings. She could be an illustration from the *Morte d'Arthur*, except for the cigarette. Fags are a clichéd prop, an old Hollywood standby. We all understand their symbolism – they're sexual, they're louche, they're something to do with your hands. And smoke is atmospheric. But Bardot isn't smoking. The blow-job symbolism has been made remedially overt and it tells you what she's thinking about. She's thinking about *l'amour*, which is the better class of sex that French intellectuals have. We know that all Bardot thought about was sex, because all we thought about when we thought about Bardot, thinking about us, was sex. That was until she started thinking about stray dogs. And then we went back to this image of her, and thought about sex again.

The other thing about this photograph is that it's completely un-American. Here is the first modern properly European object of post-war desire. She shrugs off concern with unimportant things like her coiffeur or what she did with her ash, and this distinguishes her from the manufactured, smiley, neat Californian version. And of course the French made her Marianne, stuck her bust on every hôtel de ville in the Republic; Marianne, who led the *sans culottes* over the barricades of Hollywood into a modern age of *liberté, fraternité, égalité* and *sexualité*.

I haven't mentioned sex much yet, because once you mention it there's no end to it. But looking at celebrity without mentioning sex is like admiring the cake stand without mentioning the cake. Ninety per cent of celebrity is about fucking. Celebrity is a constantly shifting league table of roger-ability. After pornography, the most hits on the worldwide web are for Britney Spears and Anna Kournikova. Why bother saying 'after pornography'? – let's face it, no one's hitting on Anna to improve their forehand. Although then again …

What distinguishes the school photo of celebrity is that almost everyone in the class is beddably beautiful. And, you may have noticed, this is just not true of the rest of us. Because unusual, extreme beauty is the norm for celebrity, ugliness, even just plain plainness, stands out as interesting. Faces and bodies that aren't instantaneously lickable tend to look clever instead, or amusing, or friendly, or more likely, just incredibly rich. Ugliness has a cachet among celebrities because it has rarity value. Because to get to the top table without being fancied must mean you've got some other, stronger magic. Pretty people are fascinated by it, are attracted to it. In the land of the pulchritudinous, the repulsive has a strange allure, and besides, standing beside it, you look even better.

Back to sex and bed. Look at the photograph of Raquel Welch. The American version of Brigitte Bardot. She is to Bardot what American cars were to European cars – a big Cadillac body, rounder, more guffaw-guzzling, a wallowing fantasy ride. And she's not about to read Sartre. This startling photograph was never printed – it was thought to be just too offensive. What I like about it is the cacophony of mixed messages. So here's Raquel, crucified. Actually crucified, on a real cross. How on earth did Terry suggest that?

She's not up there along with Spartacus, but in the traditional pose of Christ. Why? She's plainly not in agony, she's not dying for our sins, indeed she's reminding us of a few we'd still like to commit. She looks at the camera with a face that might be remembering to buy cocktail olives, or get her toenails painted. And then there's the costume. The one she wore in the photograph that made – and still makes – Welch an Olympian. The shot from the poster of *One Million Years BC*. A furry bikini. The clue to why the fur swimmies don't belong is in the title – she's got a long way to wait before Christianity.

Terry says Raquel wanted to do this bizarrely mixed metaphor because she thought it illustrated the fact that she was being crucified by the press. It's metaphorical, see. This is a self-defeating stratagem that's used again and again by celebrities. I'm being unfairly reported, so I'll take all my clothes off and get snapped for a magazine, just so you'll know how bad it's got. Raquel's original 'I'm only human in a God-like way' motivation is now entirely lost. What we're left with is a photograph that's one of the finest examples of screaming kitsch ever made. I love this picture, because it so completely encompasses the fabulous tackiness of so much celebrity. Terry's cleverness was to play up to it.

While you're there, look at the photograph beside it, again of Raquel, standing

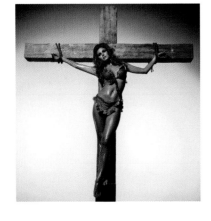

RAQUEL WELCH
page 107

in her Cheshire wedding guest's outfit with her knickers round her knees. This is a funny image. But then the addition of three leering men staring like a gynaecologists' convention up her front bottom takes it, metaphorically and physically, into another place altogether. And please note the white stilettos.

One of the images in this collection that I'd unhesitatingly call great is Frank Sinatra walking to the set. It mimics another famous picture of him with the Rat Pack in Las Vegas. But this one is far more memorable. Sinatra, clothes hanger-shouldered, top button undone, tie tugged loose, in the characteristic Blues pose, is surrounded by his posse, and they are just perfect. Extras from every hard-bitten Mafia movie. Paunchy, tough and tasteless.

It's only after a second glance that you realise the man in front is Sinatra's double, his stand-in. The animated suit that's used to mark shots. The picture is beautifully composed, all the figures placed as if in a Venetian painting. But also with that finger-snap immediacy of a Cartier-Bresson moment captured. The image croons attitude and a latent aggressive 'fuck you'. The cadent feet of the posse, their loose arms. The stand-in is not only wearing Sinatra's clothes, but his expression as well. This is a seminal image of celebrity. The double is a trophy of fame. It's like owning your own doppelgänger to do the dull things and hang about. I only eat the jam of life, the crusts I have a man for. It's one of the great fantasies – 'Oh, to be in two places at once.' The first step on the ladder to omnipotence.

But in Sinatra's case, in this company, it also has an older, darker resonance. The double is there to fool the enemy, a less important drone who can take the bullet, to save the general. It's as old as myth. It's Homer's Patroclus in Achilles' armour. Nothing so underlines Sinatra's status as owning another, anonymous, disposable self. It papers over that nagging sotto voce question: Why me? Roman emperors were given a man who would whisper, 'You're merely human,' in case they self-deified, but Sinatra's stand-in's presence ahead of him says, 'You're not merely human.'

There's not a single thing I'd change about this picture to improve it. Sinatra is an important character in the generation of modern celebrity. Not only is he the bridge from big-band music to pop star, but he's the role model for the transition from singer to actor. There were, of course, other musical and opera stars who made movies, but Sinatra was the first modern one. Now the synthesis between charts and cinema is a given. But, more than all that, Sinatra's private life became a central part of his celebrity and the fact that it wasn't good or edifying in the traditional way, but seamy and disreputable, only added to his attraction. The good/bad role model deal has become the great cliché of rock and pop and bad-boy poseurs ever since. Sinatra walking with his fixers and bodyguards is the image borrowed for the opening shot of *Goodfellas*, and by rap artists and movie tough guys. Like the households of medieval kings, their excuse is vulnerability, but their effect is power.

**Why do celebrities always marry other celebrities?** The answer is obvious. Because they can. One of the abiding truths about celebrity is that it is far more enraptured

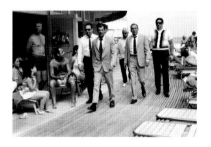

FRANK SINATRA
page 156

by stardom than we mere fans. For us it's a temporary diversion, a low-humoured interest. For them it's an obsession. Celebrities never grow out of the huggable joy of being on the bright side of the red rope, of belonging to the club. All of them started out as über-fans. It was probably this that propelled them to attempt celebrity. They are endlessly fascinated with one another, and collectively with the gravity-defying magic that keeps them famous. Celebrities tell you that it's because only other celebrities actually understand what it's like to be them. As if they were all refugees from a common reality. But this isn't true. In the same way that it wouldn't be true of grocers or gardeners. Celebrities cling together because they confirm one another's rightness. It's a self-justifying un-secret society. They marry other celebrities so that they can wake up in the morning and sigh, 'My God, would you believe who I've just shagged.'

Of course, celebrity does recognise and know other, uncelebrated, un-famous people. I remember once being at a dinner party with a very famous film star. The topic of celebrity cliques came up, and the star started on a heartfelt diatribe about the shallowness of his co-celebrities, how they were kissing one another's arses all the time, how phoney and backstabbing and vacuous fame was, and how different he was. For instance, he said, just look at this gathering of close friends. There was his agent, a director, an antique dealer, an interior decorator, an alternative health therapist, an investment manager and me, a journalist. Everyone around him worked for him, sold him things, wanted him to work for them, or was writing about him. We were all sheltering under the munificence of celebrity. This isn't to say we weren't true friends, but in each case the relationship wasn't equal.

Celebrities are extremely mistrustful of familiarity. They always suspect an ulterior motive, and usually they're right – after all, they are celebrities. Better to get it out in the open first. You can be best friends with your hairdresser because you know what he wants from you. Your hair. If by chance your patronage makes him a celebrity in his own right, all the better. And this, by the way, is what made photographers celebrities in the sixties. If the celebrity could bring the snappers in off the cold doorstep, then their photographs would have added value, which in turn would enhance their celebrity.

When the famous actor finished his man-of-the-people rant, we all laughed and nodded and offered *bons mots* of corroboration. I listened to myself doing it and wondered at the particular pleasure of making a celebrity feel warm. The slight joy you get from joining your opinion to a famous one and I thought how easy, how jolly salubrious it would be to be a full-time sycophant. That's the other thing people always ask about celebrities. How come they're always surrounded by yes men. Well, wouldn't you be? It's so much nicer than the alternative. What do you give the man who has everything? Half a dozen sincere friends who will tell him that he's a humble aesthete who, through personal generosity, owns virtually nothing except the love and goodwill of mankind.

Talking of celebrities marrying each other, take a look at the picture of Woody

Allen and Mia Farrow. This image was a sleeper. When it was taken, it must have seemed like a thoughtful and astute record of an unusually cerebral Hollywood couple. Farrow, the childlike actor who became the muse, first for André Previn and then Allen. A woman who generously turned her talent to nurturing genius and multicoloured children. She's photographed without any of the trappings of fame – no make-up, no hair-do, just an almost uncomfortably direct stare – and Allen just as we imagine him, slightly disengaged, adopting a traditional pose of deep thought. A man for whom humour is a defence against morbidity. They'll have been pleased. It's a serious, elegant portrait.

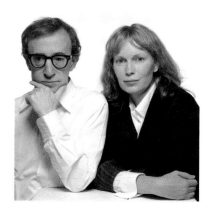

WOODY ALLEN & MIA FARROW
page 64

But then along came events and Woody and Mia were buried and revealed in one of the great celebrity scandals of the nineties. Now we look at this double portrait and it's a completely different picture. It's overlaid with meaning and portent. It's become an oracle's premonition. The camera appears to have seen the future. It's all there. How could we have missed it? That direct gaze is so distressing. She looks heartbroken, really sad. But strong. And you notice Allen's shoulder in front of hers, he seems to be pushing her out of the frame. His pose isn't thoughtful. It's neglectful.

Photographs are hostages to fortune. They're not fixed images, because the viewer brings a gallery of expectation, prejudice, received knowledge and aspiration to them and these change. But they change and grow, particularly where celebrity is the subject. Celebrities like photographs because they think they're fixed and controllable, but what they can't control is how we look at them.

Celebrity is a phenomenon that happens mostly in still images. But the viewer reads them like frames of film. They become points in an evolving relationship. We can go backwards and forwards, we can shuffle and compare. This book looks one way to you now, but it will look different in ten years and utterly different in fifty. The images remain the same, but are profoundly altered.

**There are a number of images here** of the rich and famous apparently making fools of themselves. Burton in a plastic bath cap; Jagger under the hairdryer waving the camera away; and my favourite, Lord Olivier wearing a girdle and silk stockings, holding his breasts. And there are any number of stars pulling faces, acting the ass, but you'll notice that almost all of them are men.

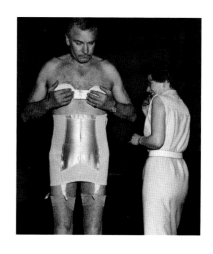

LAURENCE OLIVIER
page 142

Celebrity affects men and women differently. Their relationship with the camera is different. Look at portraits of the men, notice how many actors and pop stars adopt a pose of tilting their heads down and looking up at the lens. This disguises weak chins and lifts their eyes so that there's a crescent of white under the iris that makes them look bigger. But that's not why they do it. They do it because it's a moody look. Dangerous and interesting. It's the aggression-lite version of the boxer's traditional pose. Head down to protect nose and chin, eyes alert and predatory. Women don't do it, unless they want to look masculine. They turn their heads to one side and look alluring. Mysterious. The reason the men are willing to

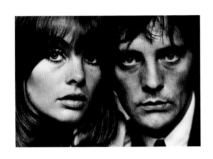

JEAN SHRIMPTON & TERENCE STAMP
page 104

mug and make idiots of themselves is a sort of faux humility: 'I'm not so grand and famous that I can't laugh at myself.' It's not entirely honest, of course. It also implies that they're so self-confident, so assured of greatness that they can afford to play around with the image. Men are allowed to be funny in a way that is still difficult for women and, most importantly, male celebrity lasts longer than female. Once they've made it, the chances are they'll keep it. They can afford to relax, just a little. If they act or sing or just hang around the right parties, women live in celebrity Valhalla only as long as their looks and bodies incite the right reaction. So the lens is rarely a laughing matter.

To say that women flirt with or seduce the camera is a male cliché. Flirting and seduction are at best pleasures and at worst relatively harmless. For a female celebrity, a photograph is hard work, and at worst it can be devastating. It's almost always women who get reputations for being difficult in front of the camera and it's generally men who incredulously say, 'Oh, for God's sake, it's only a picture, there are millions of pictures, why sweat the little stuff?' But for women it's not little. It's their livelihood. A bad photograph, a paparazzo shot catching cellulite on the beach, a roll of fat, a tired eye, can be fatal. It's not vanity that makes women precise and demanding in front of a camera – it's self-preservation. And women's pictures are looked at quite differently from men's. They're scrutinised in a more critical and combative way. Partly because they look so overtly sensual and serious.

A very good example of this double standard is the portrait of Terence Stamp and Jean Shrimpton, a pair of the most divinely beautiful faces of the sixties, and themselves a couple. The image is cropped so tight that they could almost be posing in a photo booth, and what you notice first is how like siblings they look, how androgynous their beauty is. The similarity couldn't be more obvious, but then neither could the difference. The former on the page, the latter in your perception. And then there's the fact that most photographers are men and if female celebrities don't necessarily flirt, male photographers necessarily do.

Which brings us to one of Terry's most famous pictures. Faye Dunaway, the morning after the Oscars. Terry was married to Faye and this is the ultimate Hollywood snap. If you had to explain in thirty seconds what Hollywood was to someone who'd never heard of it or seen a film, this picture would give them more clues than anything you might say. First, the *mise-en-scène*, the swimming pool, that cliché of success and fame. All Hollywood pools are indelibly marked for me by the opening shot of *Sunset Boulevard* – Joseph Cotton floating, shot by Norma Desmond. There's an echo in this picture. How many bodies has Hollywood dumped in pools – living, dead and legendary? And then there's the breakfast table, the mess of papers and, standing in the detritus, the priapic poseur, Oscar. An ornament that's half kitsch classicism and half twenties futurist set dressing. However did they come up with a naked automaton holding a sword? What's he guarding, who's he going to fight? And there's Dunaway in her bathrobe, slouched with a terrible ennui. This picture is one of the greatest celebrity shots ever taken.

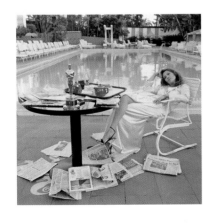

FAYE DUNAWAY
page 134

There are a lot of pictures of the Rolling Stones in this book, singular and collective. You might easily pass over the group shot outside the Tin Pan Alley members' club. You might pass it by because it's so familiar. Every bad boy group in the intervening thirty years has been photographed in this sulky, surly pose. And that's its point. As far as I can tell, this is the archetype for all those album-cover group shots. This was the picture that scowled, as rock music wanted to scowl, and has been plagiarised endlessly ever since. It's not just celebrities who adopt the poses of other celebrities. Photographers pushed for time, pressured to get a safely usable shot, nick from each other with a gay abandon.

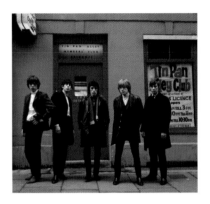

THE ROLLING STONES
page 130

I tried to get through this essay without overusing the word 'icon', as it always makes me wince whether I see it in print or hear it outside an Orthodox church. It's a word that's become exhausted and worn out by lazy overuse. The trouble is that in terms of celebrities and their images, it's so perfectly apposite. Intense objects of worship overlaid with the beaten gold of aspiration and admiration, precious and venerable in themselves, but more so as images to focus other-worldly thoughts on. And celebrity is another world.

I began by making the comparison between celebrities and the classical gods of mythology whose motives weren't necessarily good but had the power to donate great joy, or the callousness to inflict damnation and ruin. Whose lives mimicked the earth-bound world and had sometimes existed in it. Whose love lives were glutinous, whose demands were impossible. You can continue the analogy until it becomes tedious. But what you notice throughout this book is how subconsciously celebrities take on the body language of older, revered images, acquiring by association their gravitas. The stylised poses of nineteenth-century studio paintings, the formal calm of Georgian portraits, the silent grandeur of Elizabethan propaganda.

Here is Elle Macpherson as an odalisque, Jerry Hall à la Botticelli. Many of these images remind me of the silent, patiently waiting figures of early Renaissance altarpieces, sometimes carrying an object that refers to their beatification or martyrdom, their faces masked with a glaze of reverence. The one thing gods and mortals both share is a belief in gods. And the only supreme power that mortals hold over gods is this belief. The ancient Greeks knew that Olympus would finally fall when people stopped believing in it. And Terry thinks, perhaps believes, that the end of the Age of Celebrity, the Götterdämmerung of fame, is already approaching.

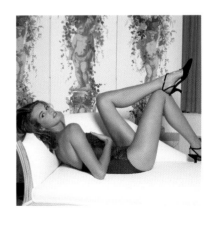

ELLE MACPHERSON
page 34

Celebrities aren't what they were, or perhaps they are what they've always been, but just less so. The spiralling number and diversity of people who are famous now is devaluing the currency. The public is ceasing to believe in them – anyone seems to be able to achieve celebrity. There is a weariness with the whole pantheon. Fans becomes cynical and malicious, so celebrities stop behaving like gods and plead how ordinary they are, make themselves unexceptional. And photography has changed. The unchecked paparazzi have finally driven celebrity into the burkha of baseball cap and dark glasses. The process of photography is no longer mutually

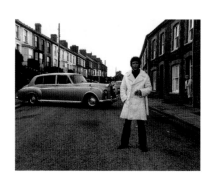

TOM JONES
page 118

beneficial – now it's a war of attrition, of deception. Colour printing, the process that a few decades ago started the gold rush of celebrity, now barely needs a subject to make an image of. Retouching photographs is no longer the decorous enhancement of retrospective make-up – it's computerised plastic surgery, in which legs are slimmed and breasts grow curves and imperfections vanish. How soon before they do away with real heroes and gods altogether and they become just electronically generated, ethereal objects of wish fulfilment and lust; when the religion of celebrity no longer needs to believe in the corporeal body at all? Terry thinks all this and that he was lucky to get in at the beginning and still be working at the end.

I want to finish with one last image – of Tom Jones. Not the big picture of him with that lumpy mining-town face and the chunky jewellery. No, the smaller picture – Jones standing in the mean back-to-back street where we assume he came from, smart, sharp, dressed in a white fur-coat. He's flash as a fighting cock. Behind him the huge Rolls blocks the street and a wee wifey in the middle of her housework pokes her head from the door to have a look at our Tom, and you know what she's thinking, 'Oh, didn't he do well, I remember when he was just a little tearaway, his mum must be proud. But that coat, what if you spilt something down it, and that motor, not very practical' – and you know what he's thinking too. I remember the first time I saw this image, years ago, it stuck in my mind. So evocative of so much. It poses that endlessly asked, still unanswered question: Why me, what did I do right?

The most famous quote of the celebrity era is Andy Warhol's prediction that 'Everyone will be famous for fifteen minutes' and, by implication, celebrity will cease to have any value. **But the photographer adds a caveat – in one-sixtieth of a second he can still make you immortal.**

AA GILL
London, 2003

# CELEBRITY

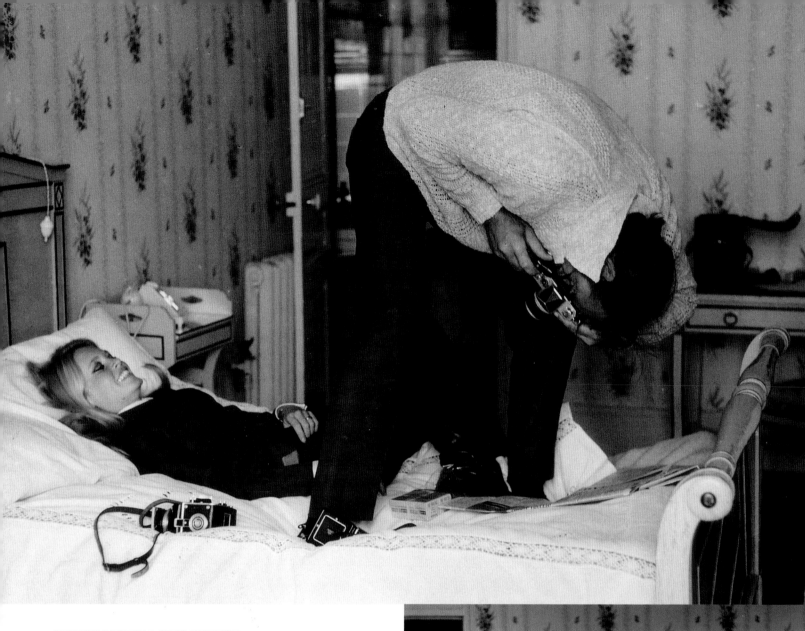

**BRIGITTE BARDOT & SEAN CONNERY**
France, 1968

*right,*
**BRIGITTE BARDOT**
Spain, 1971

I took these shots in Deauville,
on the set of *Shaloko*. This
was the first time Sean and
Brigitte had met and the
natural chemistry between
them was obvious – they
got along very well

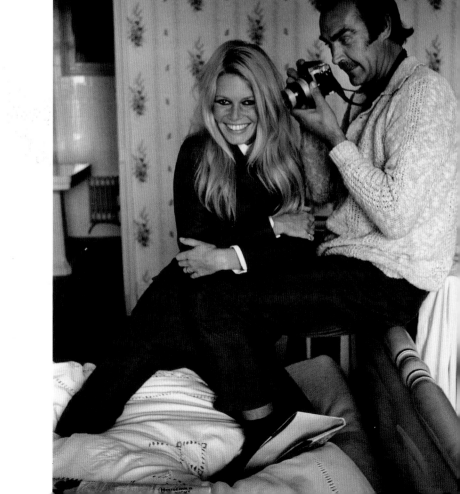

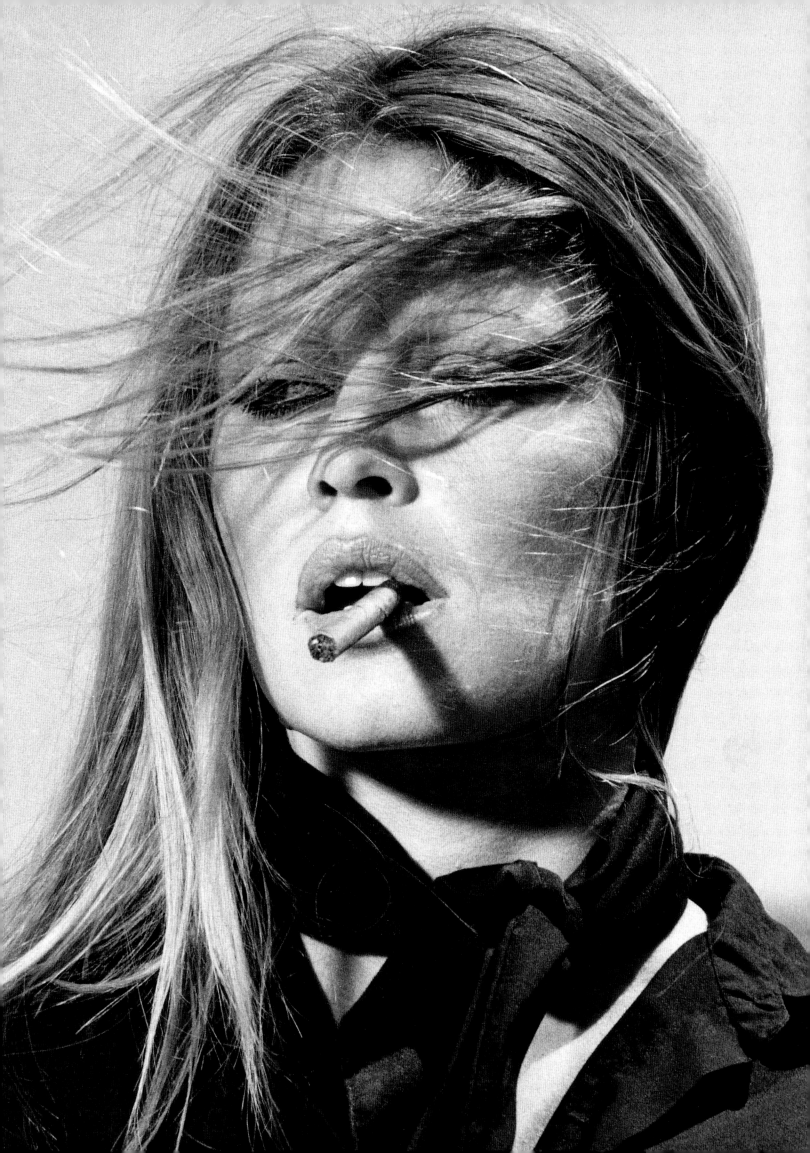

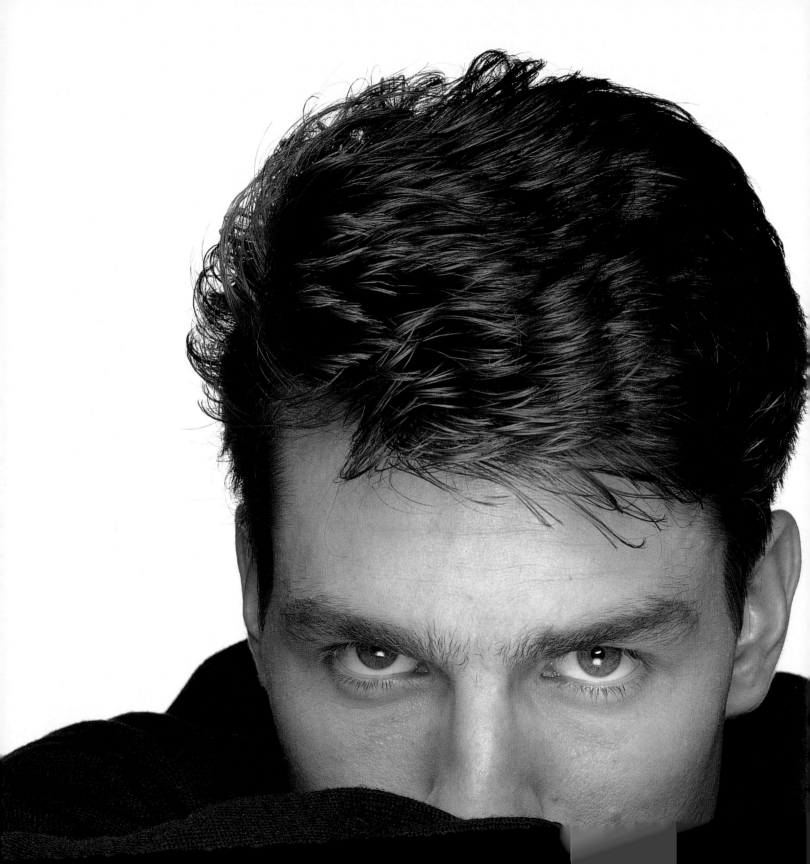

This was Cruise's first cover for *Premiere* magazine and it was clear that it would only be a matter of time until he was a huge star. It's not often that you come across a man you know is going to be a movie legend

EPN▷13

EPN▷

TOM CRUISE
Hollywood, 1992

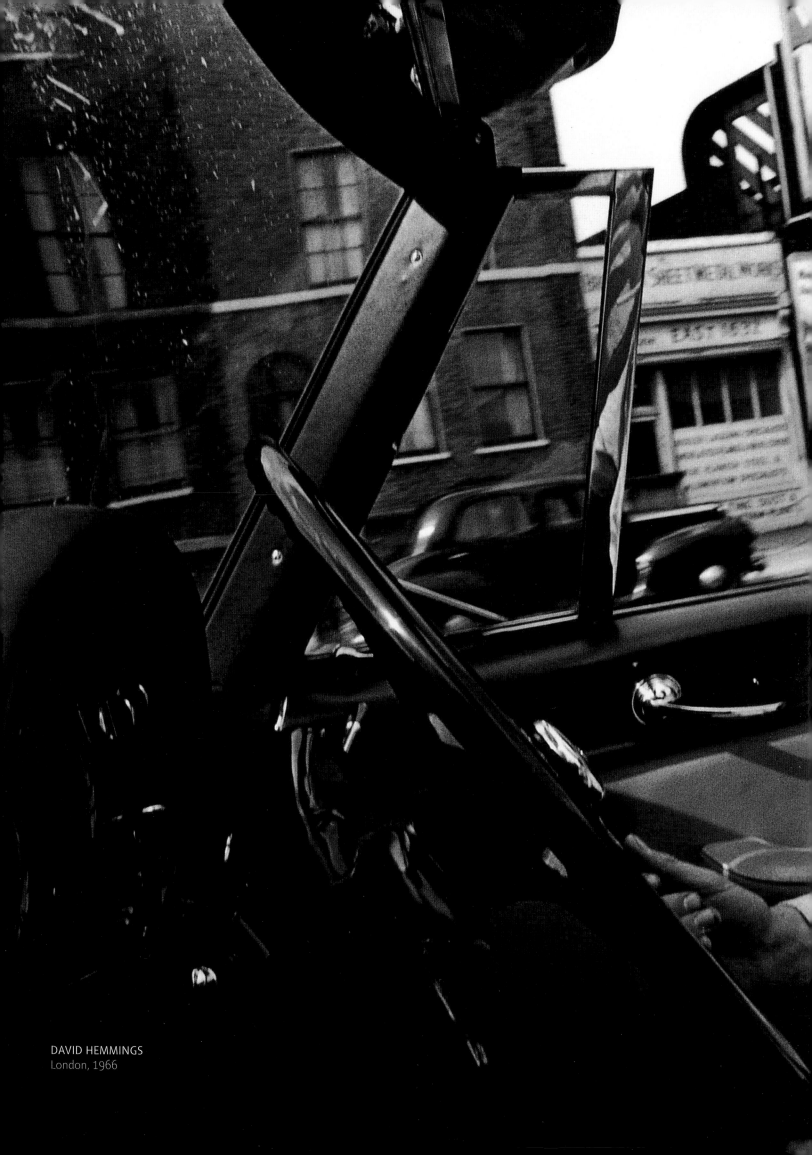

DAVID HEMMINGS
London, 1966

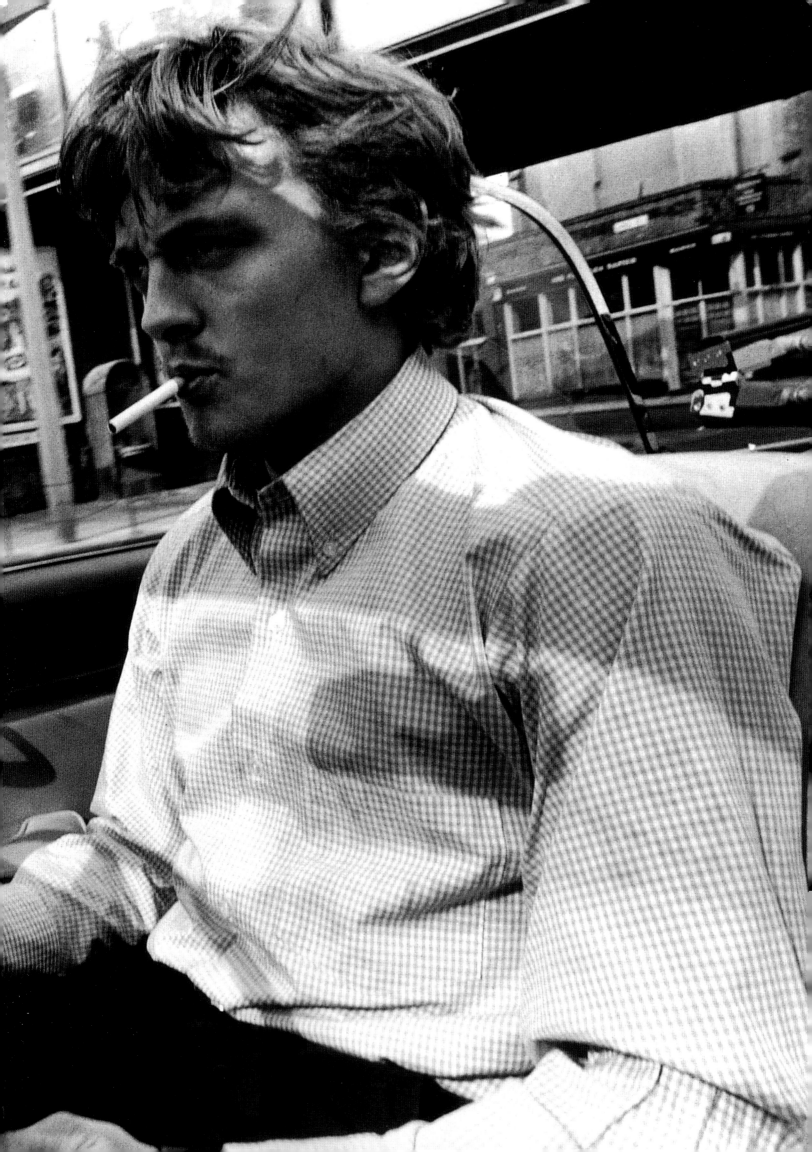

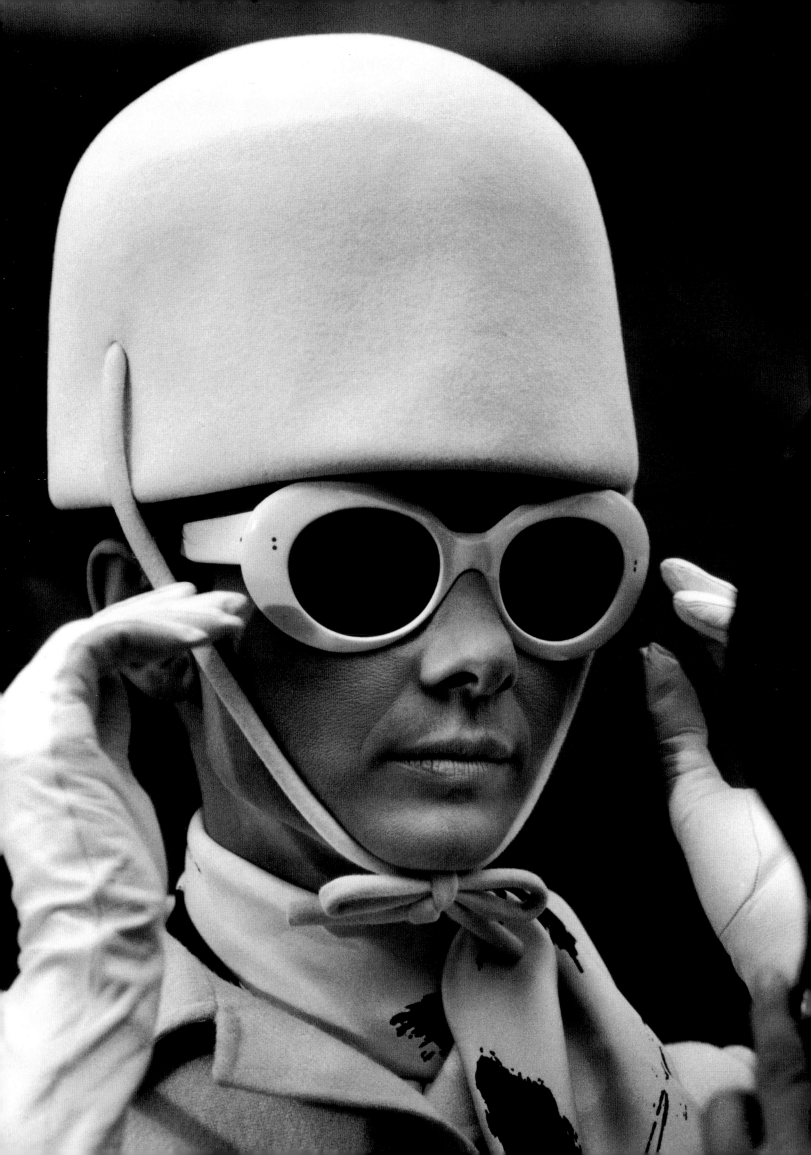

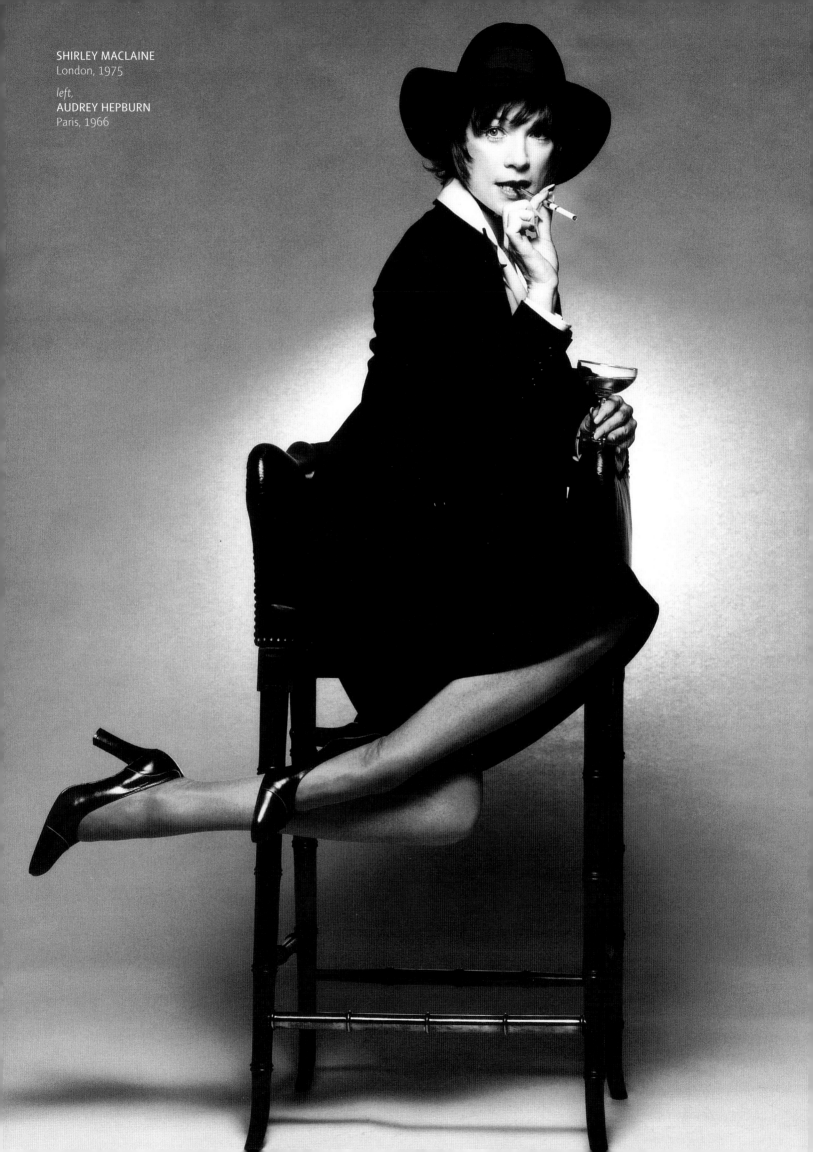

SHIRLEY MACLAINE
London, 1975

*left,*
AUDREY HEPBURN
Paris, 1966

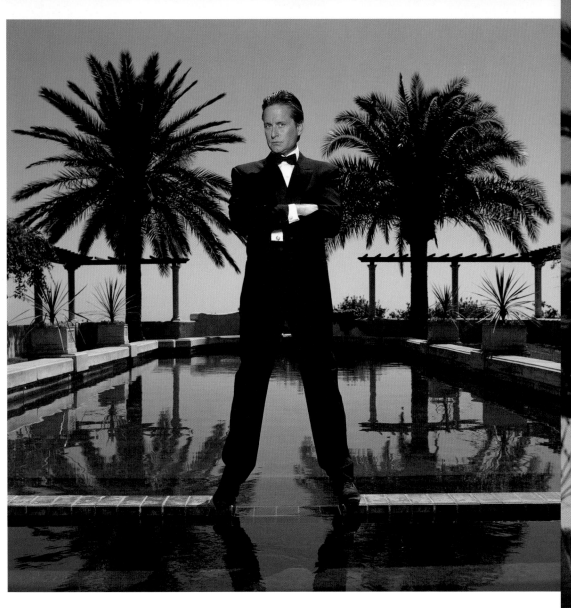

MICHAEL DOUGLAS
Santa Barbara, 1988

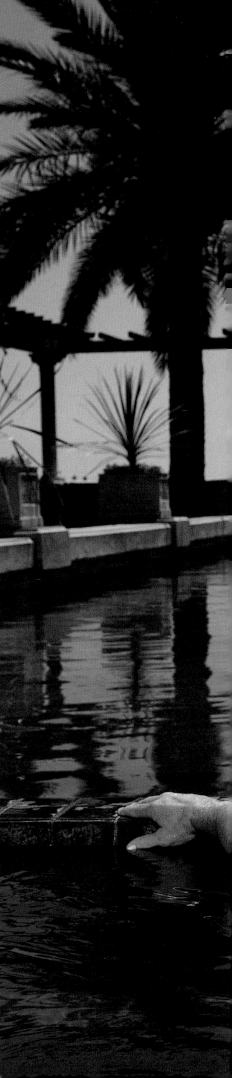

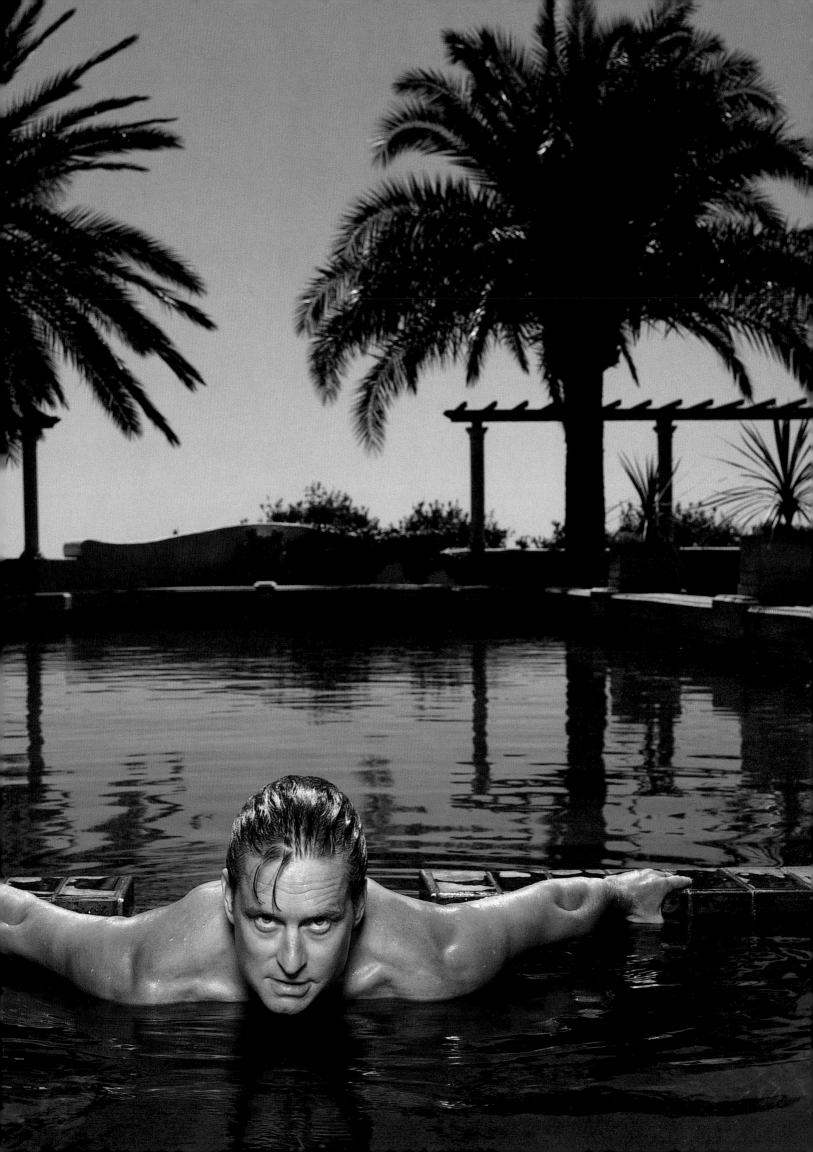

This portrait says it all about Bianca: she's sharp and not to be messed with. I took it as a publicity shot for her role as a hooker in *Success*

BIANCA JAGGER
Munich, 1978

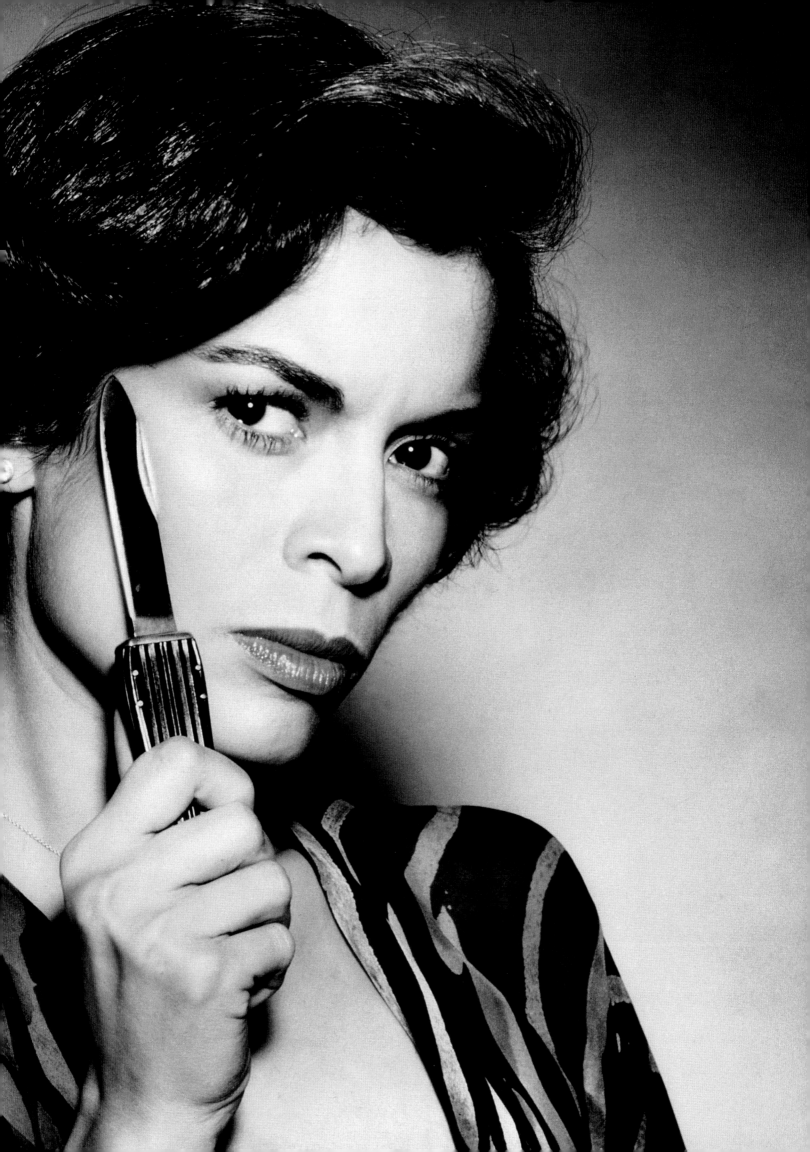

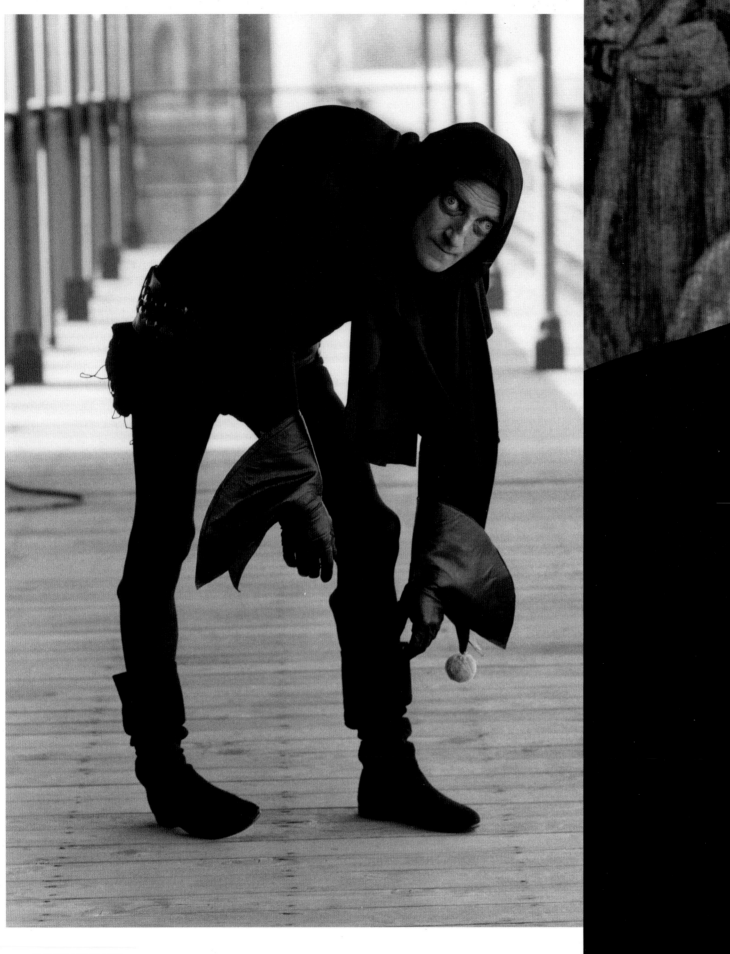

MARTY FELDMAN
London, 1973

*right,*
CHRISTOPHER LEE, VINCENT PRICE,
JOHN CARRADINE, PETER CUSHING
Hampshire, England, 1983

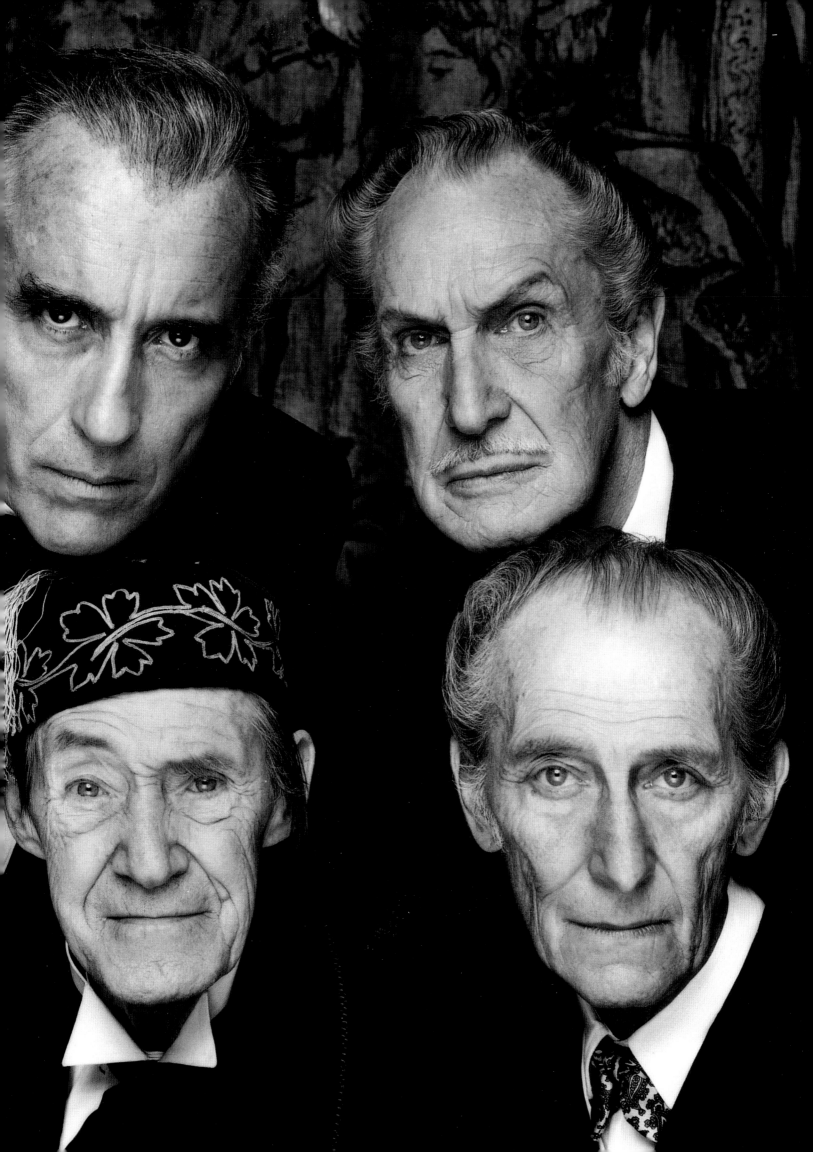

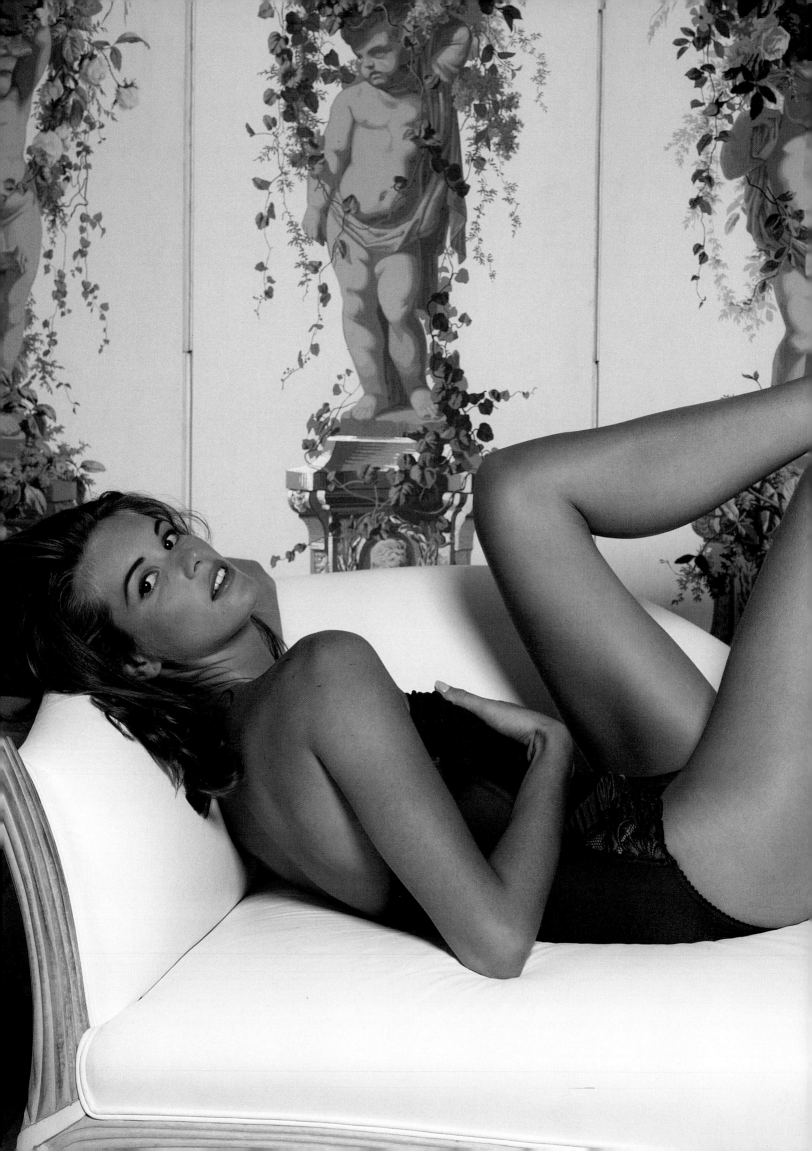

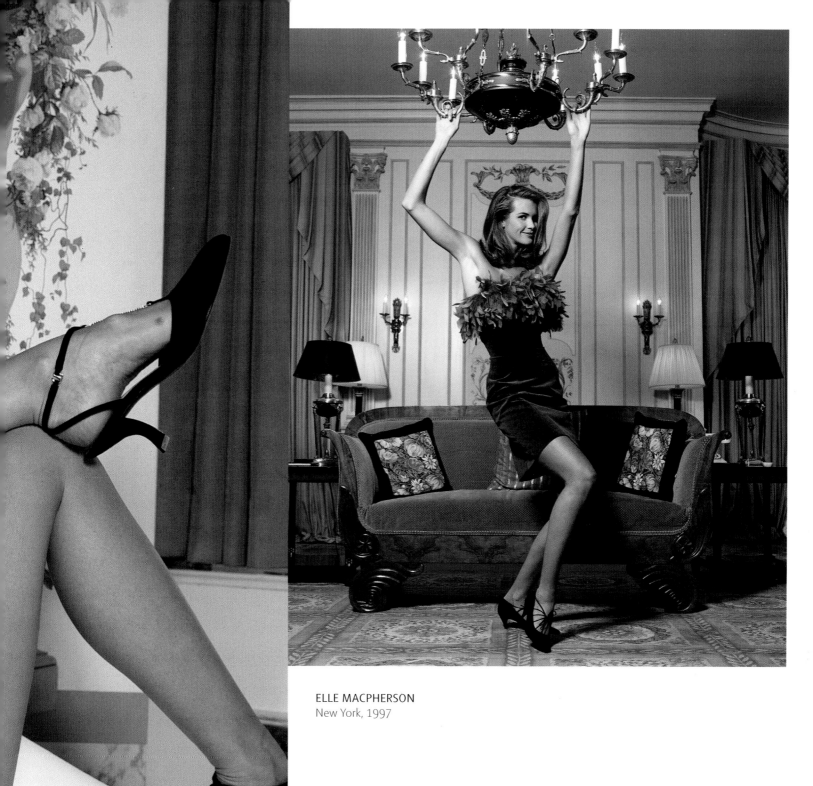

ELLE MACPHERSON
New York, 1997

Elle oozes sex appeal, a great
sense of fun and towers over most
men. She could have pulled down
the chandelier, let alone swung from it

ROD STEWART
Windsor, England, 1971

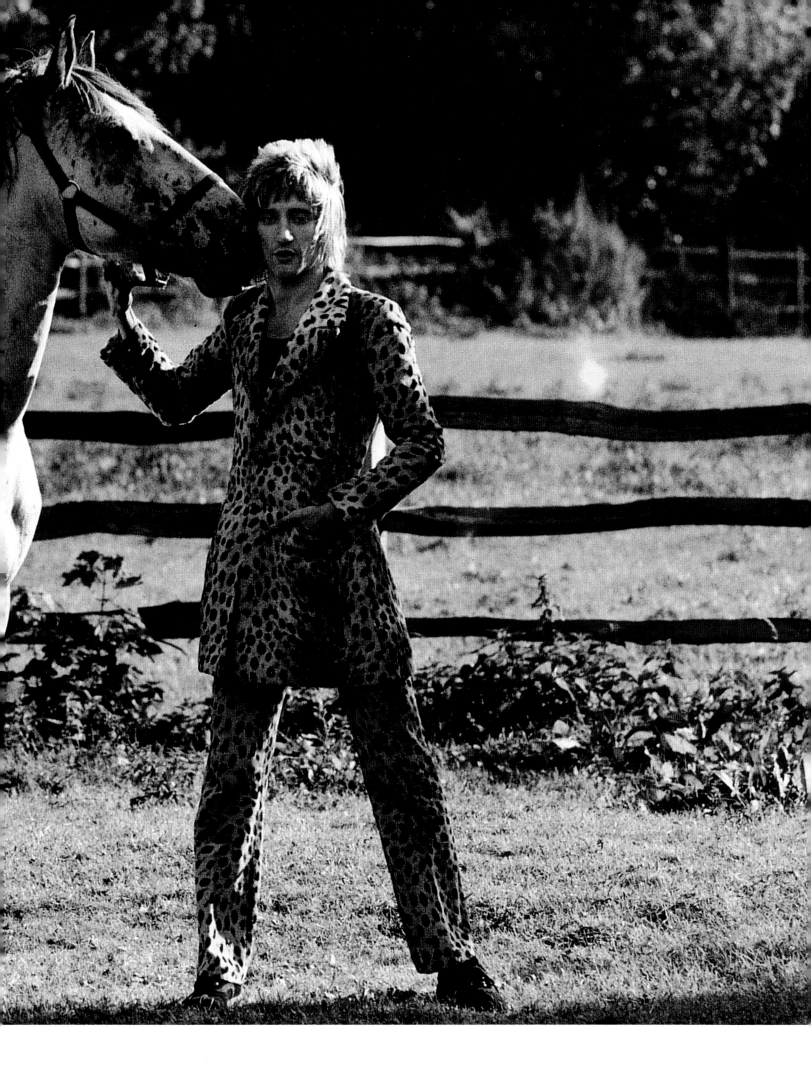

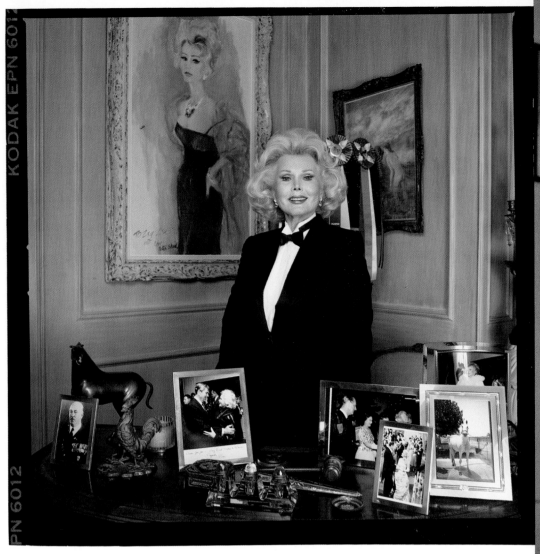

ZSA ZSA GABOR
Bel Air, 1992

*right,*
BETTE DAVIS
Beverly Hills, 1988

I took this in the apartment of Miss Davis
– as she was always addressed – the year
after her stroke. When I arrived she
knew exactly where she wanted to
be photographed (in front of a portrait
of herself), and had chosen her
gown. She epitomised the true
professionalism of a special generation of
brilliant Hollywood stars

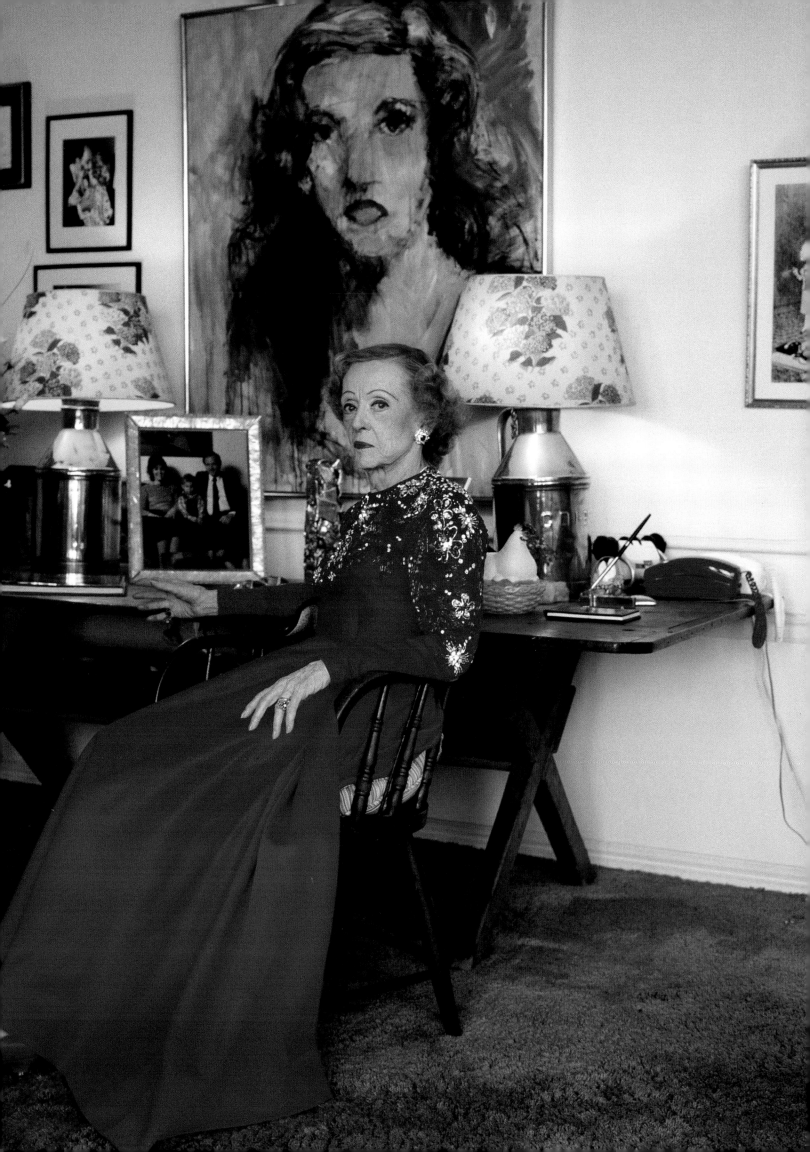

KODAK EPN 6012

STEVEN SPIELBERG, HARRISON FORD,
GEORGE LUCAS
Los Angeles, 1992

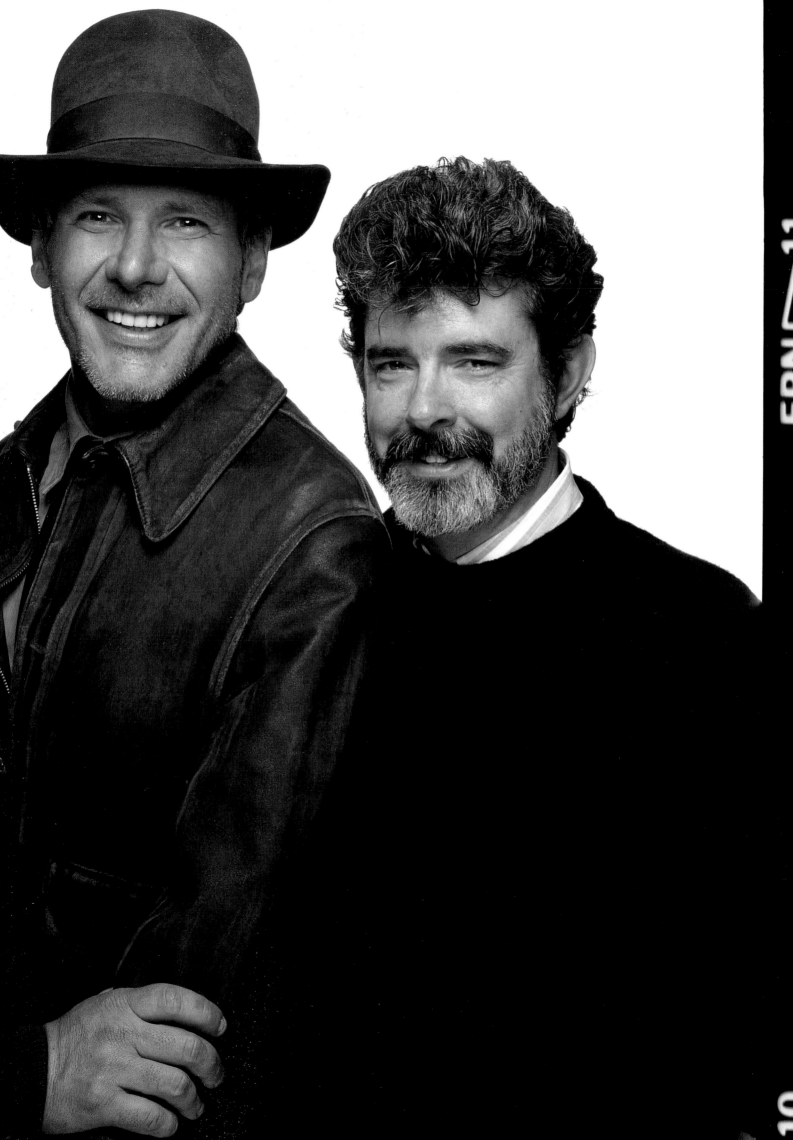

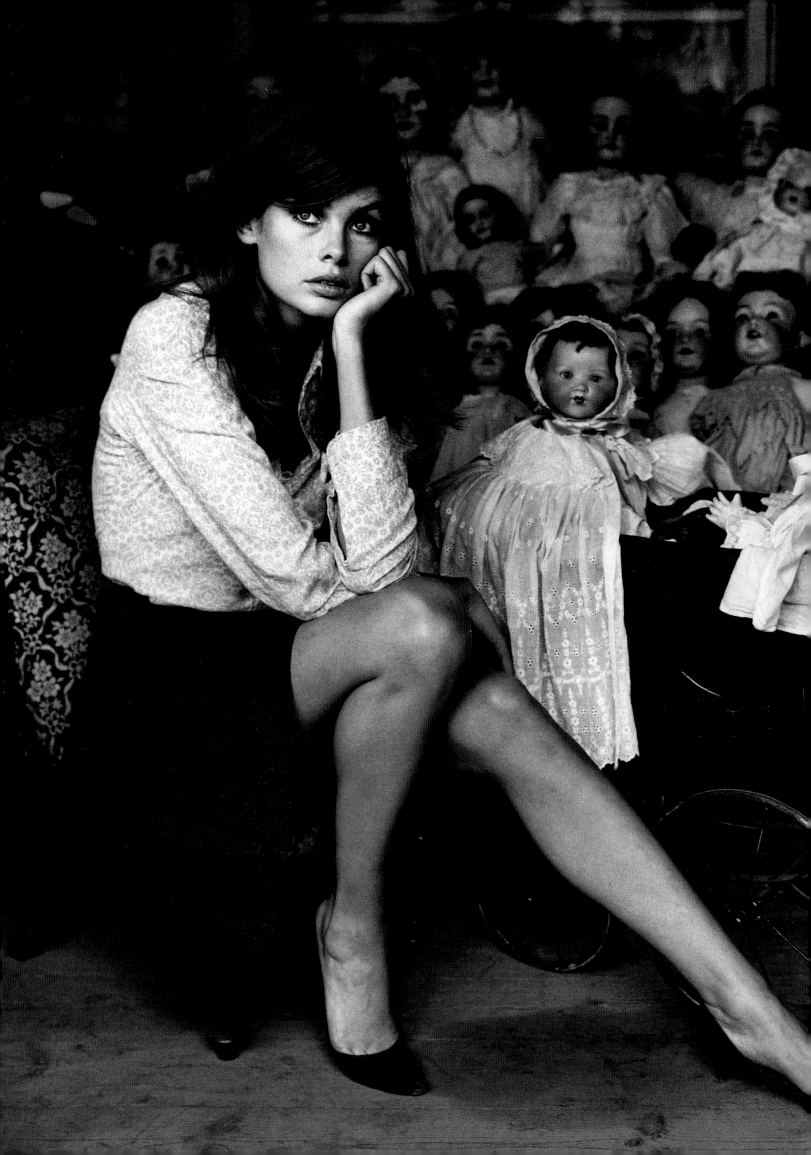

Jean was England's greatest ever model at this time. Her doll-like features had always struck me (she had great legs too) so one afternoon we went off to a dolls' hospital in Chiswick and played around there. We got some good pictures, too

JEAN SHRIMPTON
London, 1964

43

STEVE McQUEEN
Hollywood, 1969

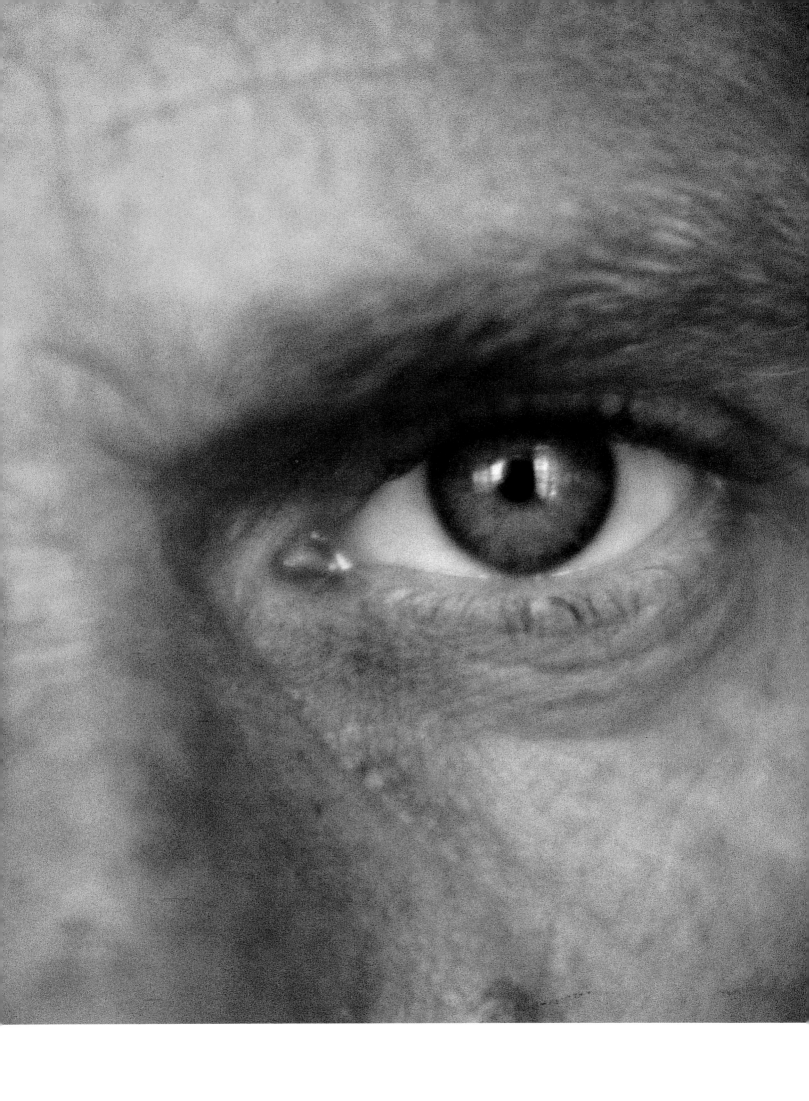

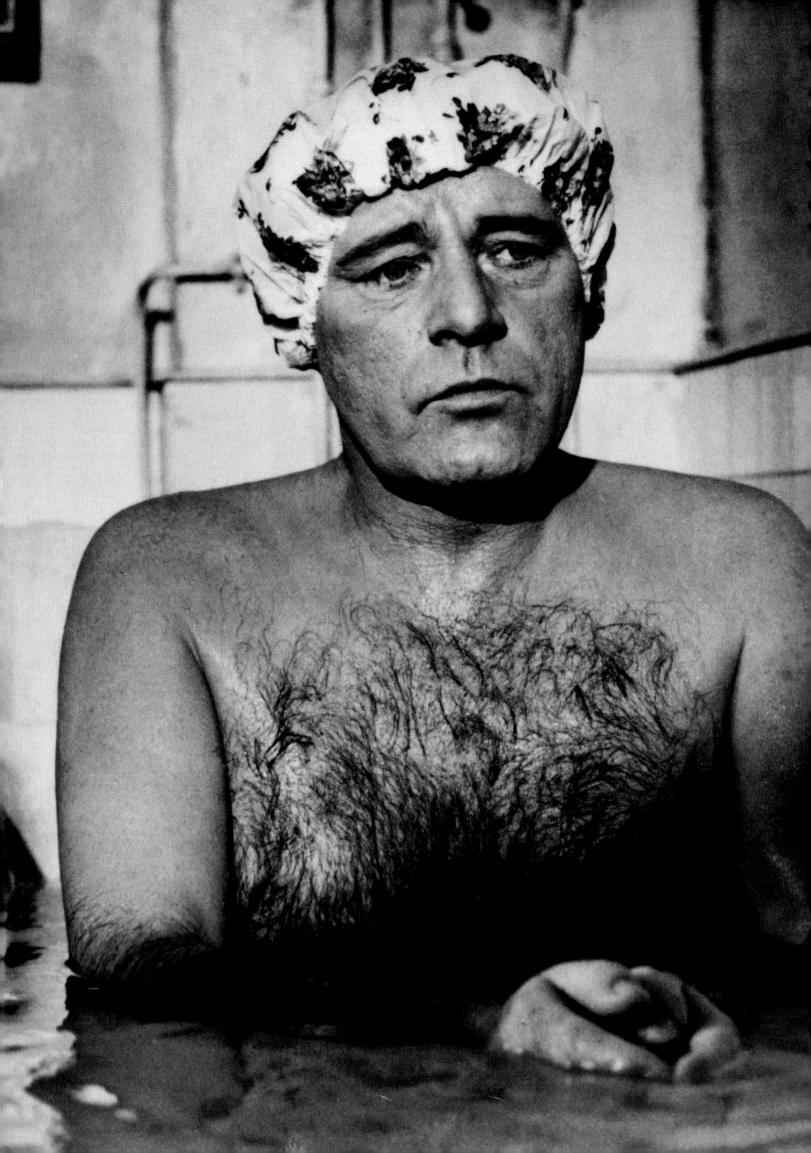

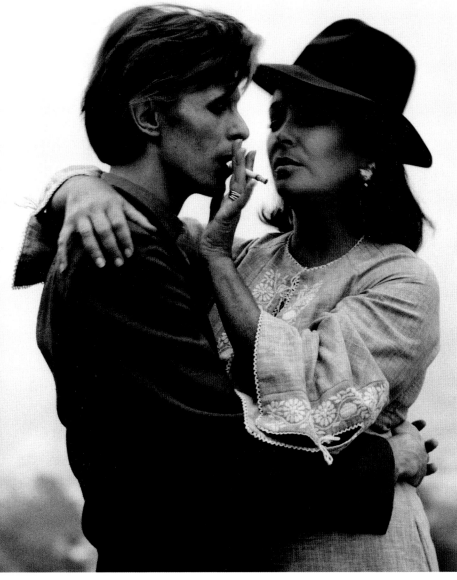

DAVID BOWIE & ELIZABETH TAYLOR
Beverly Hills, 1975

*left,*
RICHARD BURTON
Paris, 1969

David was two and a half hours late for his first meeting with Liz, which I had arranged at George Cukor's house. He arrived dishevelled and out of it. Liz was pretty annoyed and on the verge of leaving, but we managed to persuade her to stay. She was thinking of asking him to appear in *Bluebeard*, but she went off the idea after that

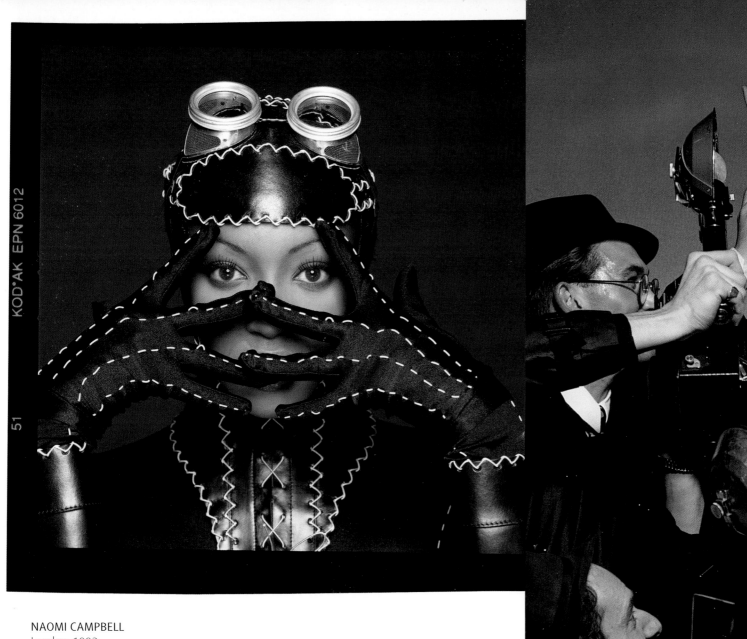

KOD•AK EPN 6012

NAOMI CAMPBELL
London, 1993

*right,*
KATE MOSS
London, 1993

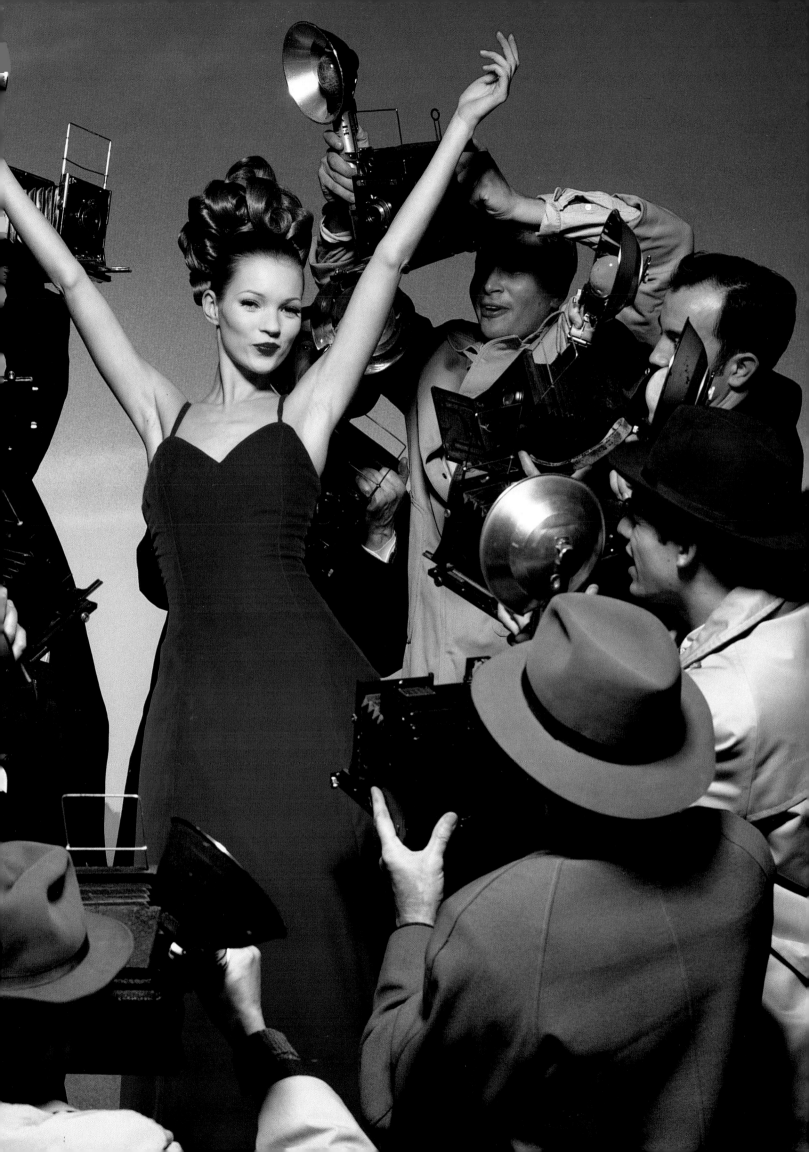

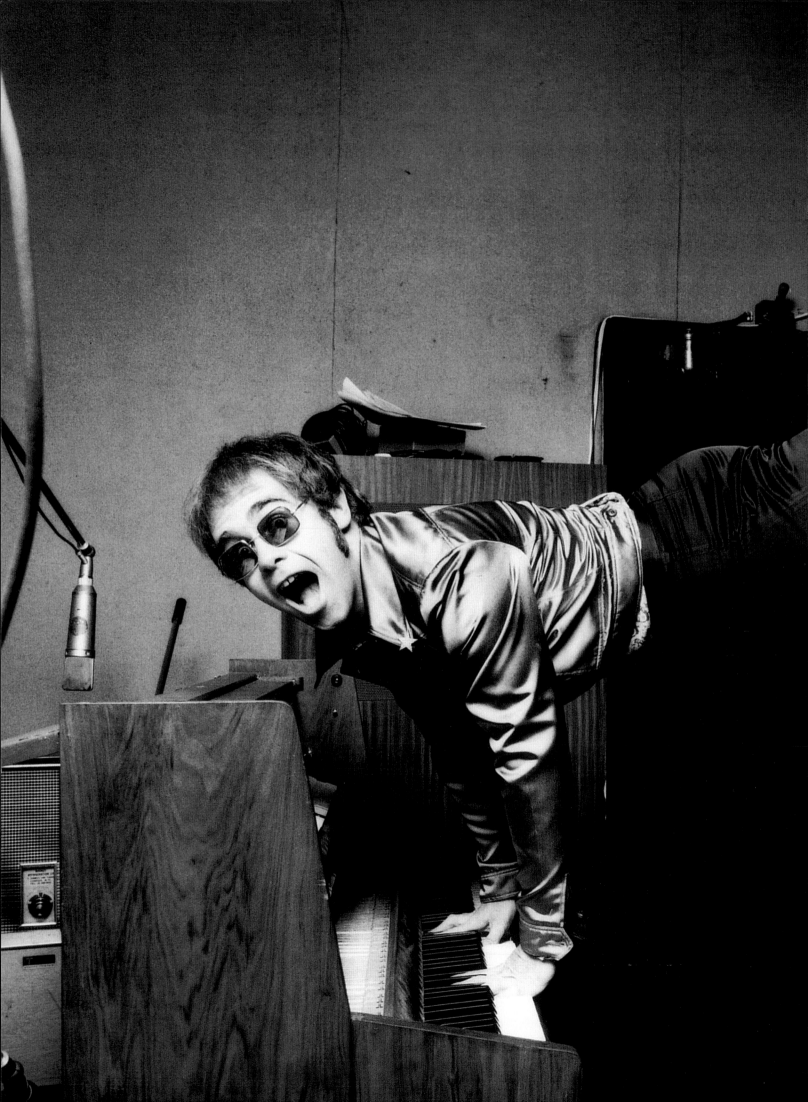

ELTON JOHN
London, 1972

51

LIFE

SHIRLEY TEMPLE
GROWS UP

MARCH 30, 1942 10 CENTS
YEARLY SUBSCRIPTION $4.50

SHIRLEY TEMPLE
Los Angeles, 1986

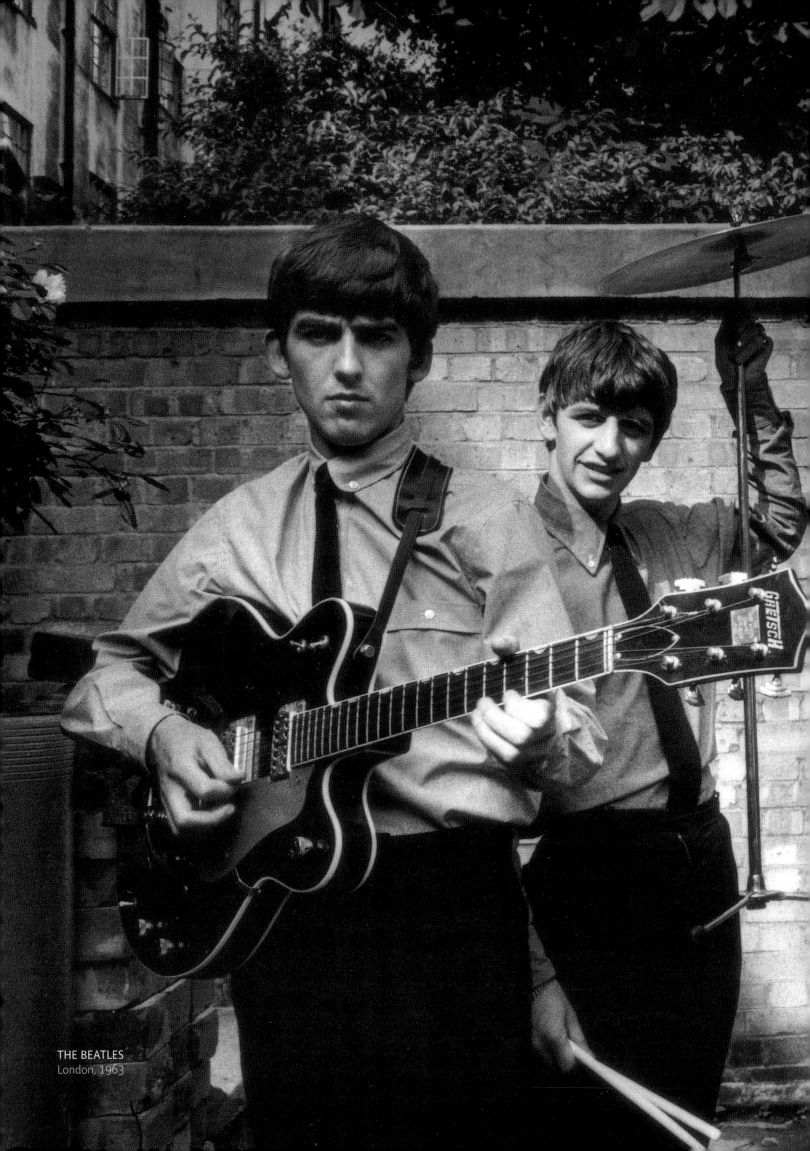

THE BEATLES
London, 1963

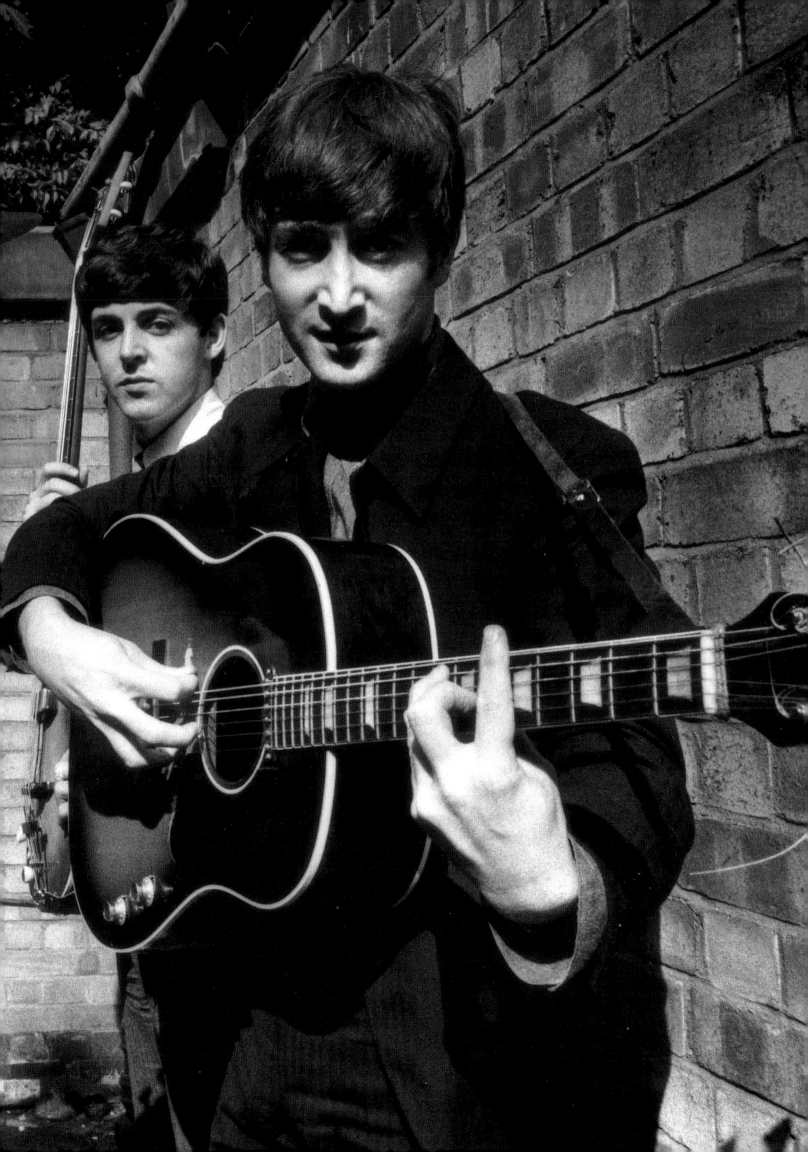

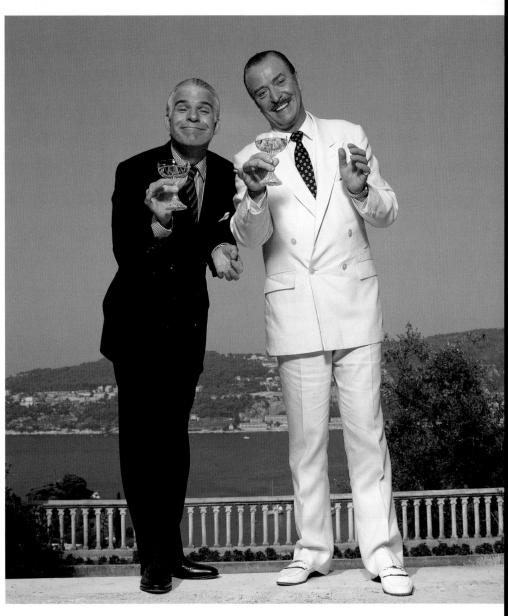

STEVE MARTIN & MICHAEL CAINE
Côte d'Azur, 1988

*right,*
MICHAEL CAINE & BOB HOSKINS
London, 1985

Michael and I were out drinking one night
in the mid eighties. He mentioned he was
doing a movie with Bob and I asked if I
could take some shots of the filming.
I turned up the next day at the Raymond
Revue bar and started bossing the two of
them around. I had no idea that it was Bob
himself who was starring in the movie

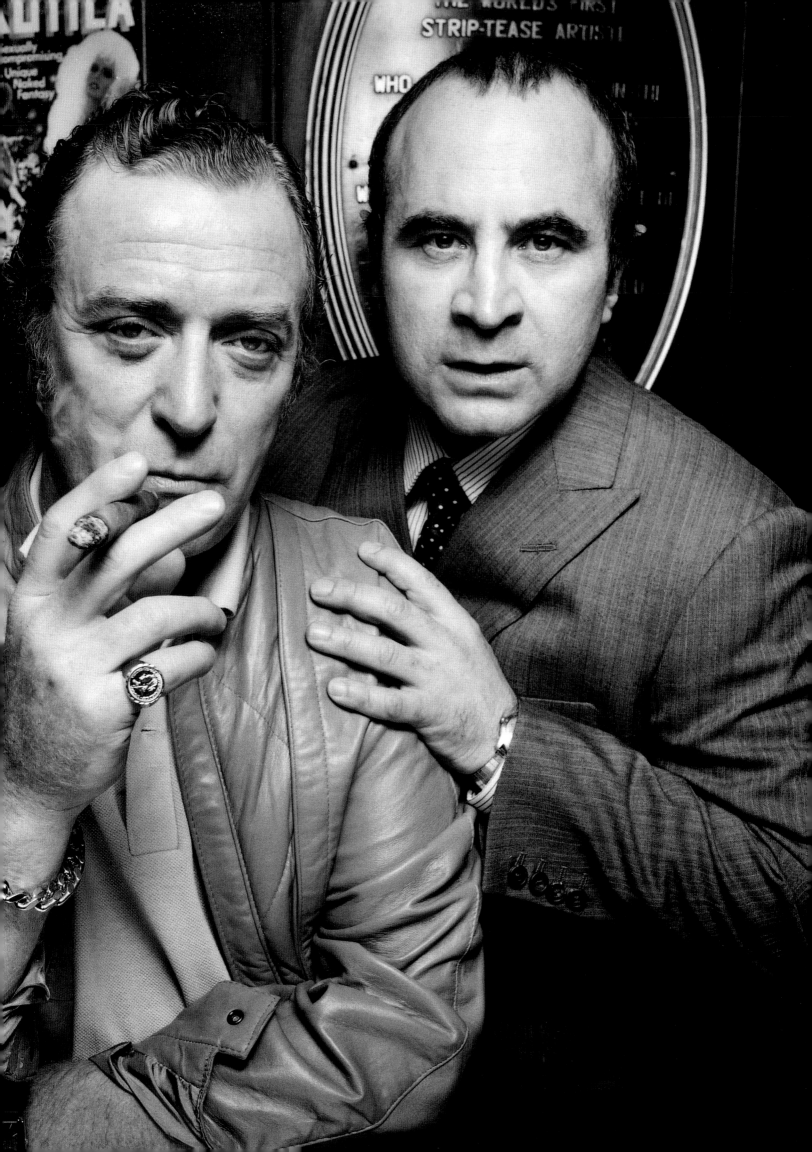

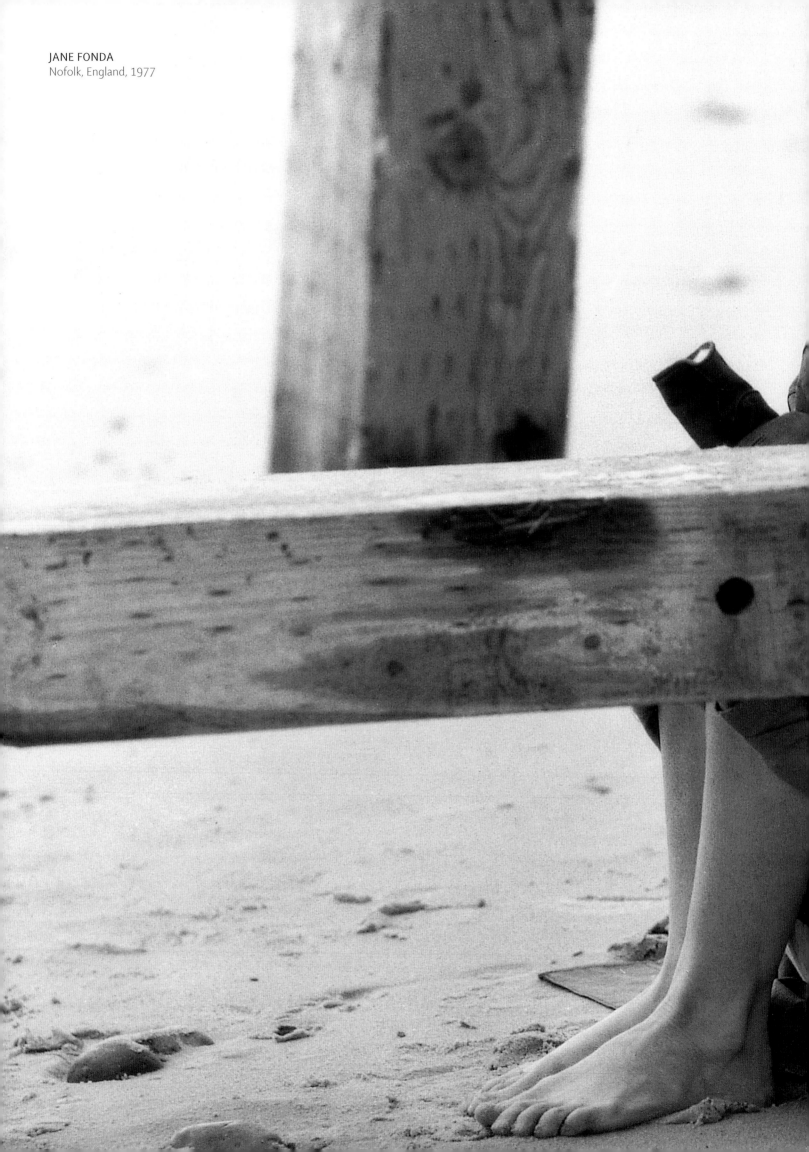

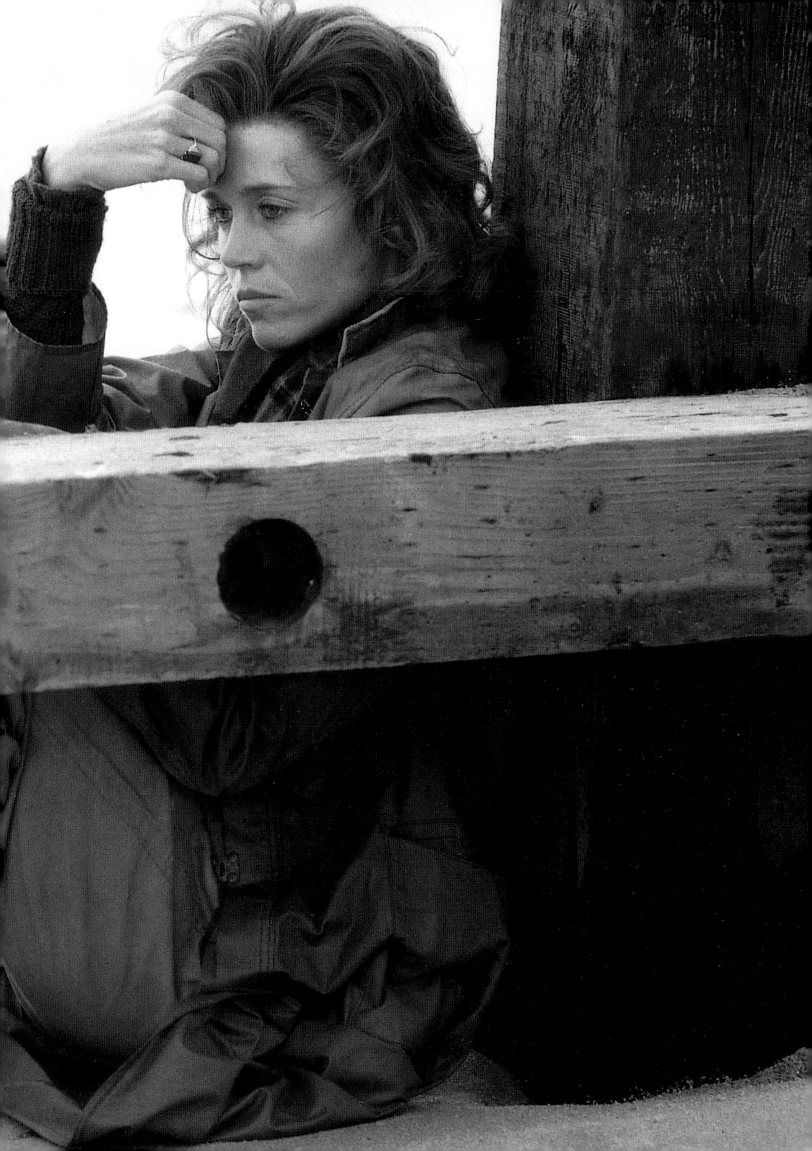

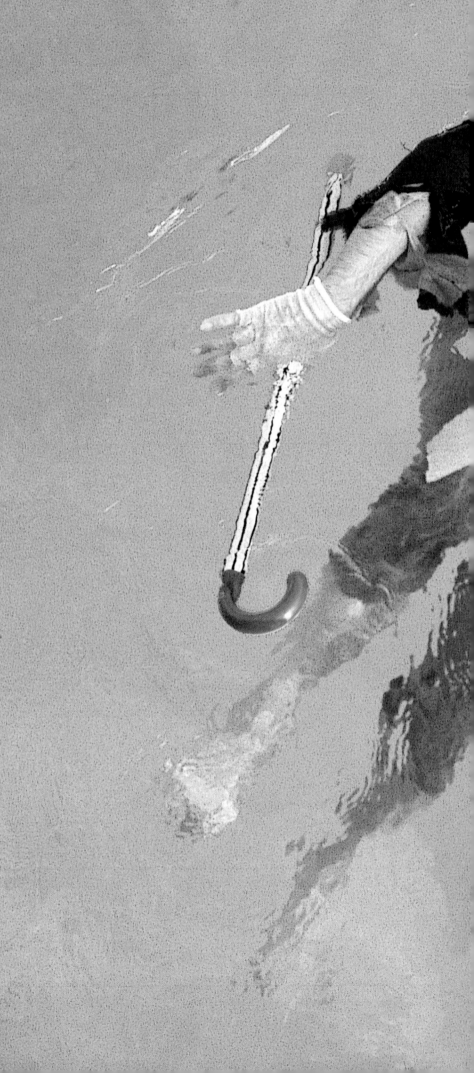

ANTHONY NEWLEY
Beverly Hills, 1968

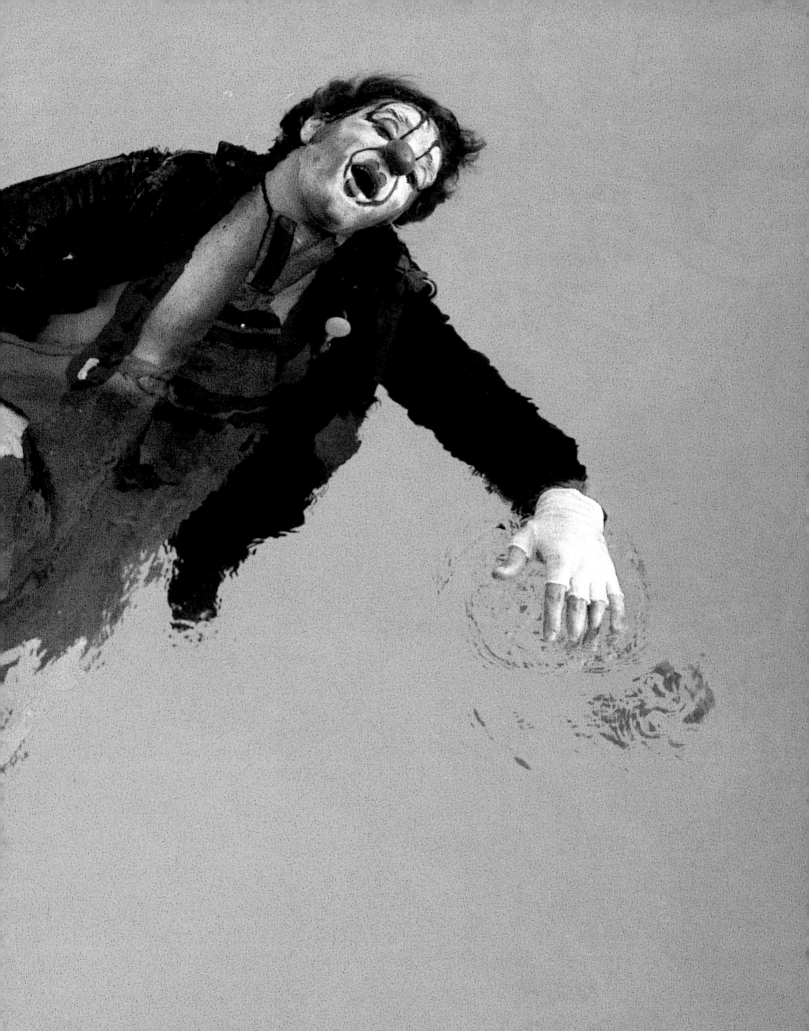

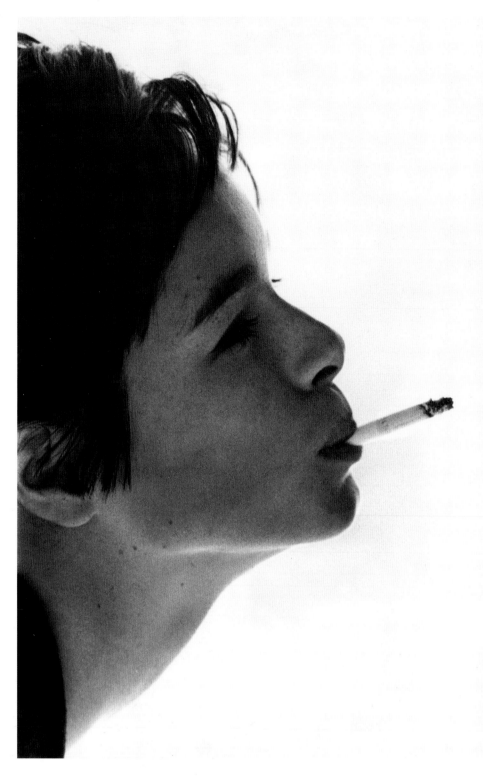

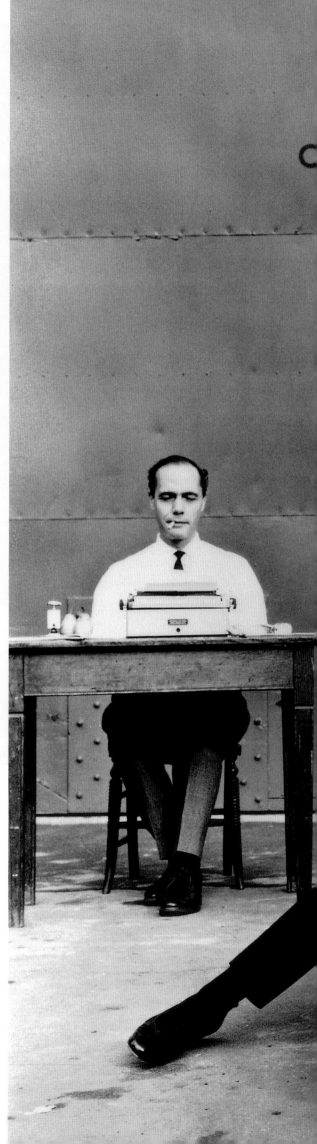

GERALDINE CHAPLIN
London, 1966

*right,*
**MONICA VITTI**
Shepperton Studios, England, 1965

—

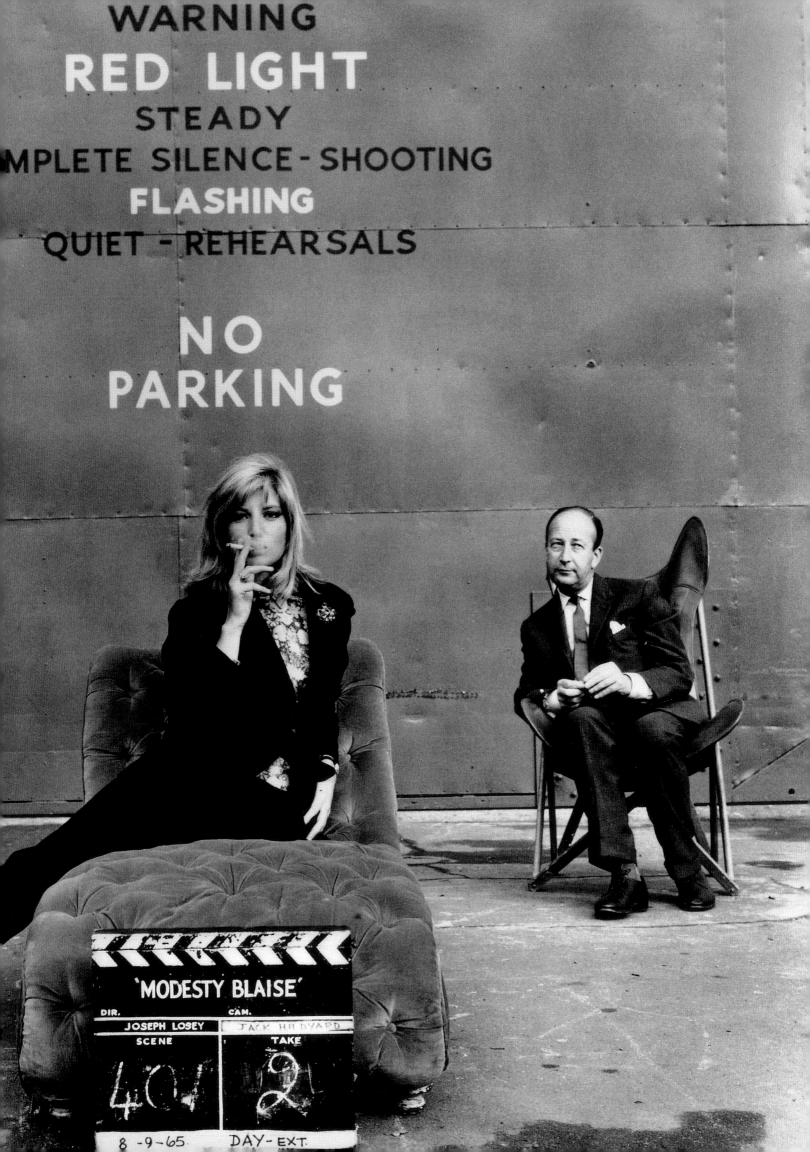

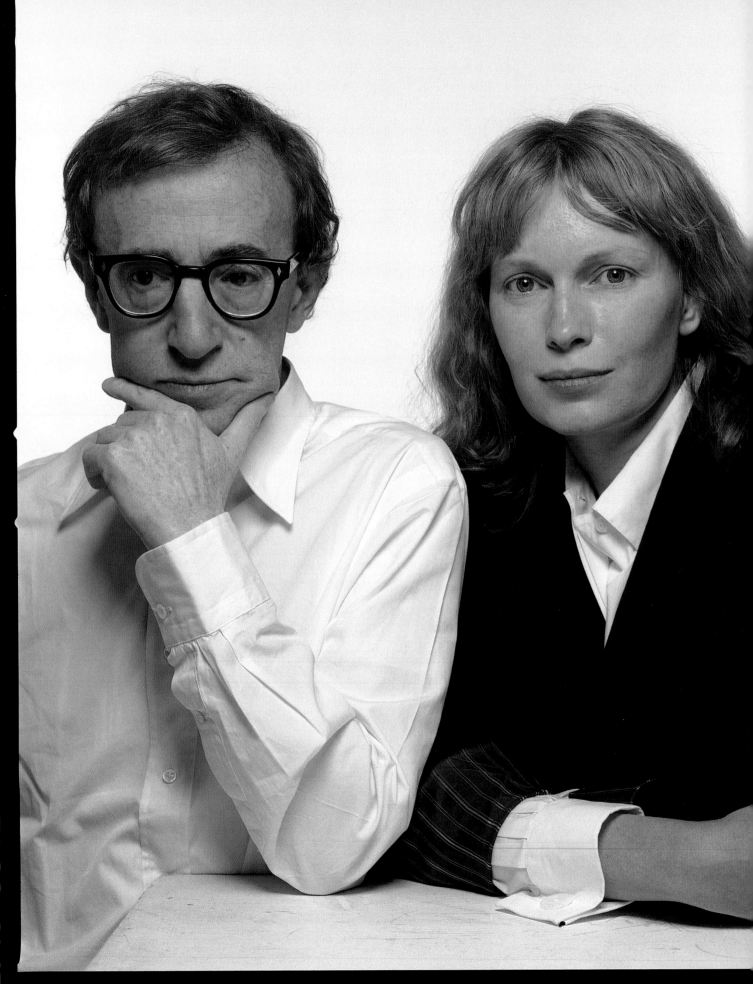

I knew Woody and Mia, although not well, when I turned up for this shoot. I immediately sensed there was something wrong between them. There was real tension in the air, which translates itself visually, I think. Some months later his affair with Soon-Yi was broken to the public

WOODY ALLEN & MIA FARROW
New York, 1991

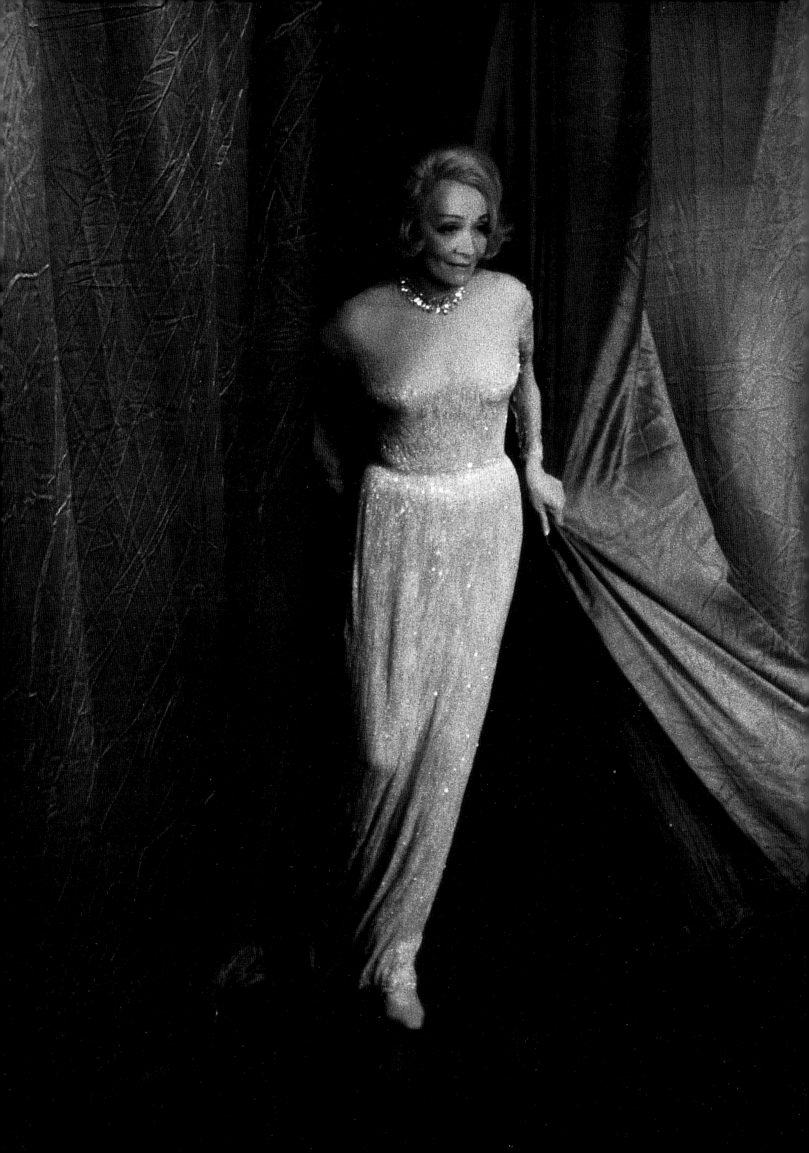

MARLENE DIETRICH
London, 1975

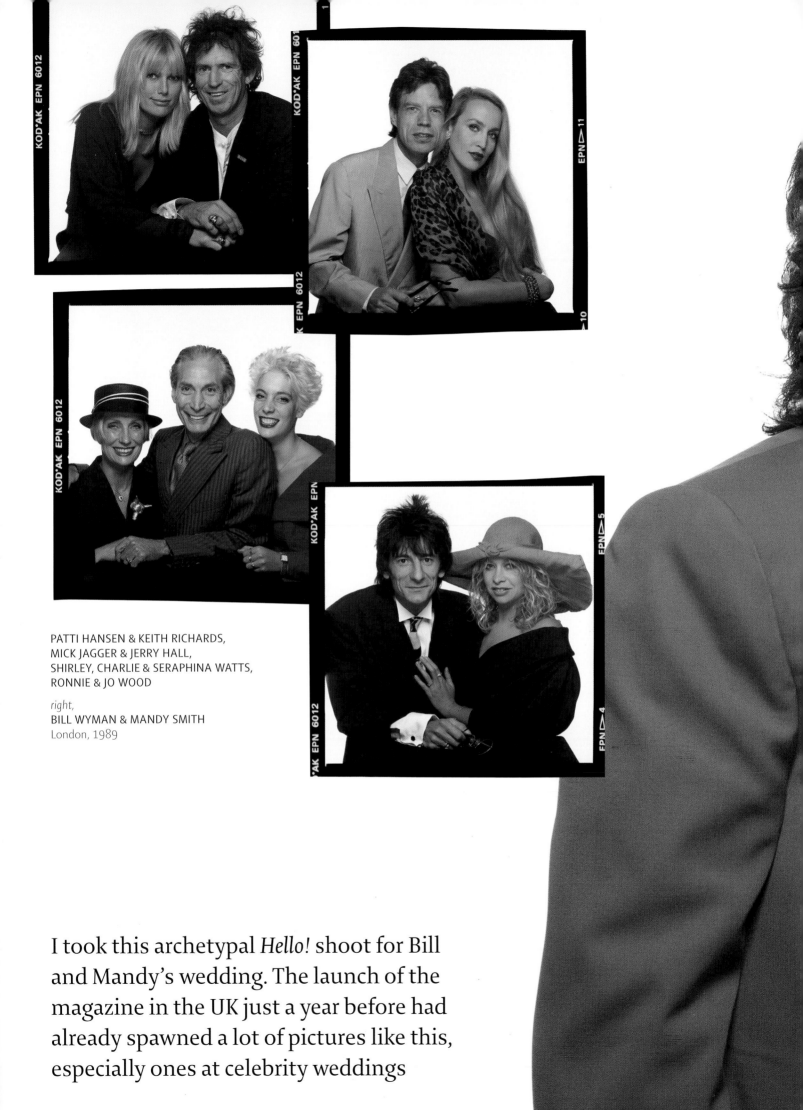

PATTI HANSEN & KEITH RICHARDS,
MICK JAGGER & JERRY HALL,
SHIRLEY, CHARLIE & SERAPHINA WATTS,
RONNIE & JO WOOD

*right,*
BILL WYMAN & MANDY SMITH
London, 1989

I took this archetypal *Hello!* shoot for Bill
and Mandy's wedding. The launch of the
magazine in the UK just a year before had
already spawned a lot of pictures like this,
especially ones at celebrity weddings

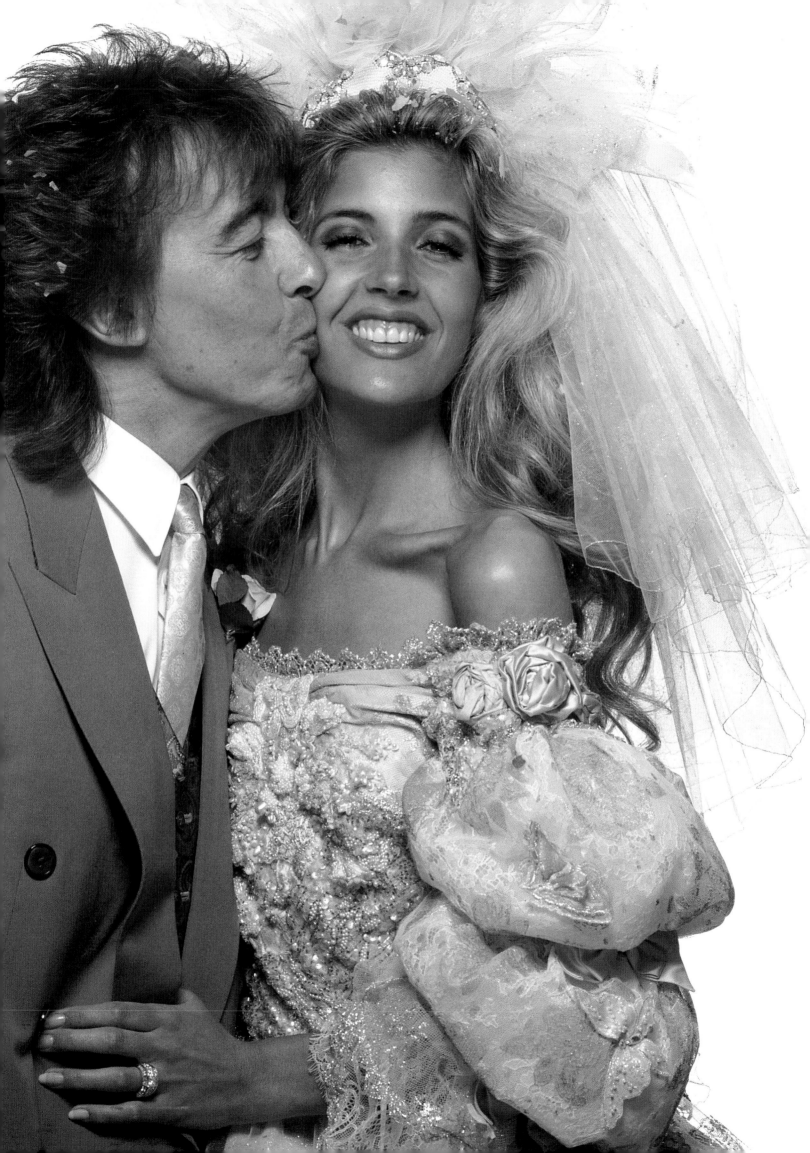

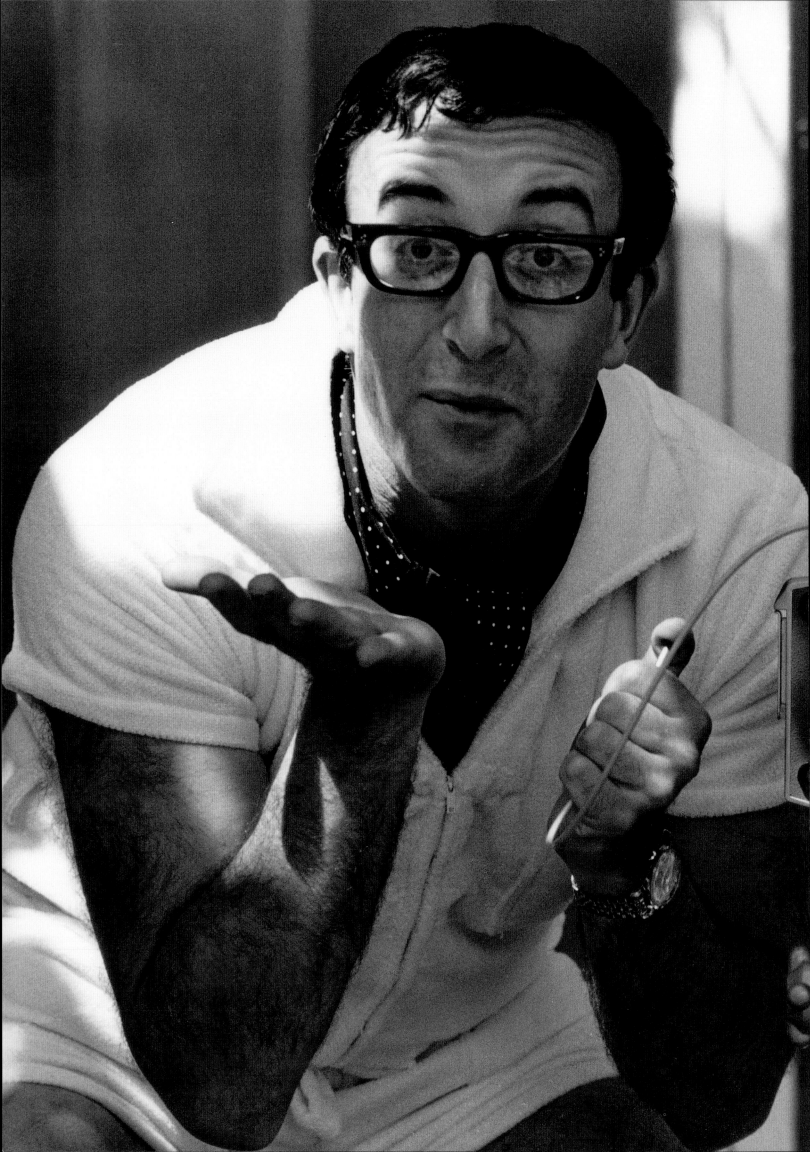

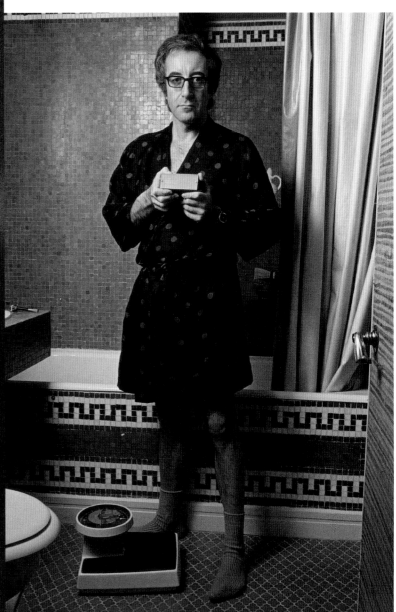

PETER SELLERS
London, 1975

*left,*
PETER SELLERS
London, 1965

Peter was a real photography
fanatic and he was playing
around with a new camera
when I took this picture. I
wouldn't say he was a natural
photographer. He certainly
knew a lot about the technical
side, but that didn't mean he
always got the shot...

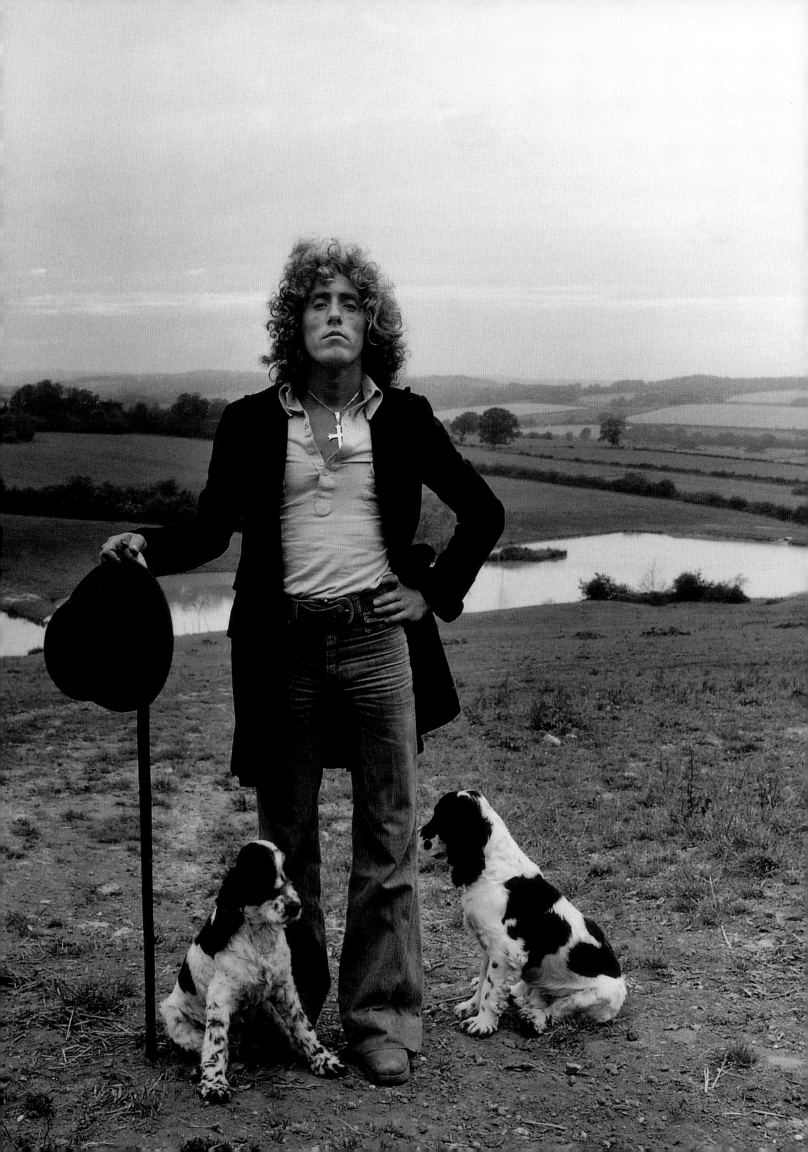

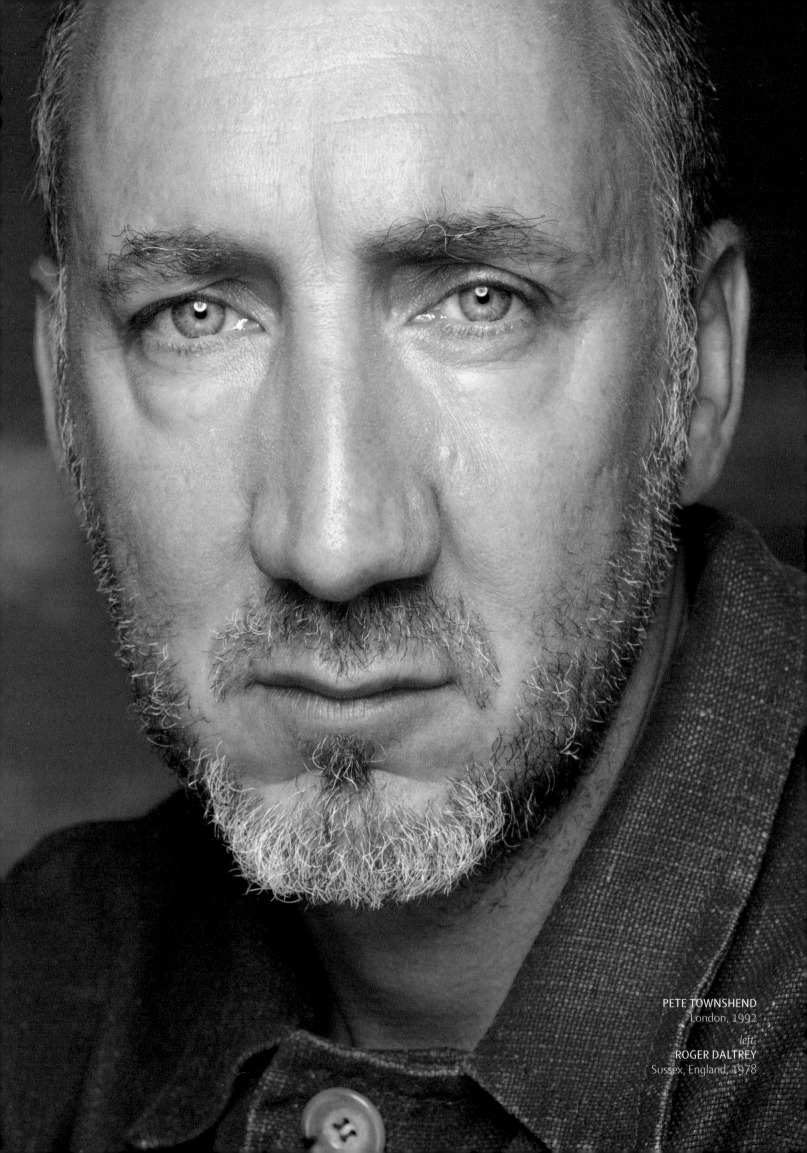

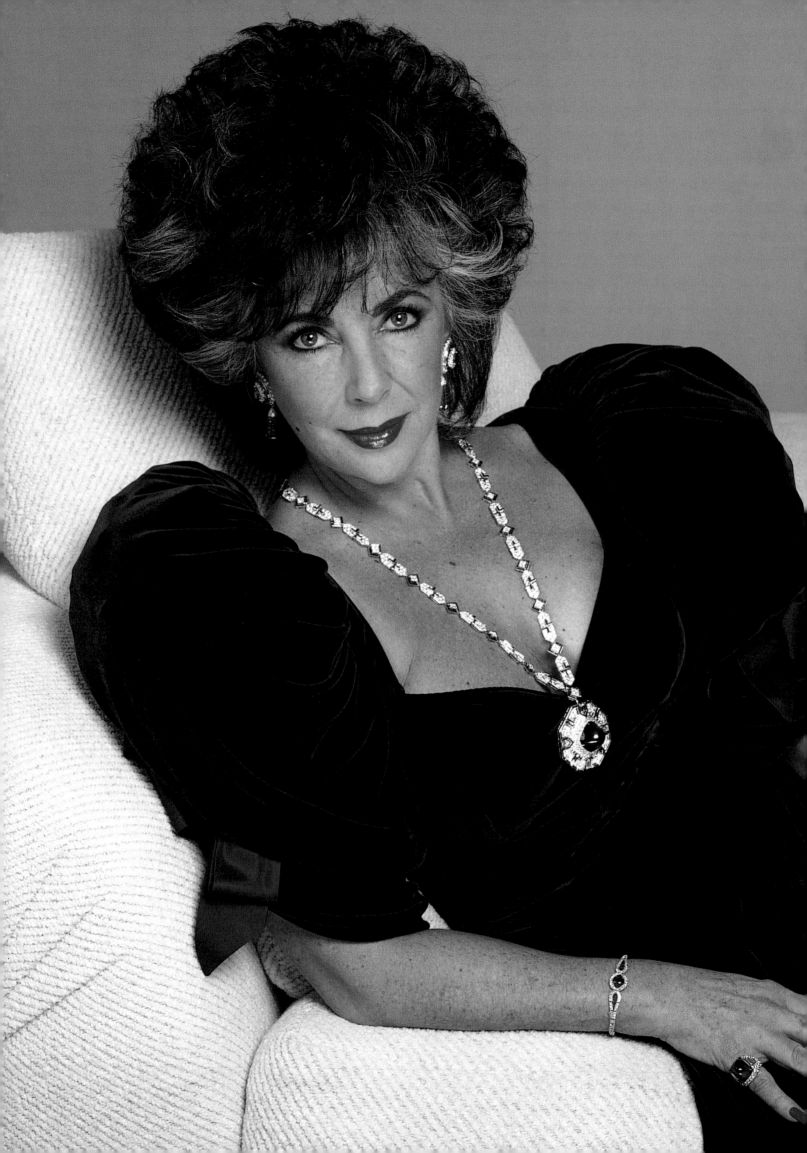

ELIZABETH TAYLOR
Beverly Hills, 1988

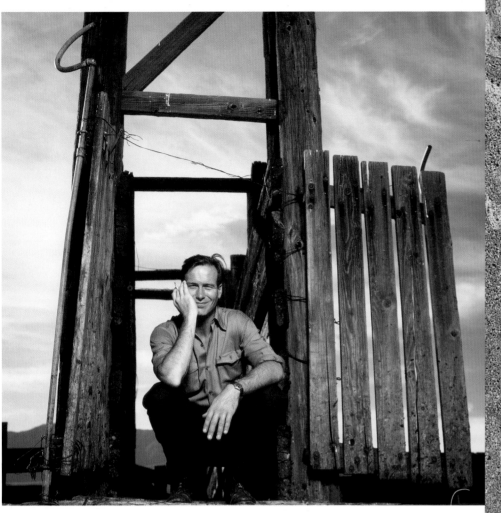

WILLIAM HURT
Los Angeles, 1987

*right,*
KENNETH BRANAGH
London, 1986

I took this shot of Ken right at the beginning of his career. He was still mainly doing stage work but it only seemed a matter of time before he would break into the movies in a big way. He was really playing it tough that day, but I was very impressed by his charisma – he had Cagney's magnetism

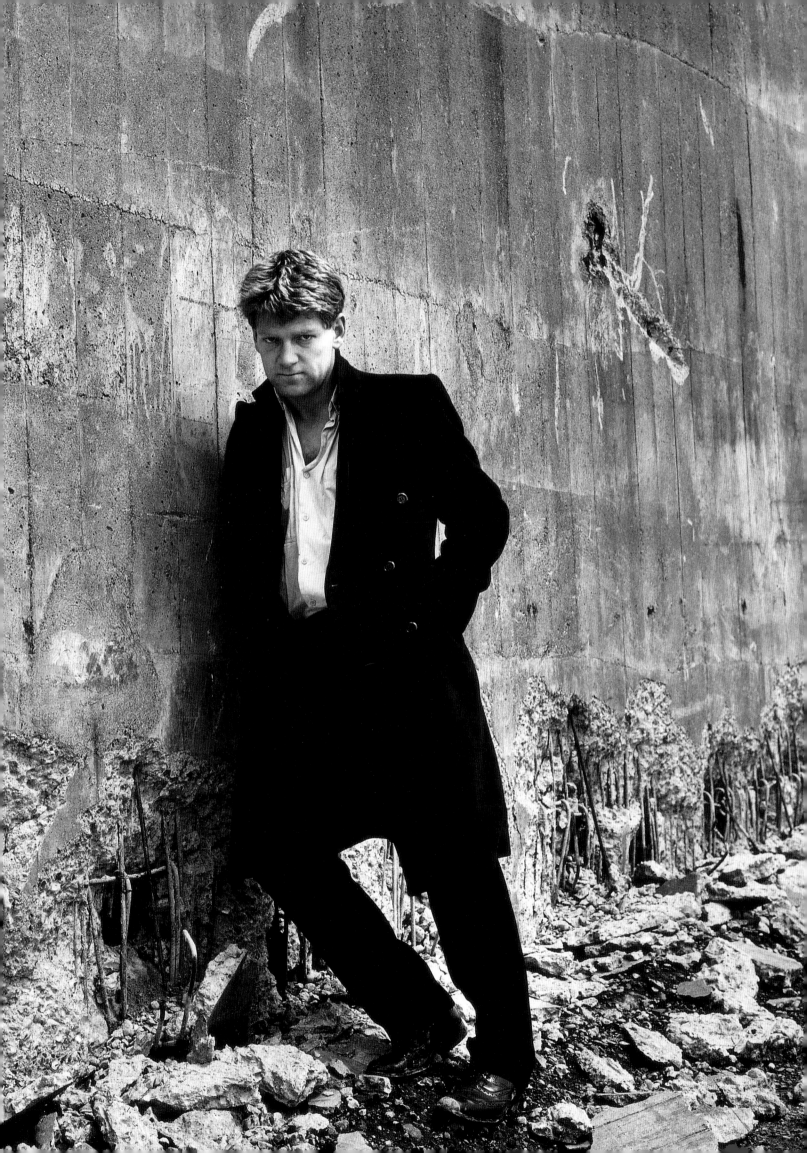

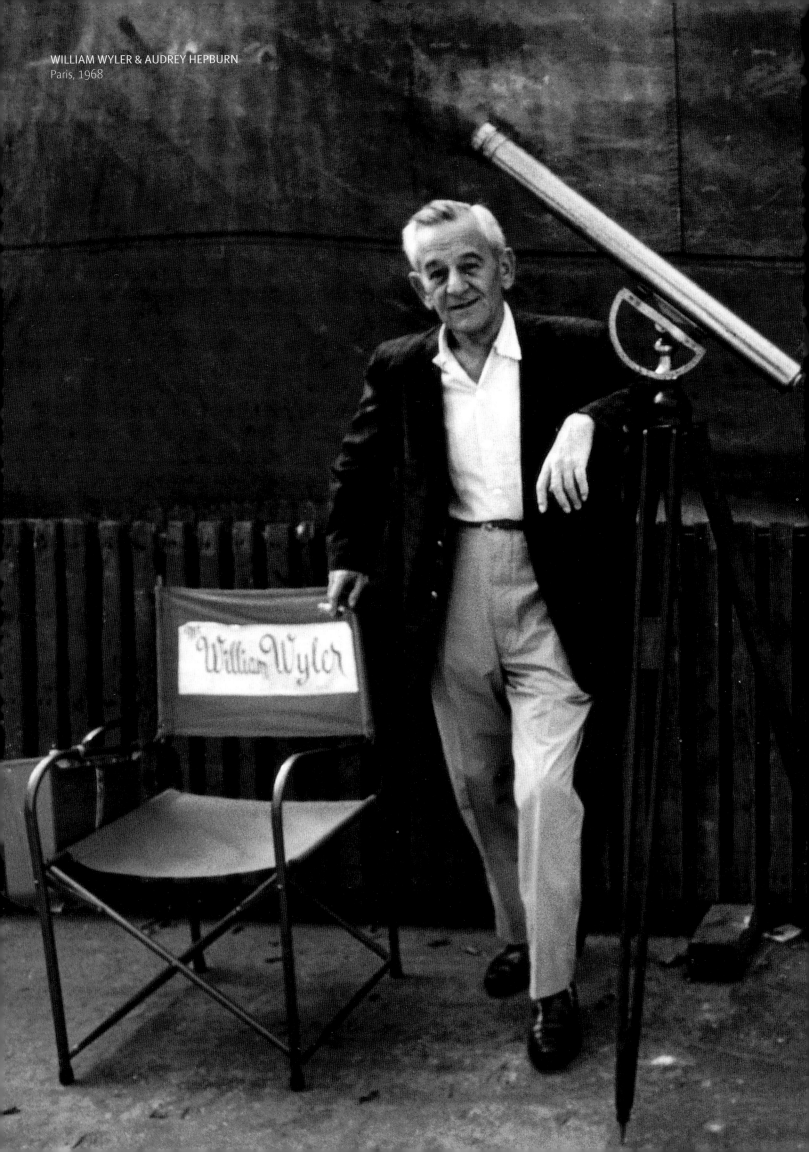

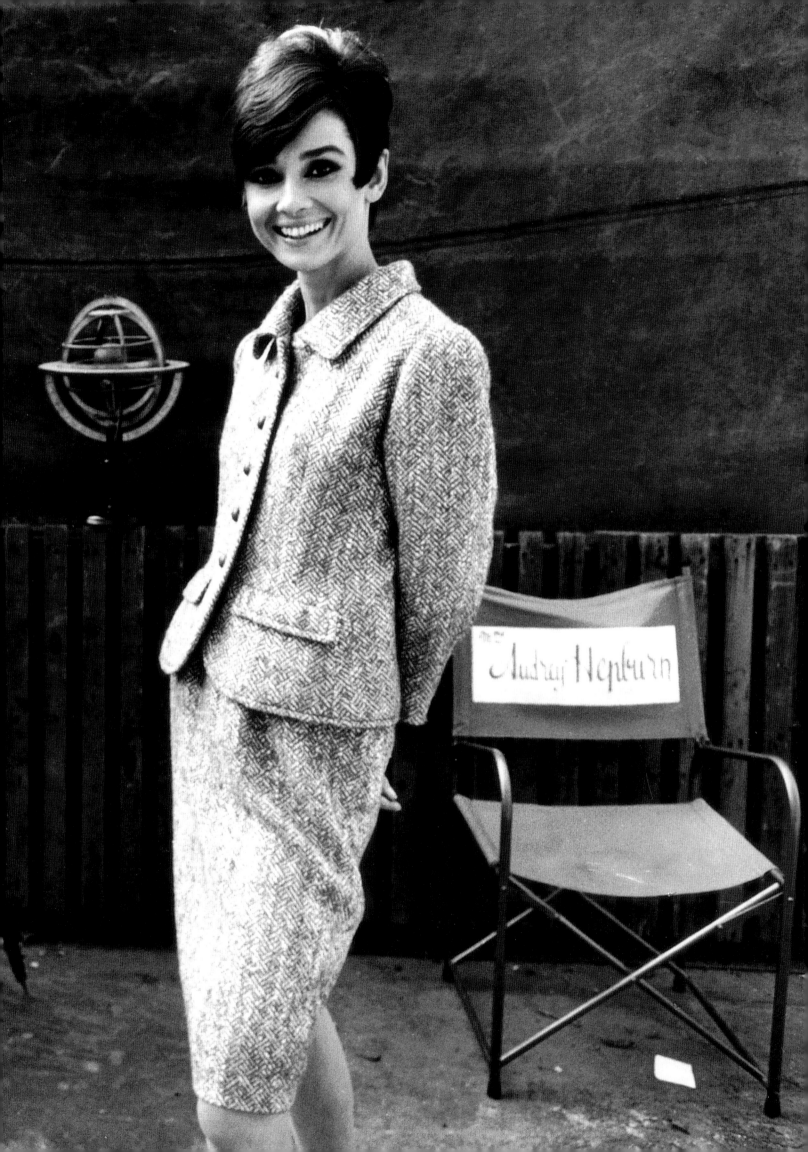

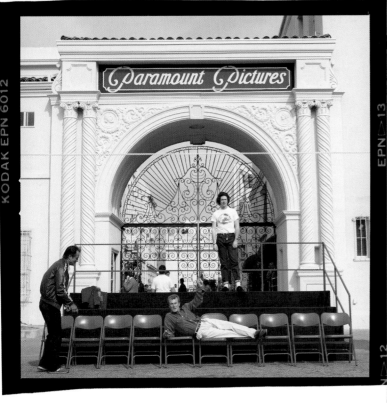

## THE PHOTOGRAPHER
Paramount Pictures 75th Anniversary party
Los Angeles, 1987

*right,*

FRONT ROW, LEFT TO RIGHT: MARTHA RAYE, DANA ANDREWS,
ELIZABETH TAYLOR, FRANCES DEE, JOEL McCREA,
HARRY DEAN STANTON, HARRISON FORD, JENNIFER BEALS,
MARLEE MATLIN, DANNY DE VITO
SECOND ROW: OLIVIA DE HAVILLAND, KEVIN COSTNER,
CORNEL WILDE, DON AMECHE, DEFOREST KELLEY,
TOM CRUISE, CHARLTON HESTON, PENNY MARSHALL,
BOB HOPE, VICTOR MATURE, ELIZABETH McGOVERN,
ROBERT DE NIRO
THIRD ROW: ANDREW McCARTHY, HENRY WINKLER, TONY PERKINS,
ROBERT STACK, MARK HAMON, FAYE DUNAWAY, BUDDY ROGERS,
GREGORY PECK, DEBRA WINGER, TIMOTHY HUTTON.
FOURTH ROW: JANE RUSSELL, MIKE CONNORS, JOHN TRAVOLTA,
JANET LEIGH, CHARLES BRONSON, TED DANSON,
LOU GOSSETT JNR, RYAN O'NEAL, RHONDA FLEMING,
LEONARD NIMOY
FIFTH ROW: WILLIAM SHATNER, PETER GRAVES, MOLLY RINGWALD,
DOROTHY LAMOUR, OLIVIA NEWTON-JOHN, CINDY WILLIAMS,
MATTHEW BRODERICK, GENE HACKMAN, WALTER MATTHAU,
ROBIN WILLIAMS
BACK ROW: ALI MacGRAW, BURT LANCASTER, SCOTT BAIO,
RHEA PERLMAN, BRUCE DERN, JAMES CAAN, GLENN FORD,
FRED MacMURRAY, SHELLEY LONG, JAMES STEWART

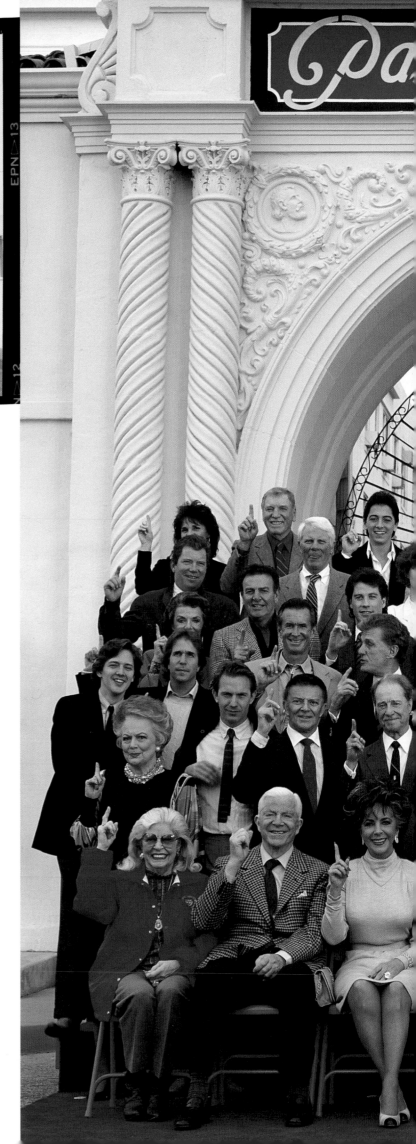

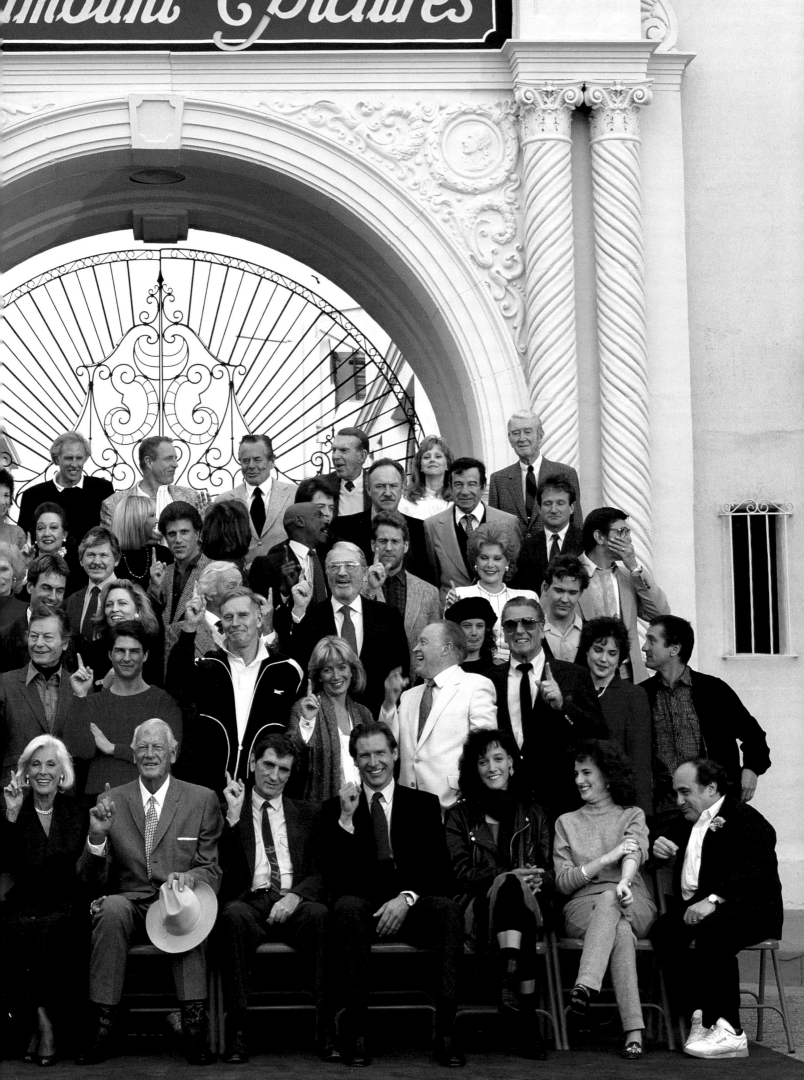

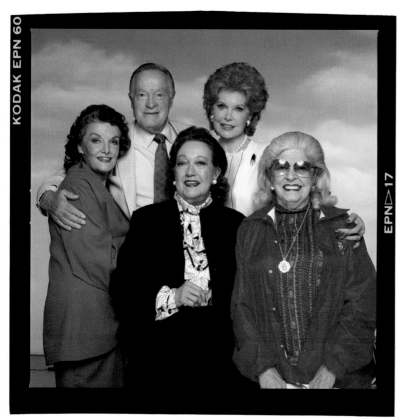

CLOCKWISE FROM LEFT: JANE RUSSELL, BOB HOPE, RHONDA
FLEMING, MARTHA RAYE & DOROTHY LAMOUR

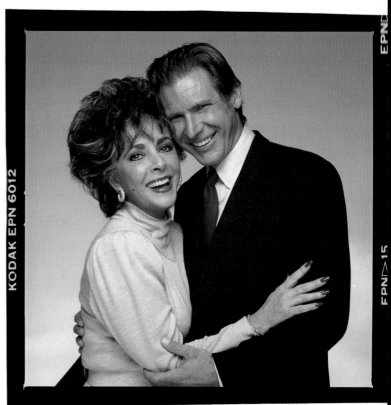

ELIZABETH TAYLOR & HARRISON FORD

RYAN O'NEAL & ALI MacGRAW

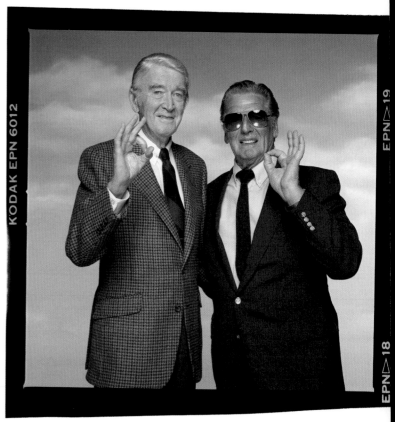

JAMES STEWART & VICTOR MATURE

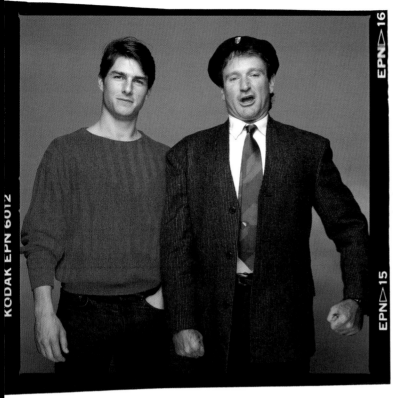

TOM CRUISE & ROBIN WILLIAMS

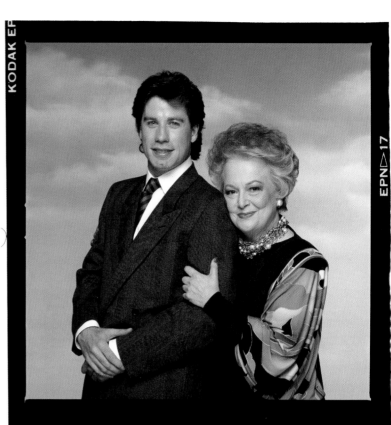

JOHN TRAVOLTA & OLIVIA DE HAVILLAND

ANTHONY PERKINS & JANET LEIGH

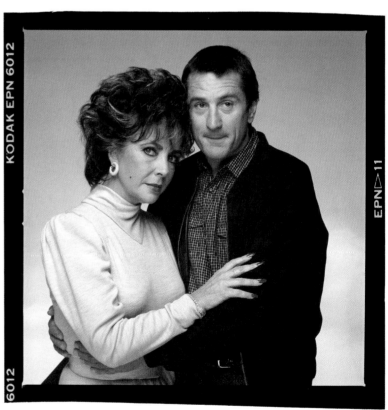

ELIZABETH TAYLOR & ROBERT DE NIRO
Paramount Pictures 75th Anniversary party
Los Angeles, 1987

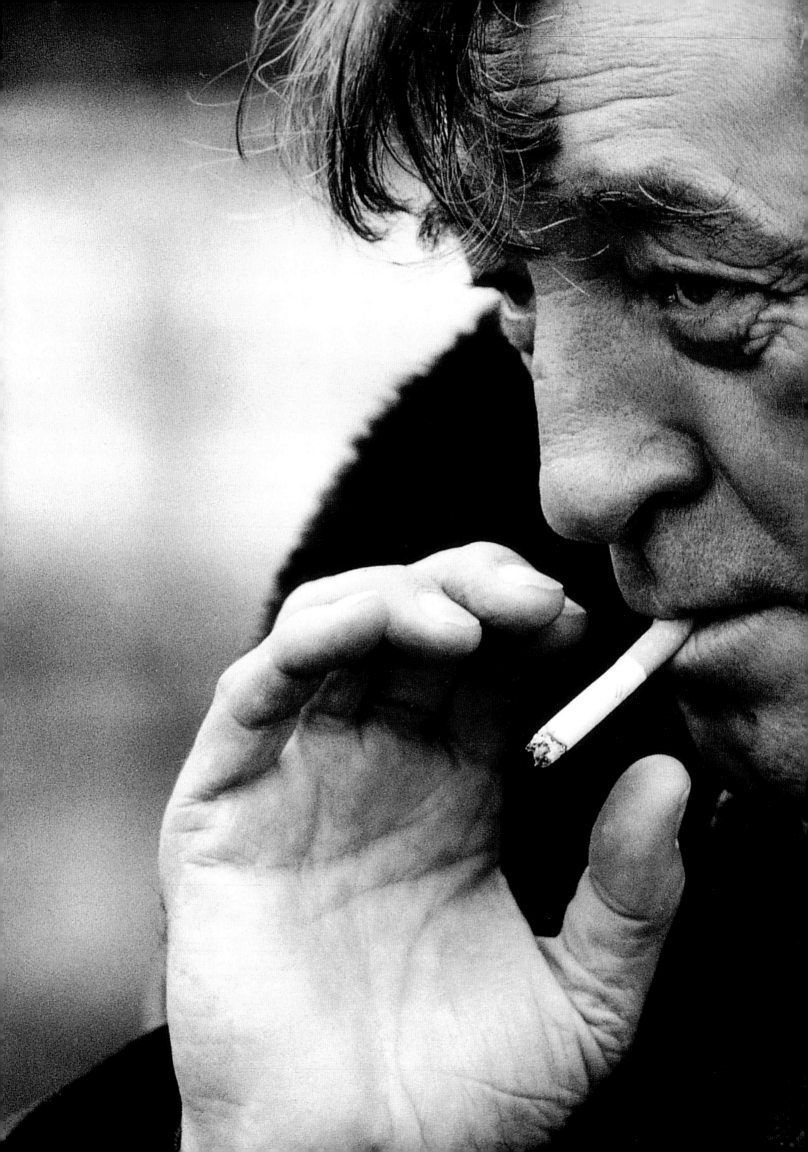

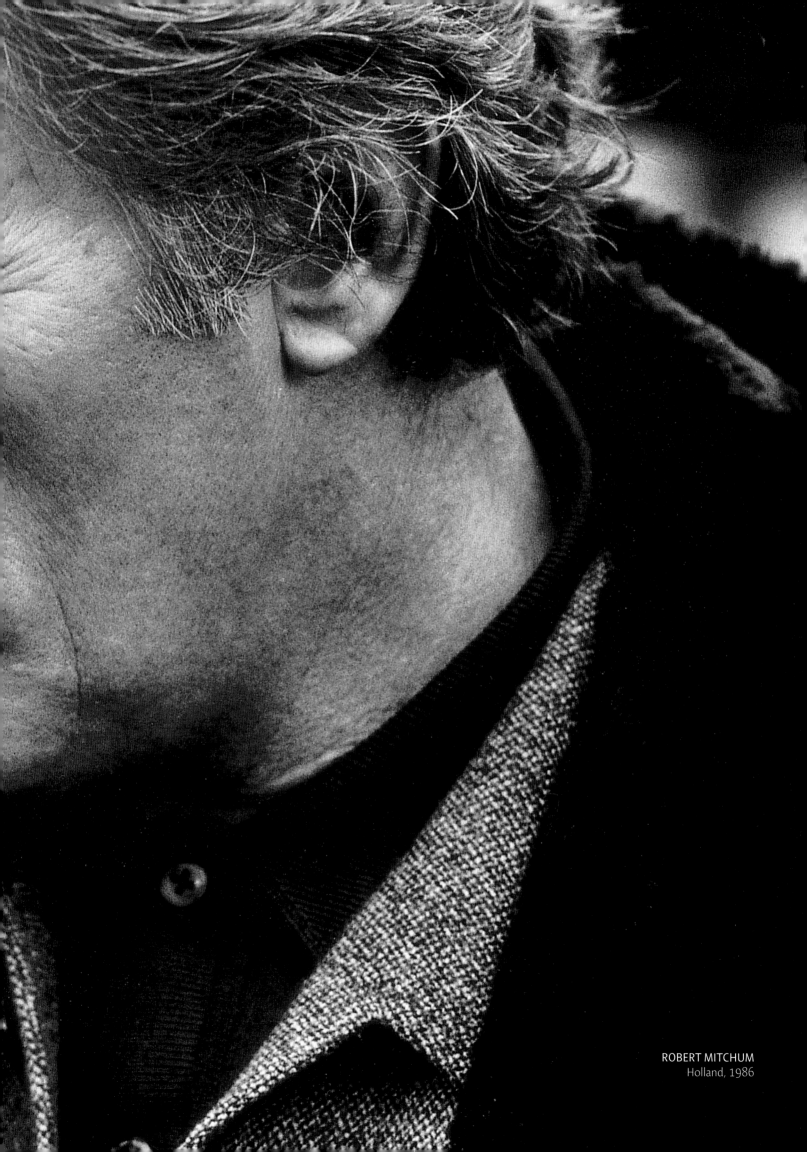

ROBERT MITCHUM
Holland, 1986

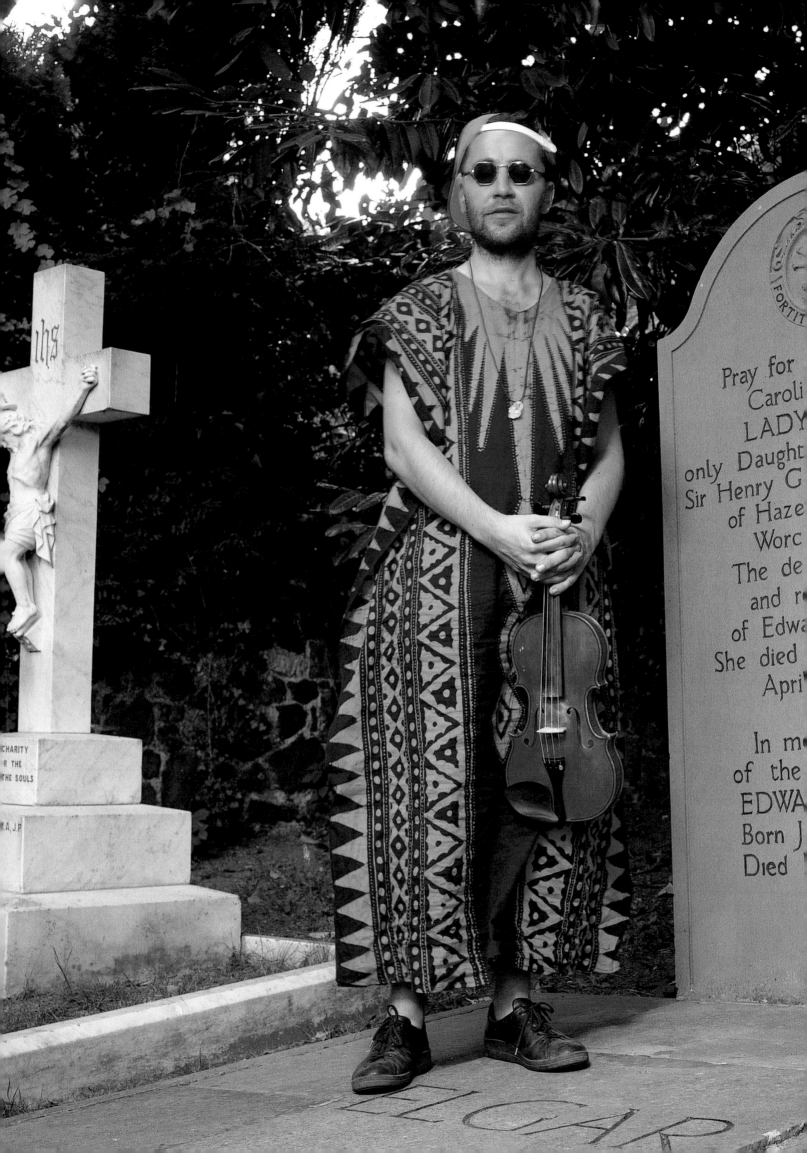

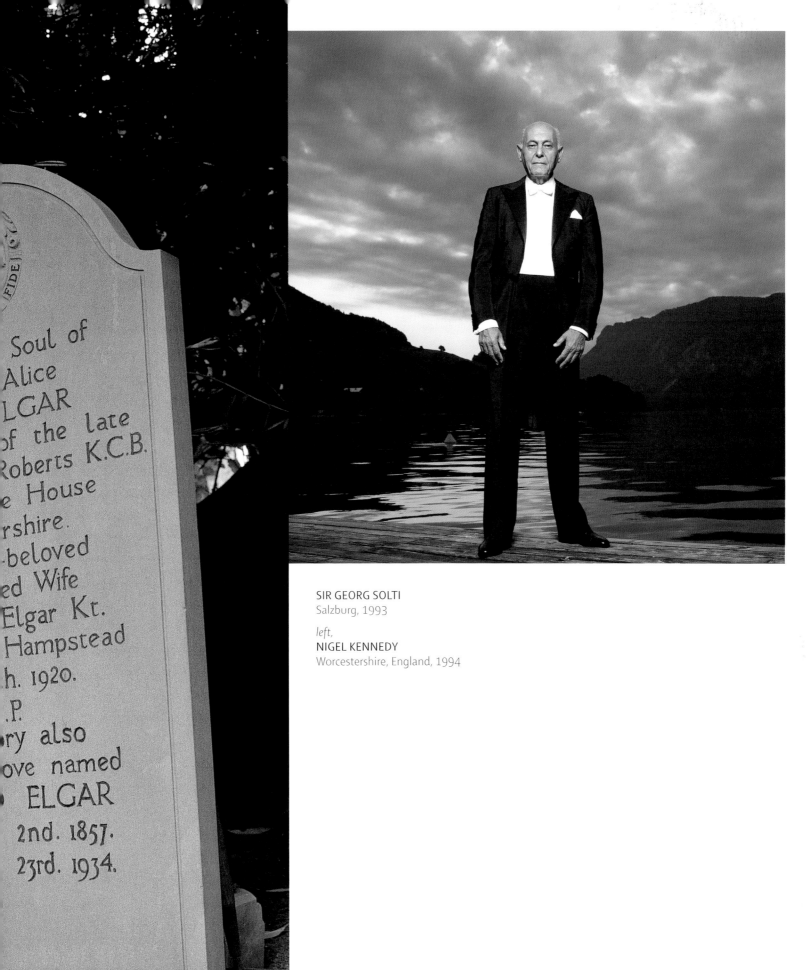

SIR GEORG SOLTI
Salzburg, 1993

*left,*
NIGEL KENNEDY
Worcestershire, England, 1994

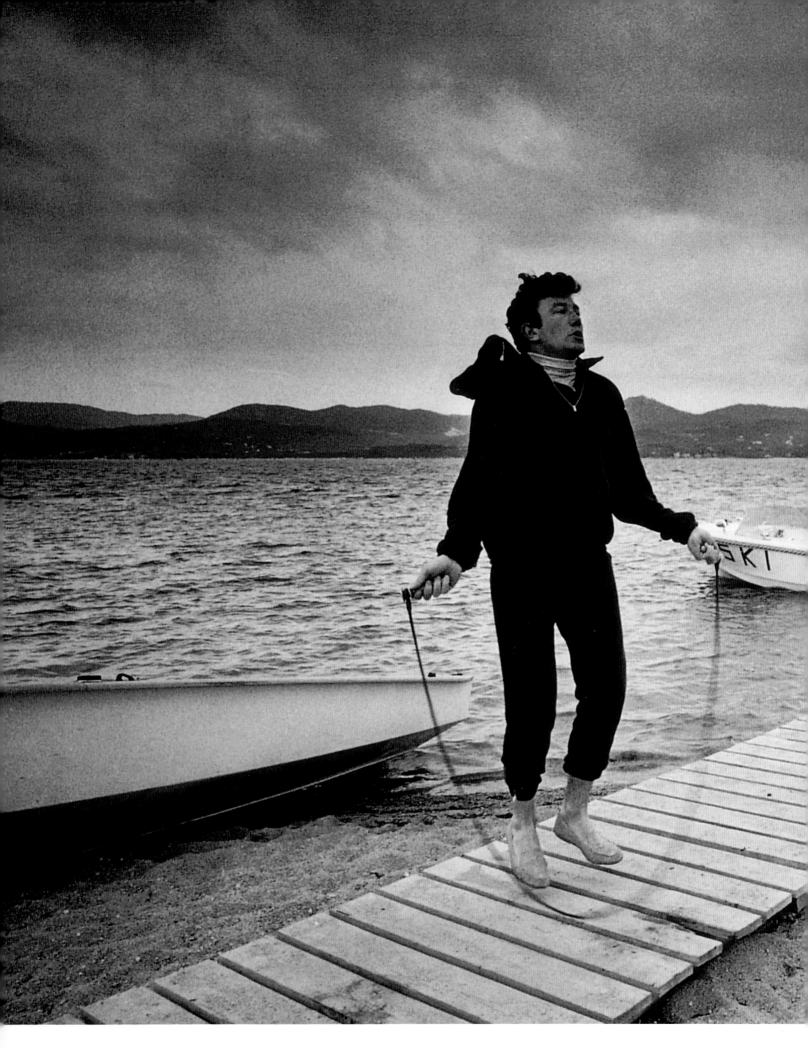

ALBERT FINNEY
San Tropez, 1966

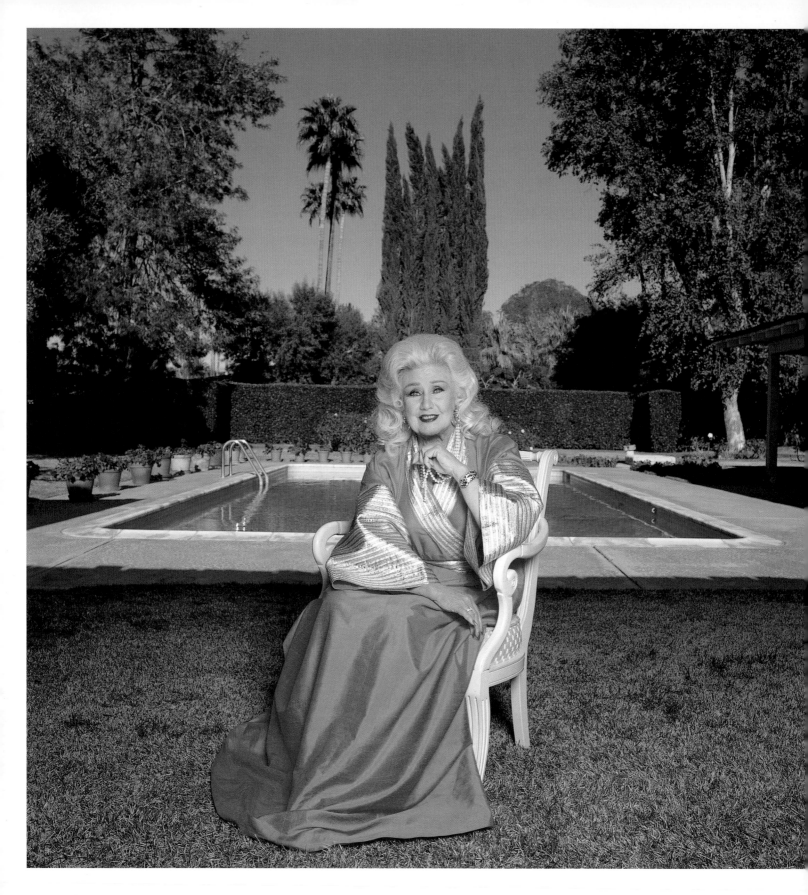

GINGER ROGERS
Palm Springs, 1988

*right,*
FRED ASTAIRE
Hollywood, 1988

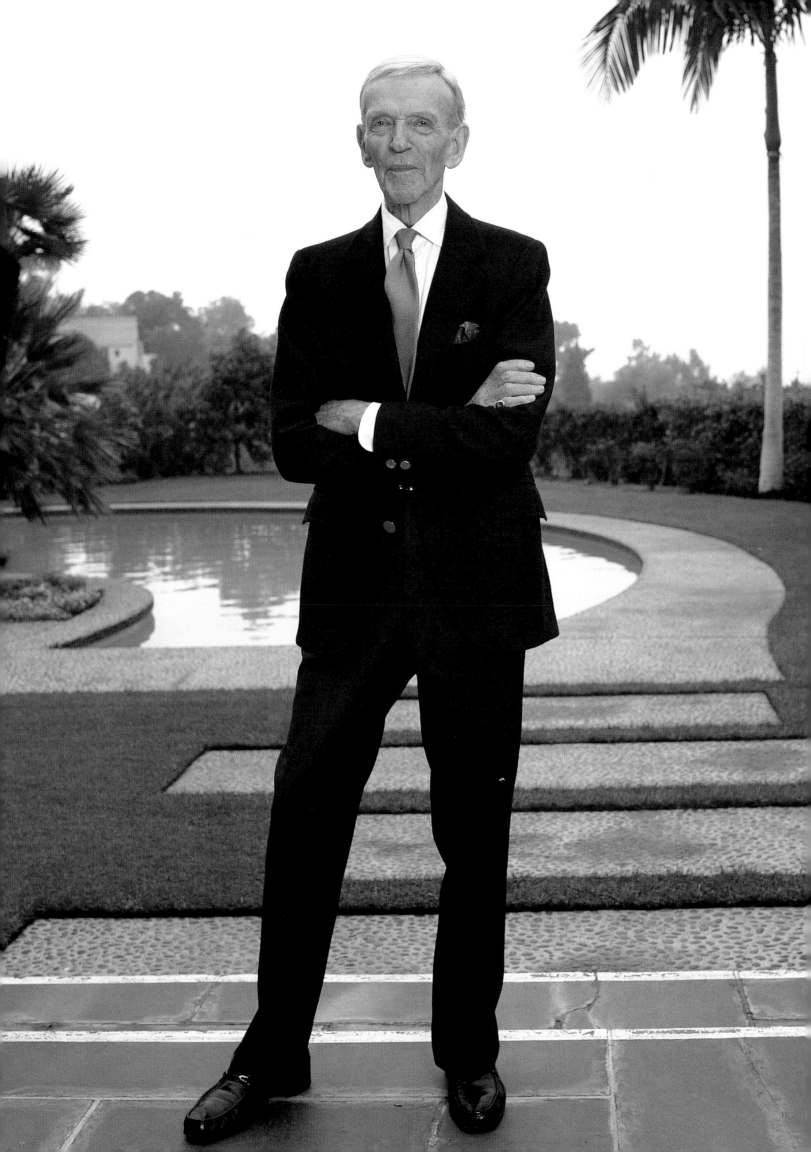

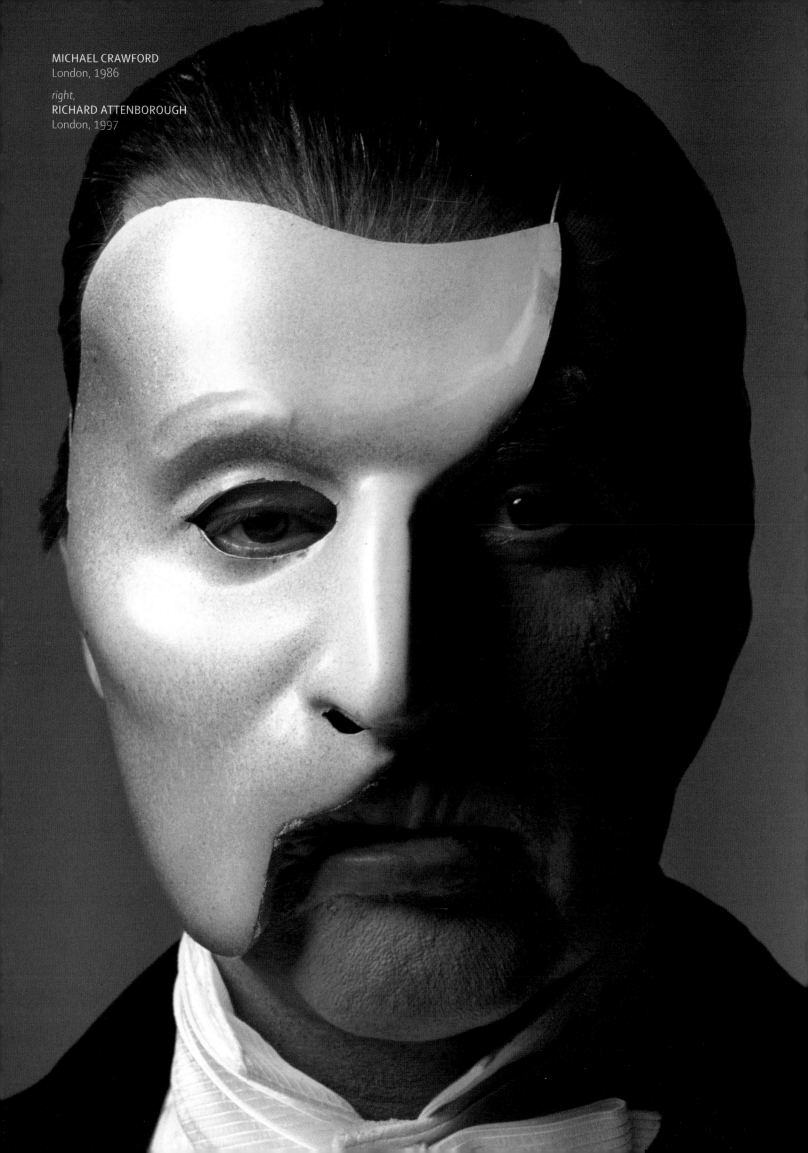

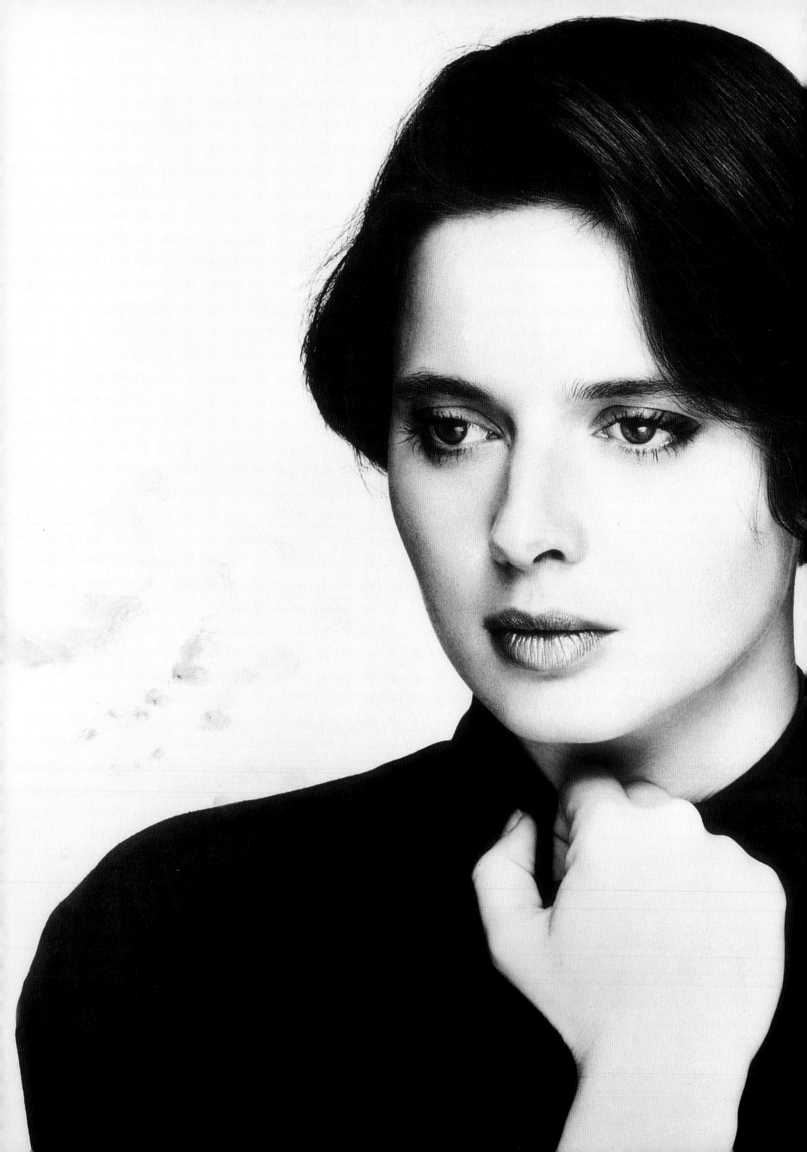

ISABELLA ROSSELLINI
London, 1984

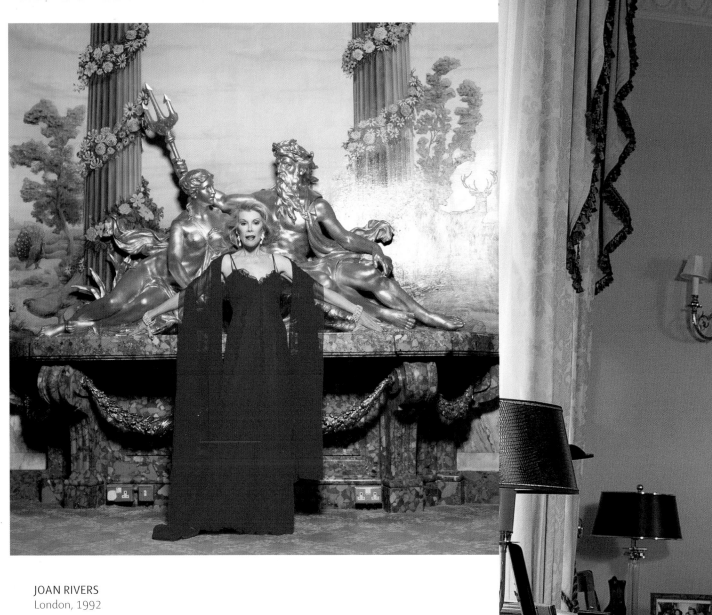

**JOAN RIVERS**
London, 1992

*right,*
**IVANA TRUMP & RICCARDO MAZZUCCHELLI**
London, 1991

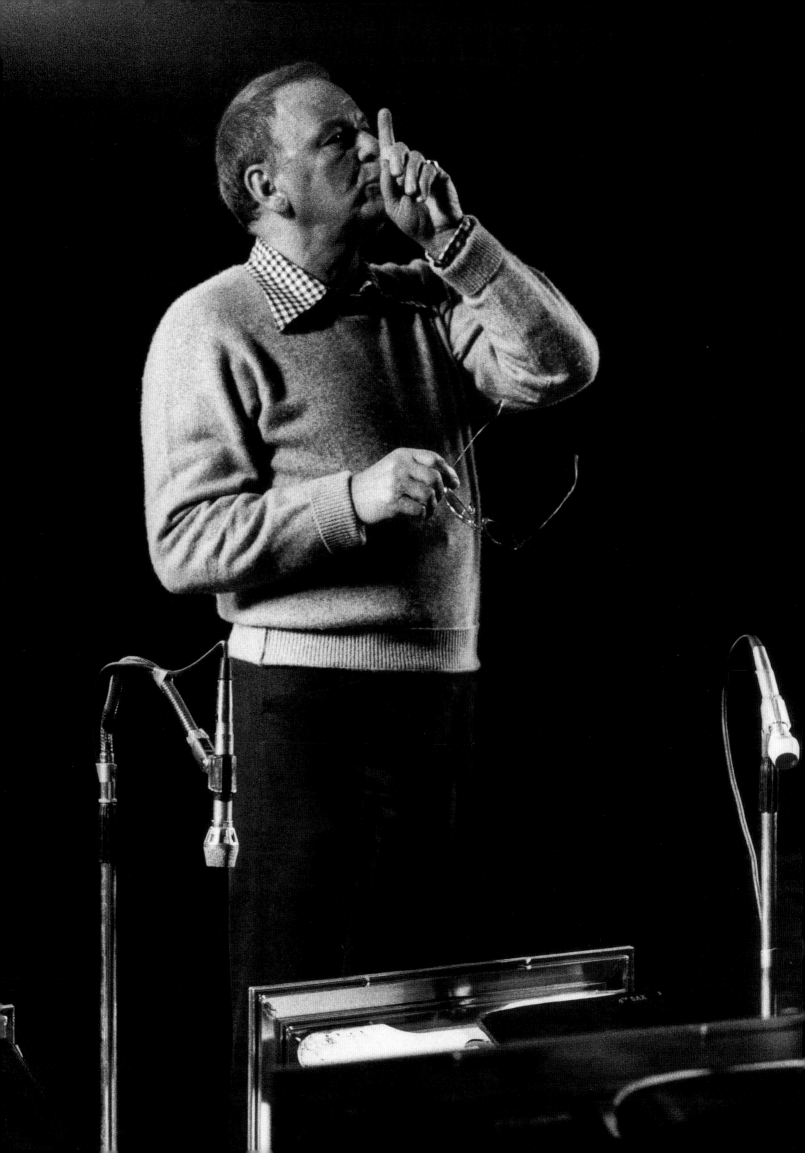

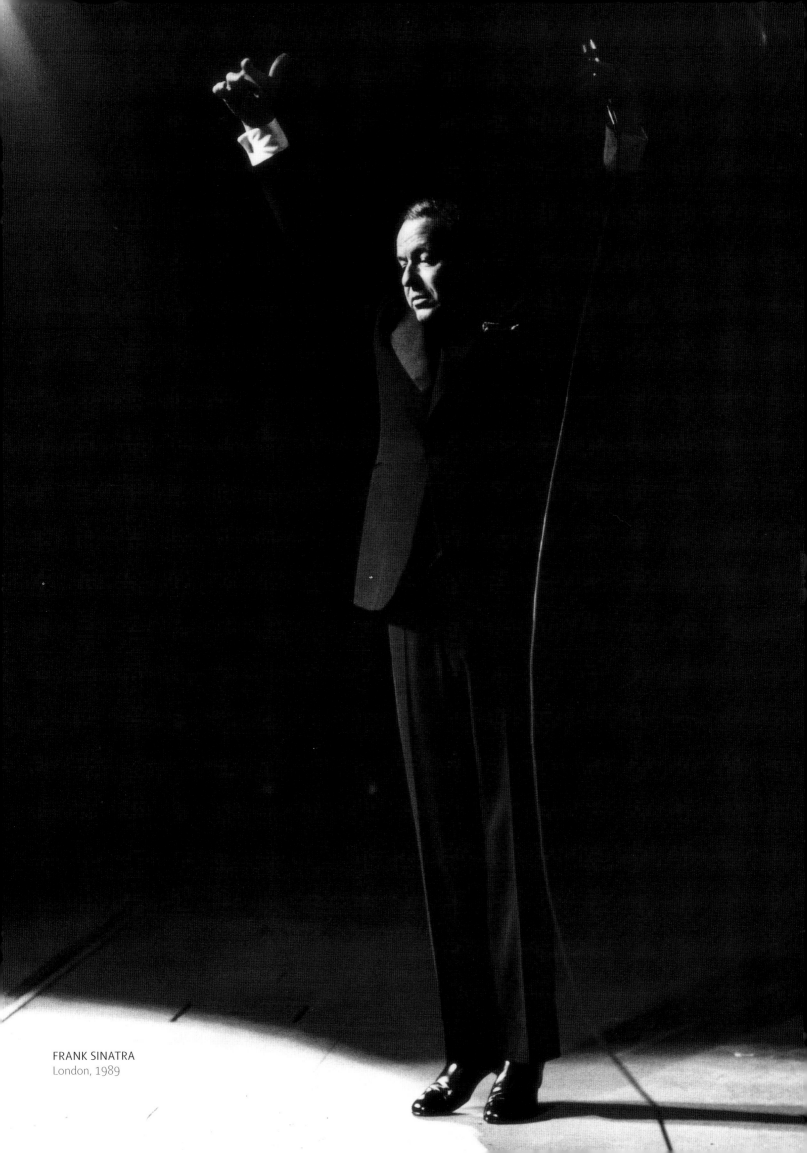

FRANK SINATRA
London, 1989

JOHN CLEESE
London, 1997

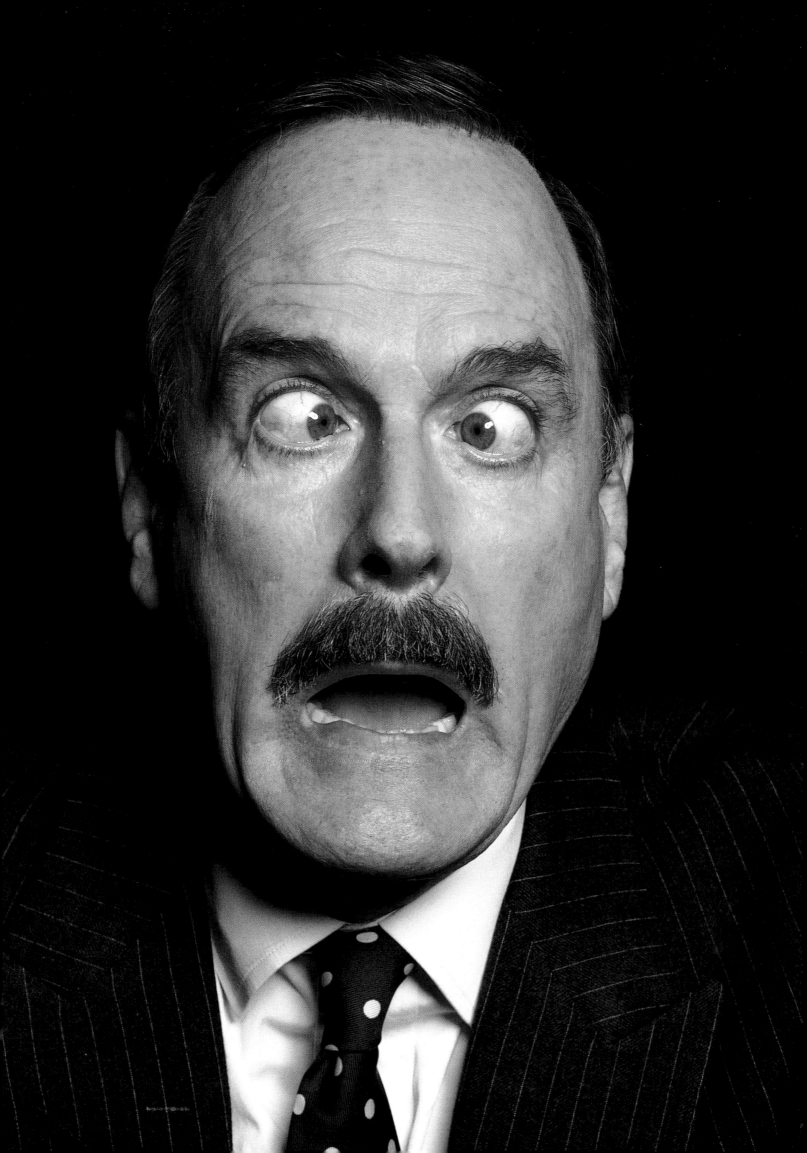

In the early nineties I was asked to Sandringham House to take a portrait of the Queen and Prince Philip. I'd taken a few shots when suddenly the dorgi – apparently, a cross between a dachshund and a corgi – at their feet sat bolt upright. Neither of them flinched and I managed to get the picture. When I sent them the negatives to my surprise this was the shot they picked out. Their professionalism veiled a great sense of humour

PRINCE PHILIP, HER ROYAL HIGHNESS QUEEN ELIZABETH II & BRANDY
Norfolk, England, 1992

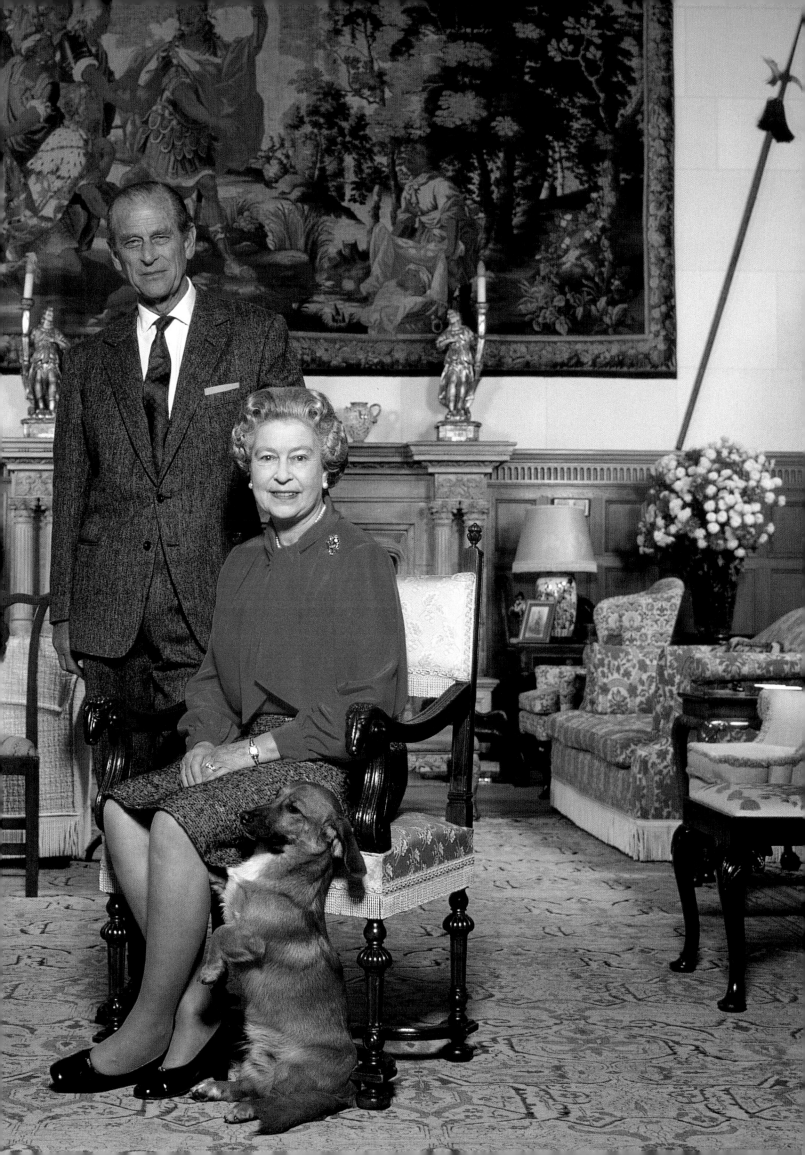

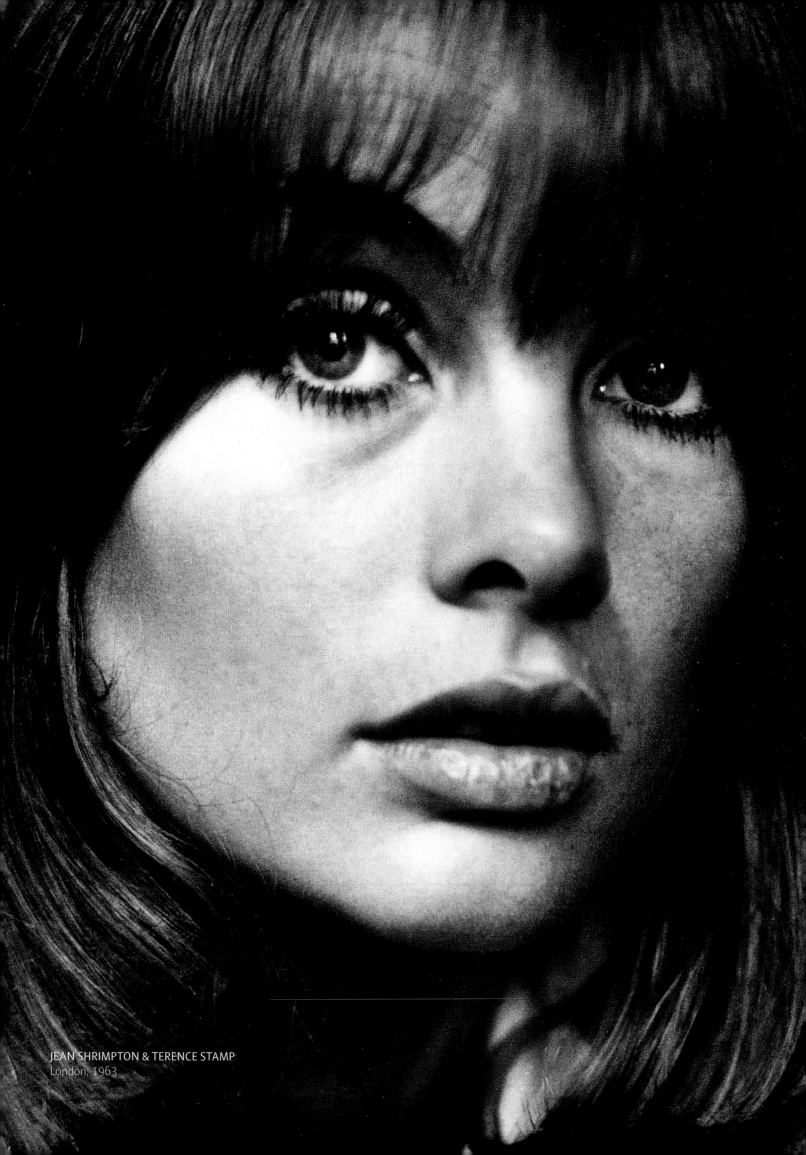

JEAN SHRIMPTON & TERENCE STAMP
London, 1963

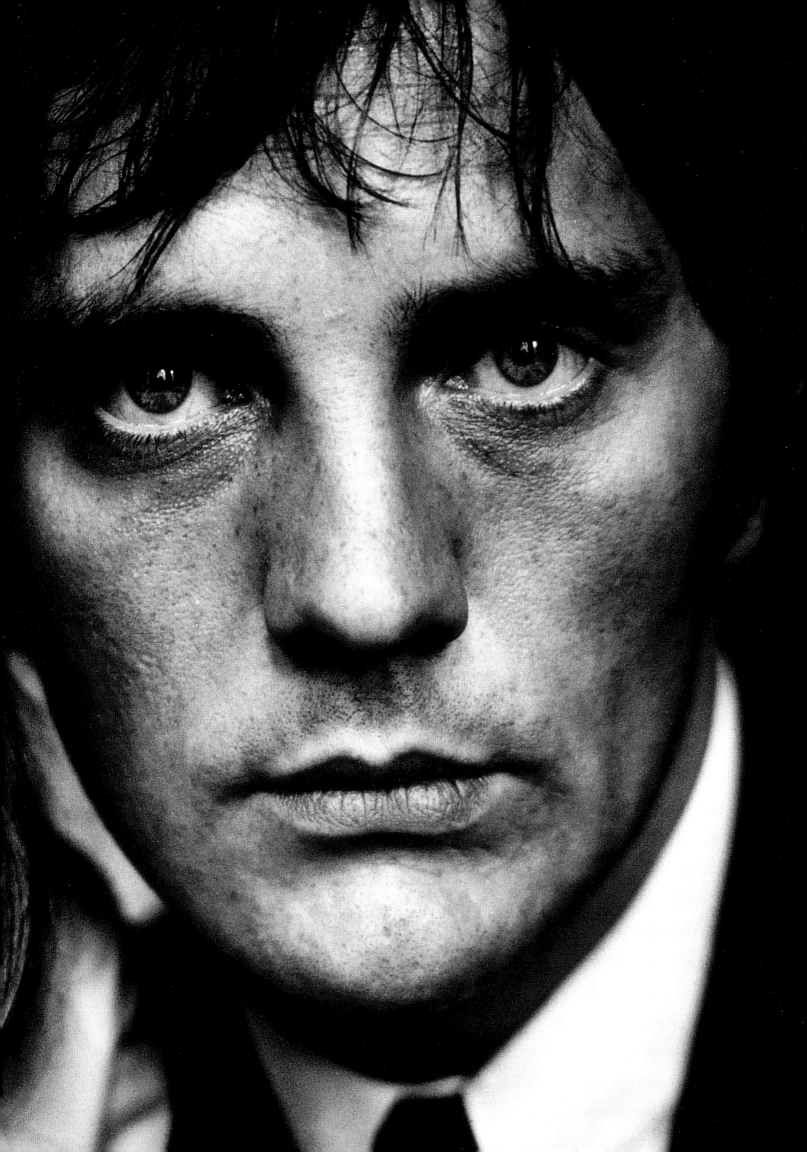

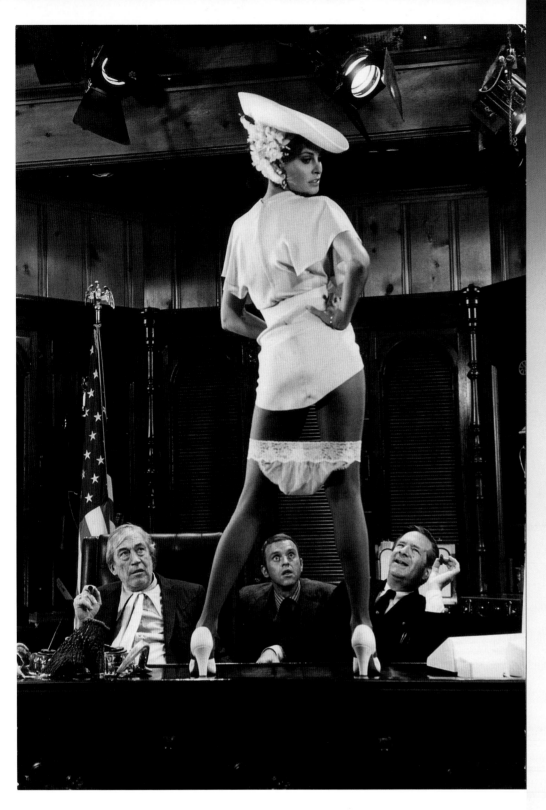

RAQUEL WELCH
Los Angeles, 1970

*right,*
RAQUEL WELCH
Los Angeles, 1966

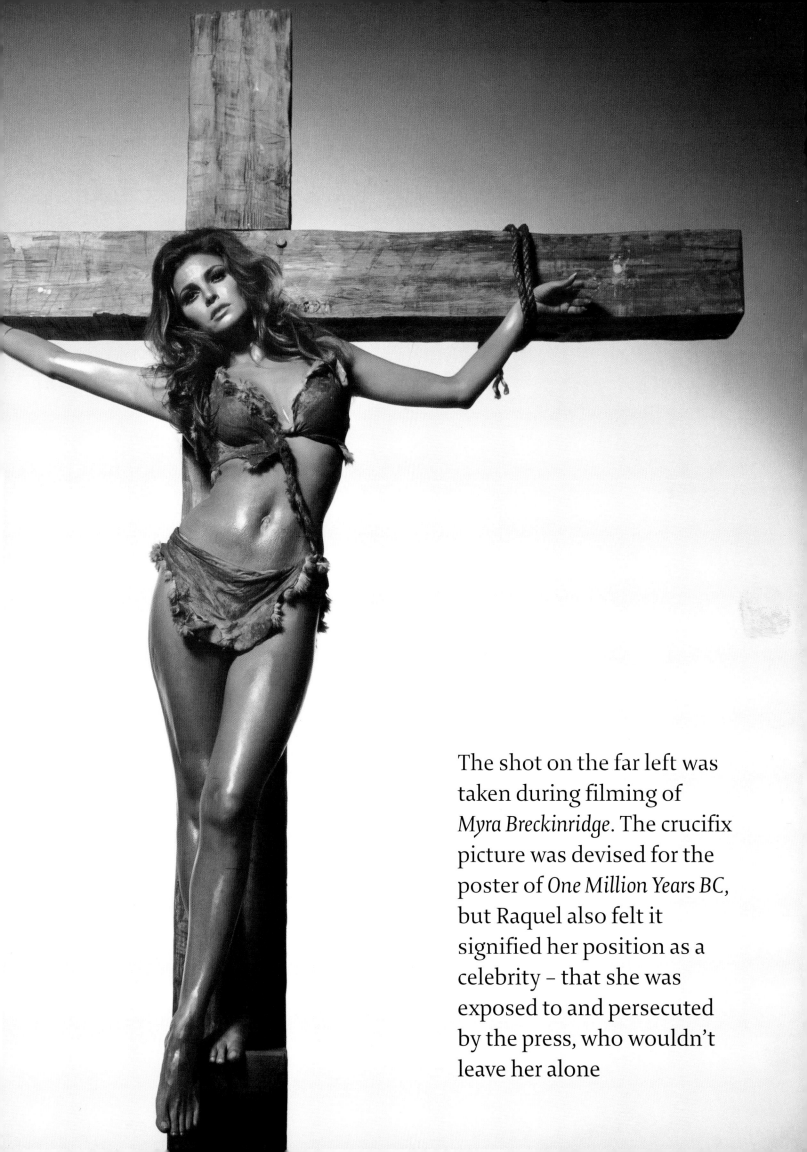

The shot on the far left was taken during filming of *Myra Breckinridge*. The crucifix picture was devised for the poster of *One Million Years BC*, but Raquel also felt it signified her position as a celebrity – that she was exposed to and persecuted by the press, who wouldn't leave her alone

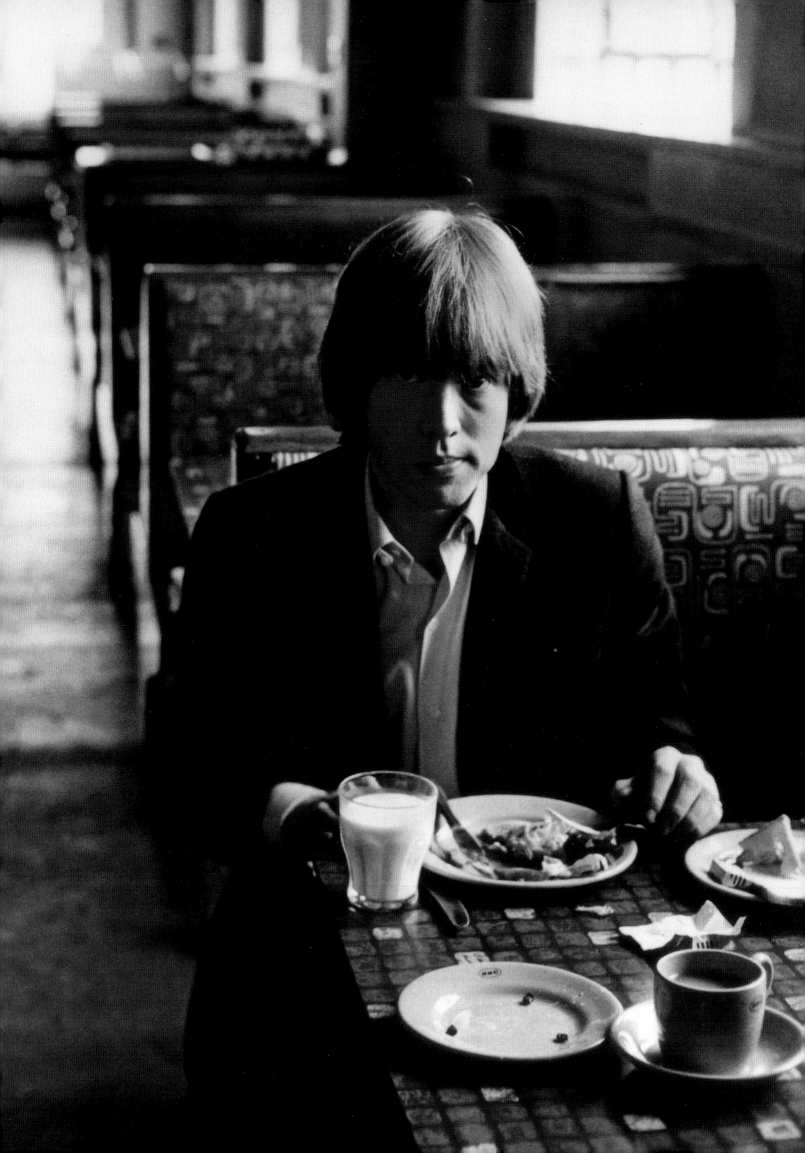

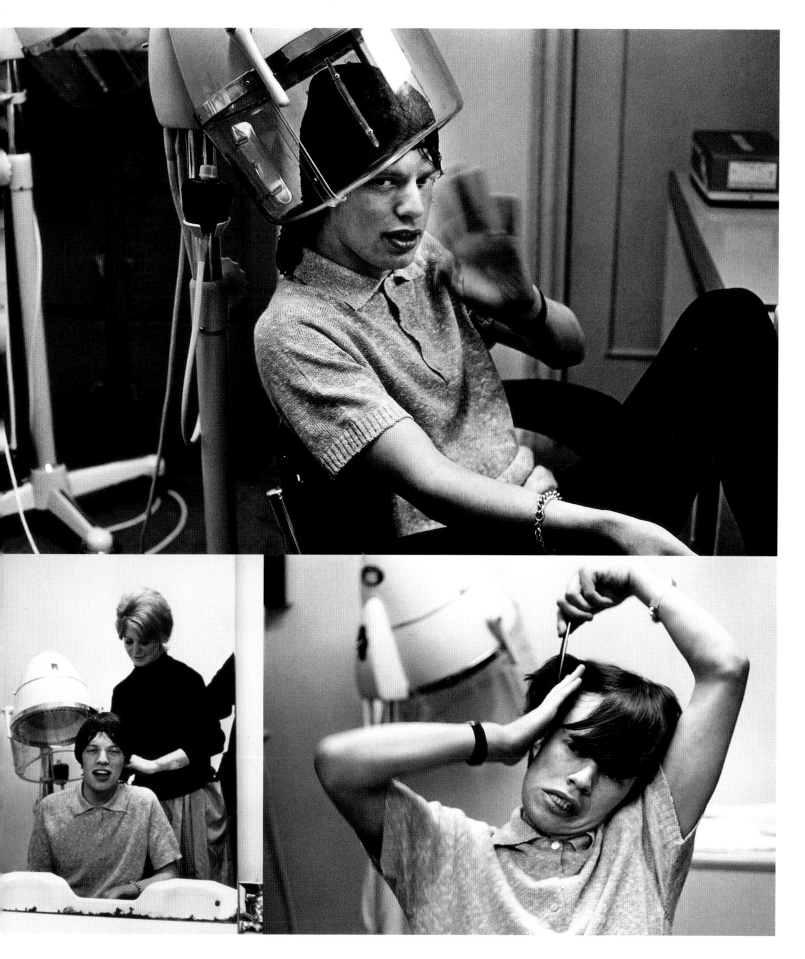

MICK JAGGER

*left,*
BRIAN JONES
BBC Studios, London, 1963

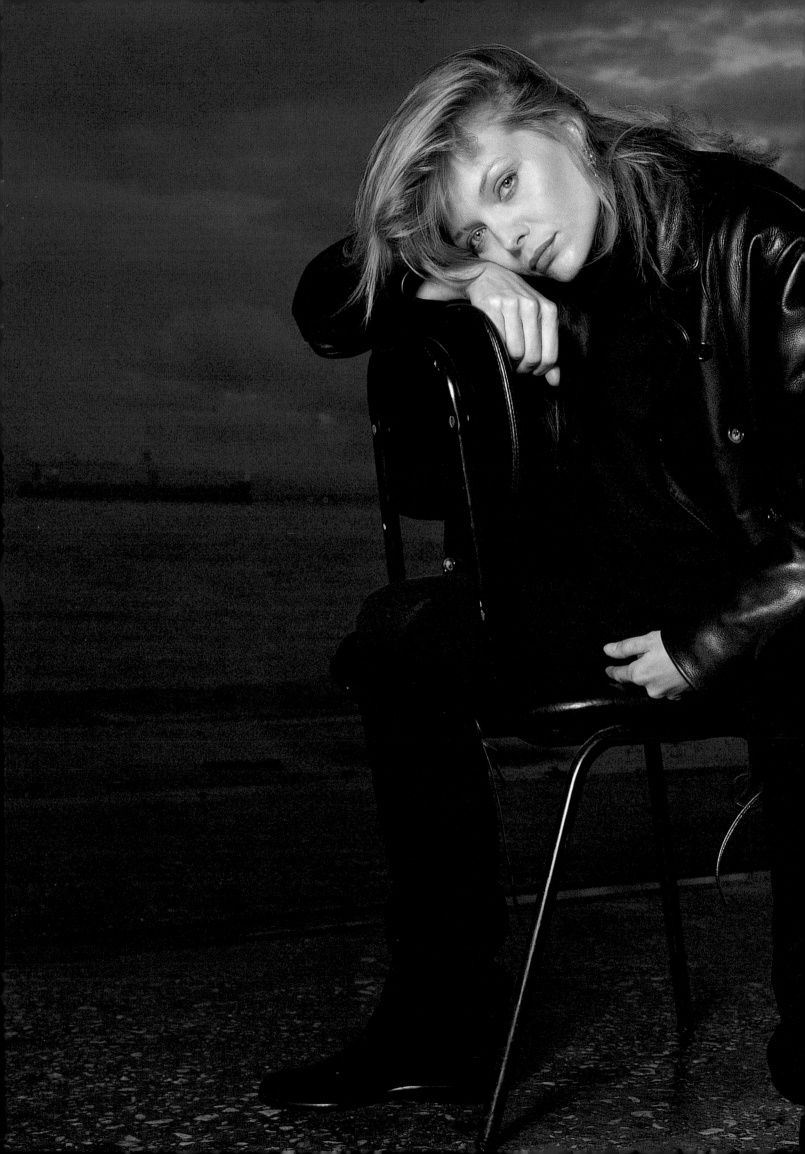

MICHELLE PFEIFFER
Portugal, 1990

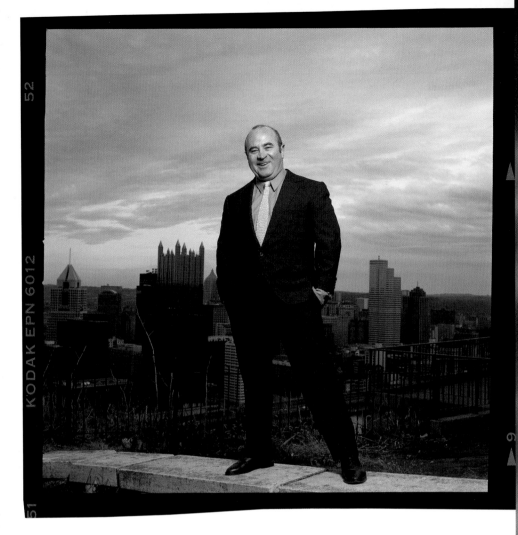

BOB HOSKINS
Philadelphia, 1990

*right,*
AL PACINO
Los Angeles, 1995

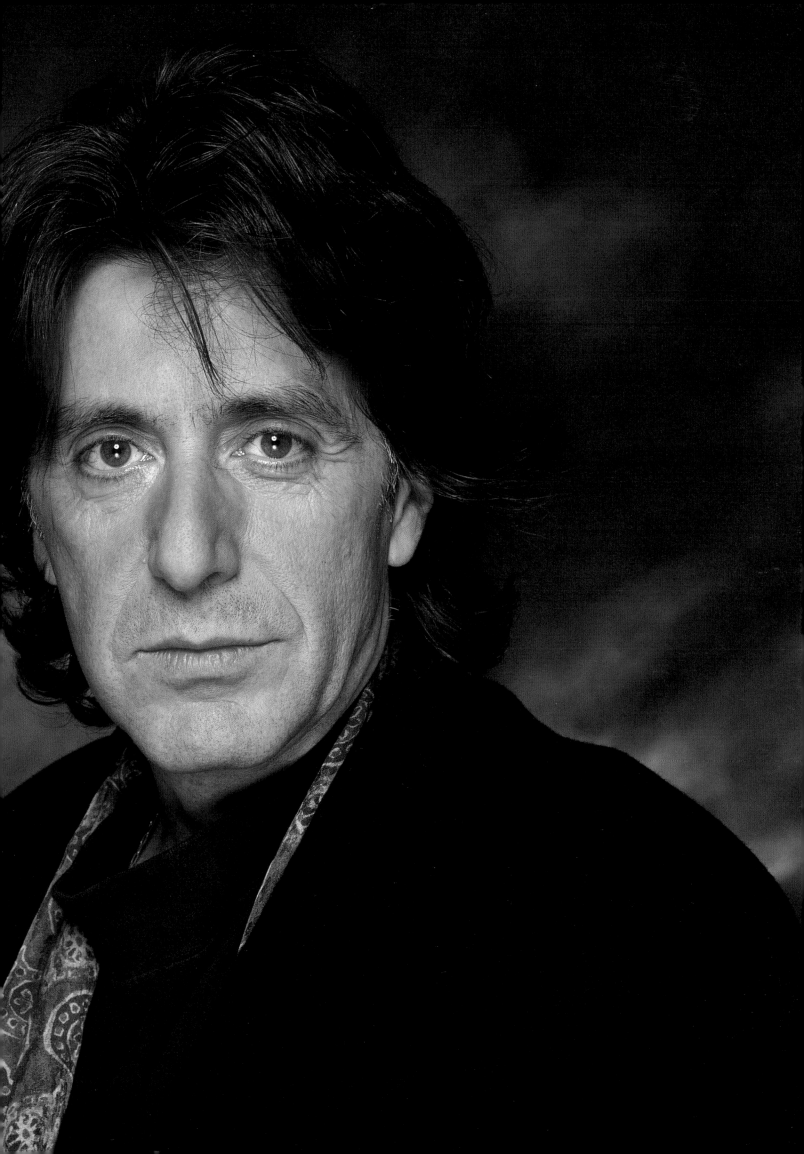

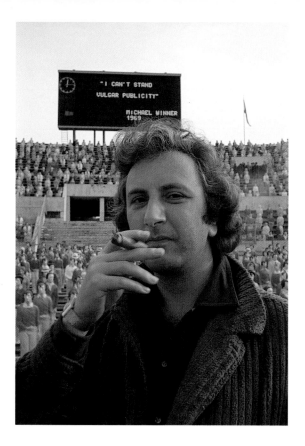

MICHAEL WINNER
Rome, 1969

*right,*
ANDREW NEILL
Barbados, 1992

Andrew was asked to do this
shoot as part of a charity
promotion. It was by far the
most way-out charity picture
I ever took. We found him a
beautiful, leggy companion –
the receptionist at his hotel,
as it happened – to be one
of Santa's perks!

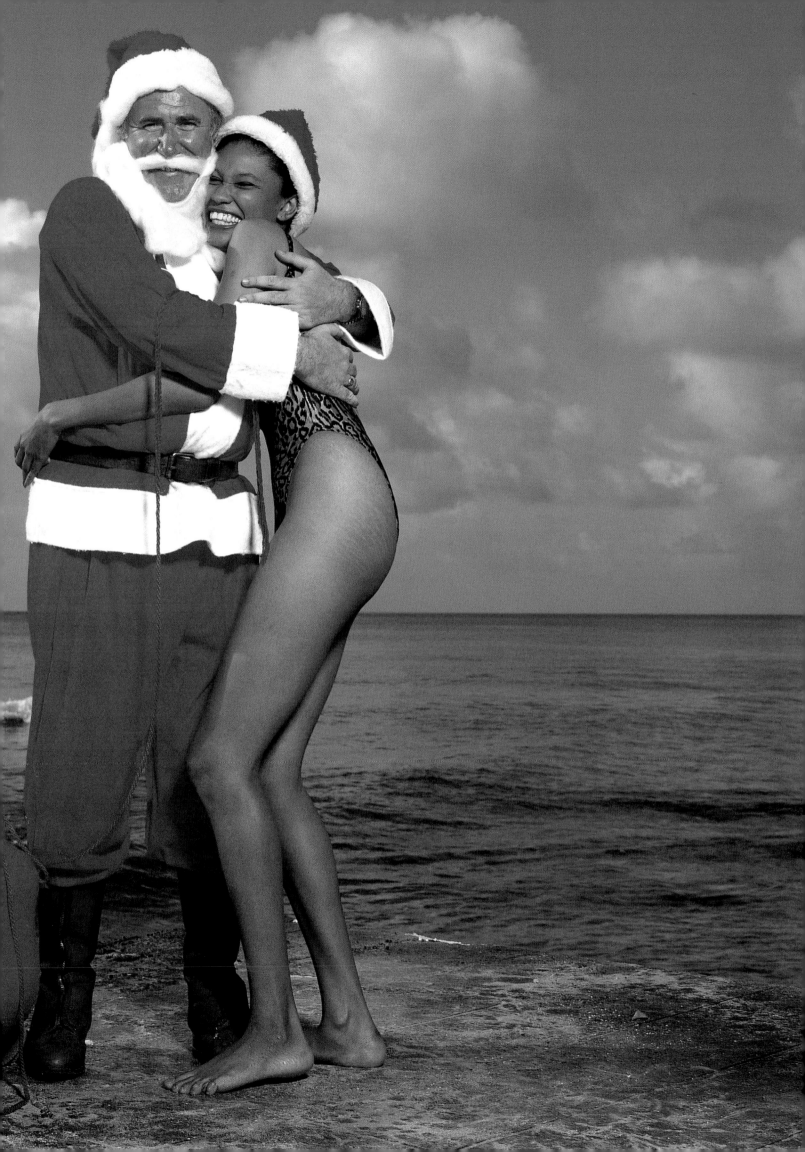

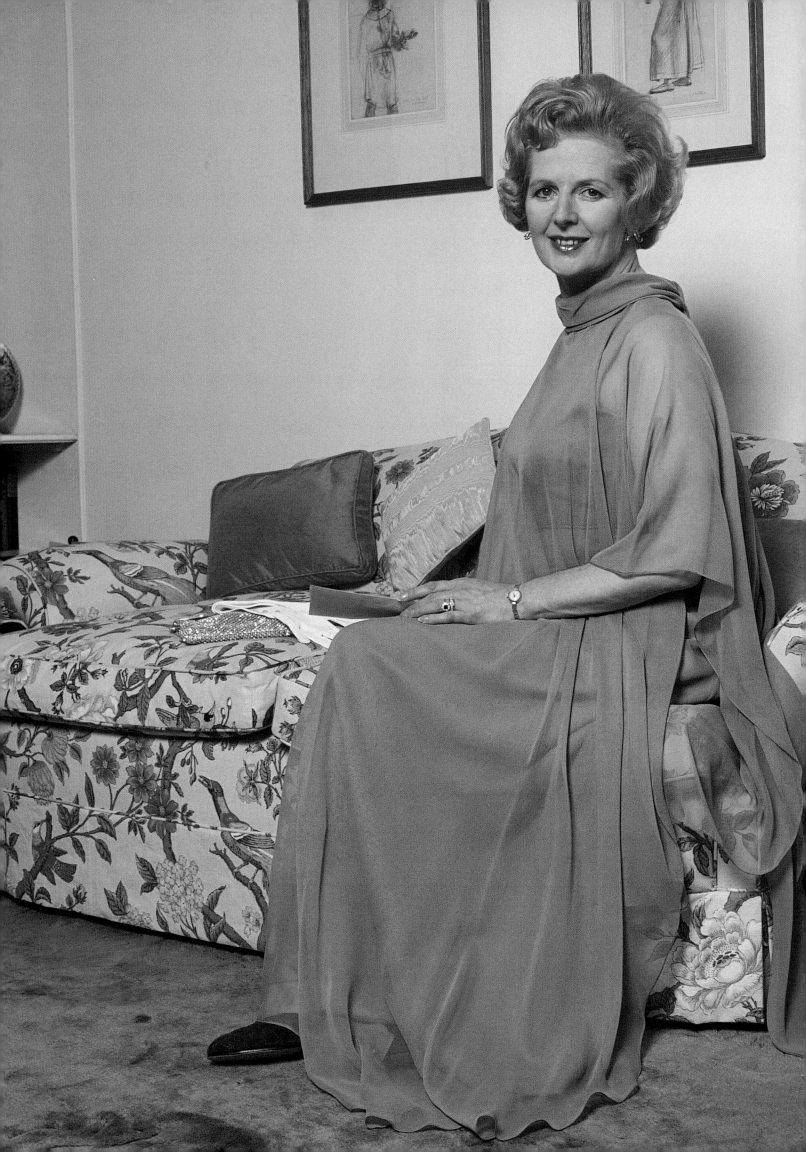

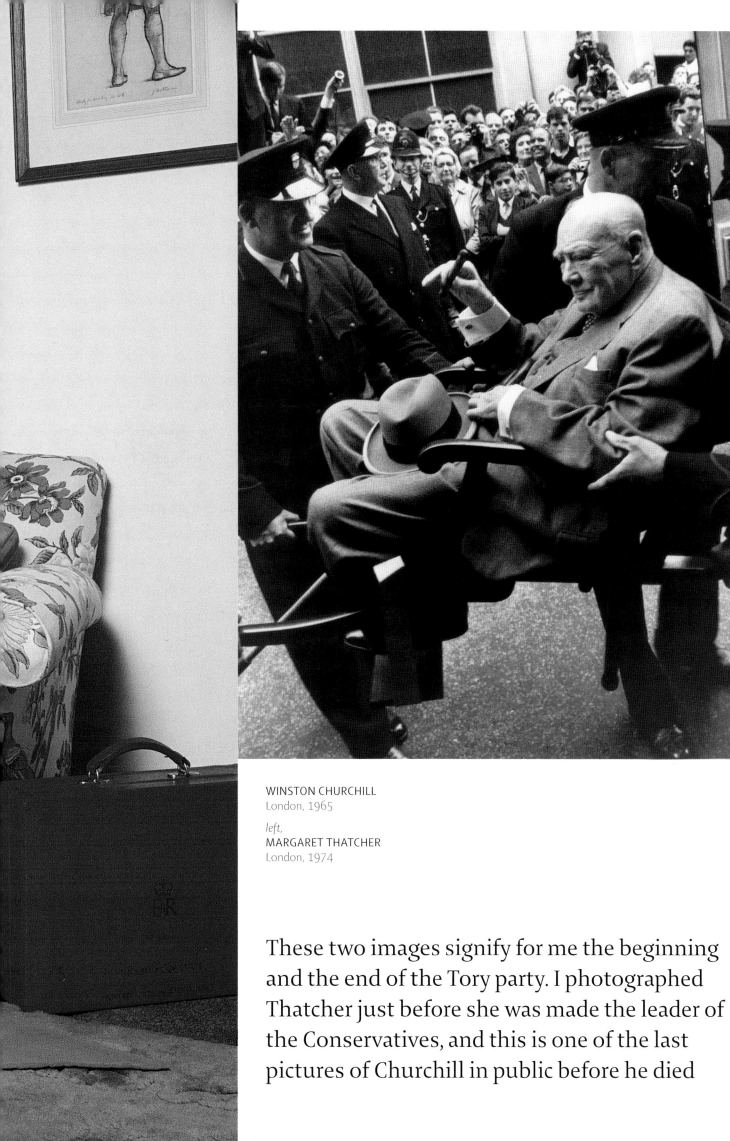

WINSTON CHURCHILL
London, 1965

*left,*
MARGARET THATCHER
London, 1974

These two images signify for me the beginning
and the end of the Tory party. I photographed
Thatcher just before she was made the leader of
the Conservatives, and this is one of the last
pictures of Churchill in public before he died

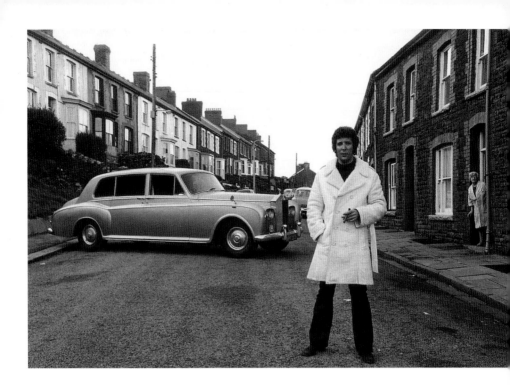

**TOM JONES**
Pontypridd, Wales, 1974

*right,*
**TOM JONES**
London, 2001

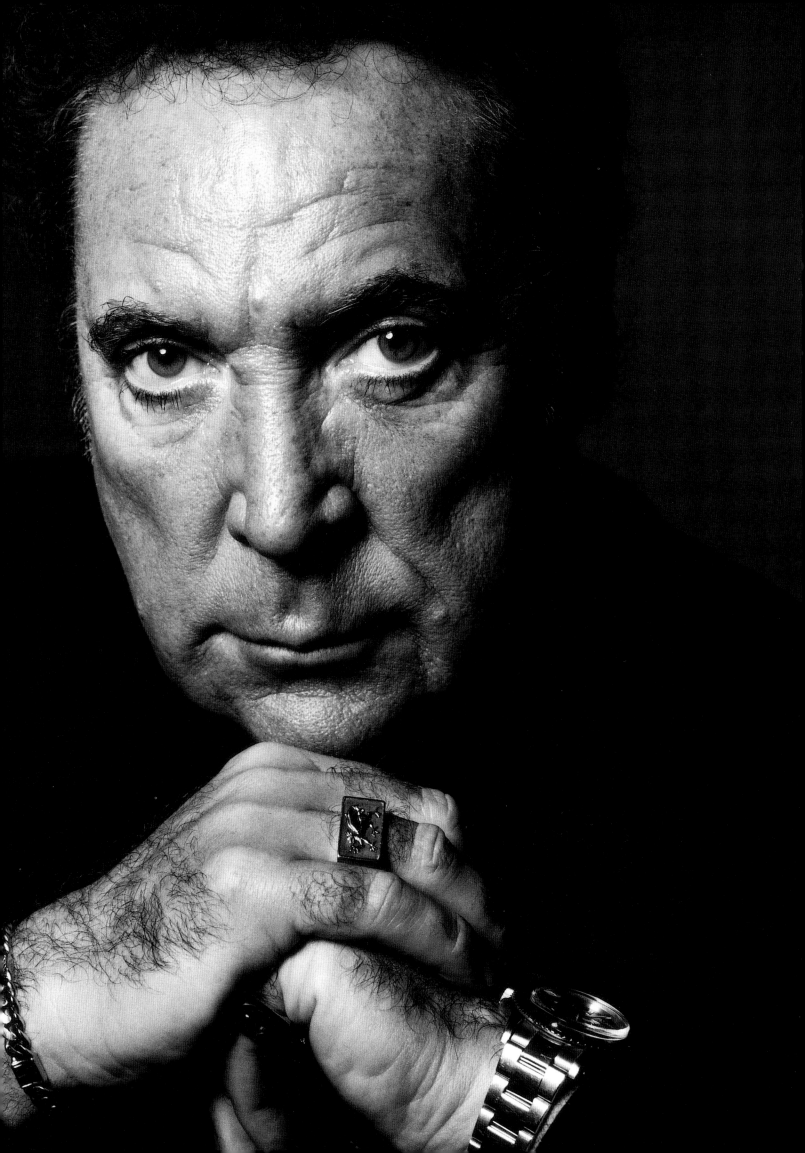

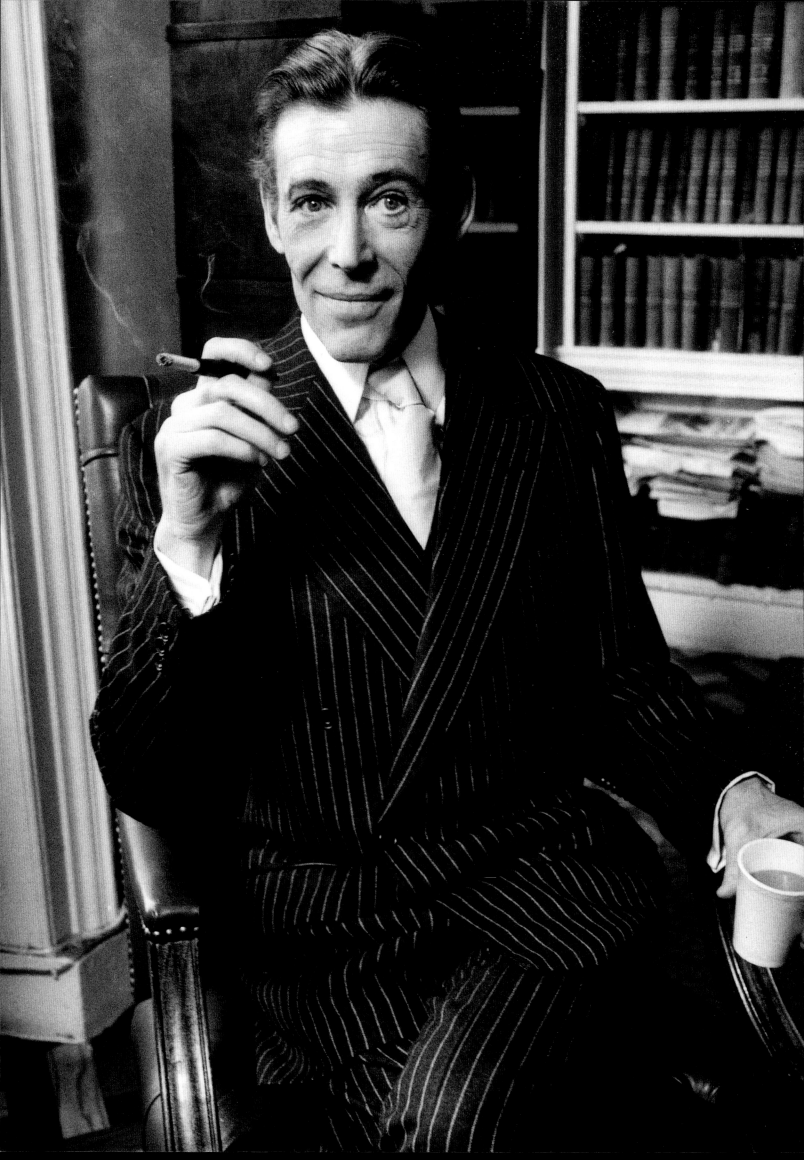

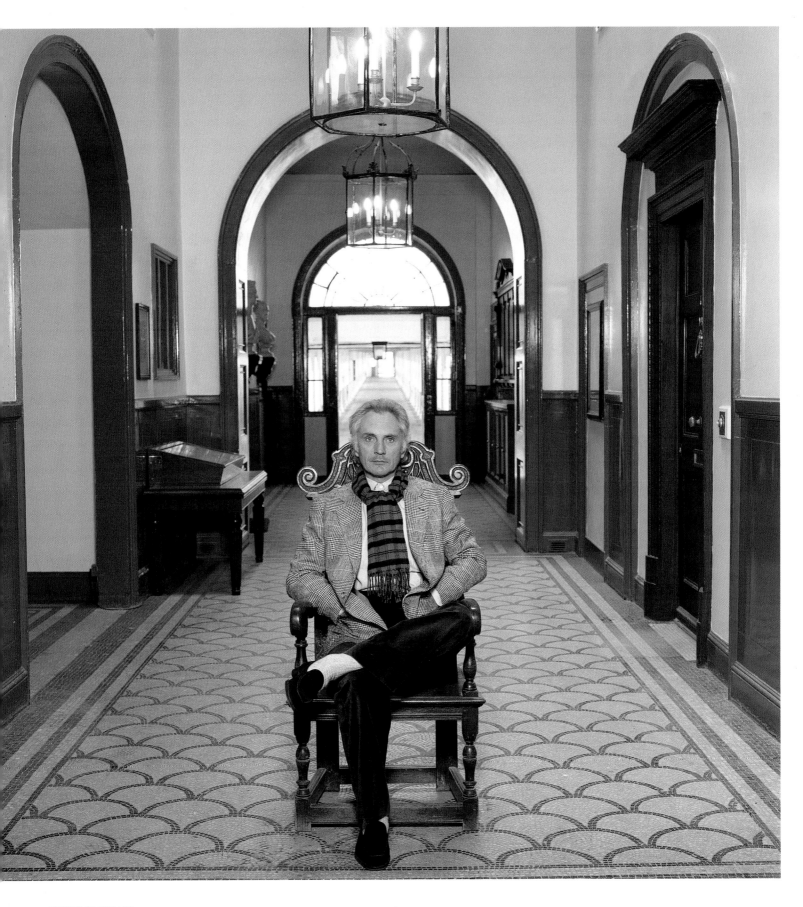

TERENCE STAMP
London, 1988

*left,*
PETER O'TOOLE
London, 1976

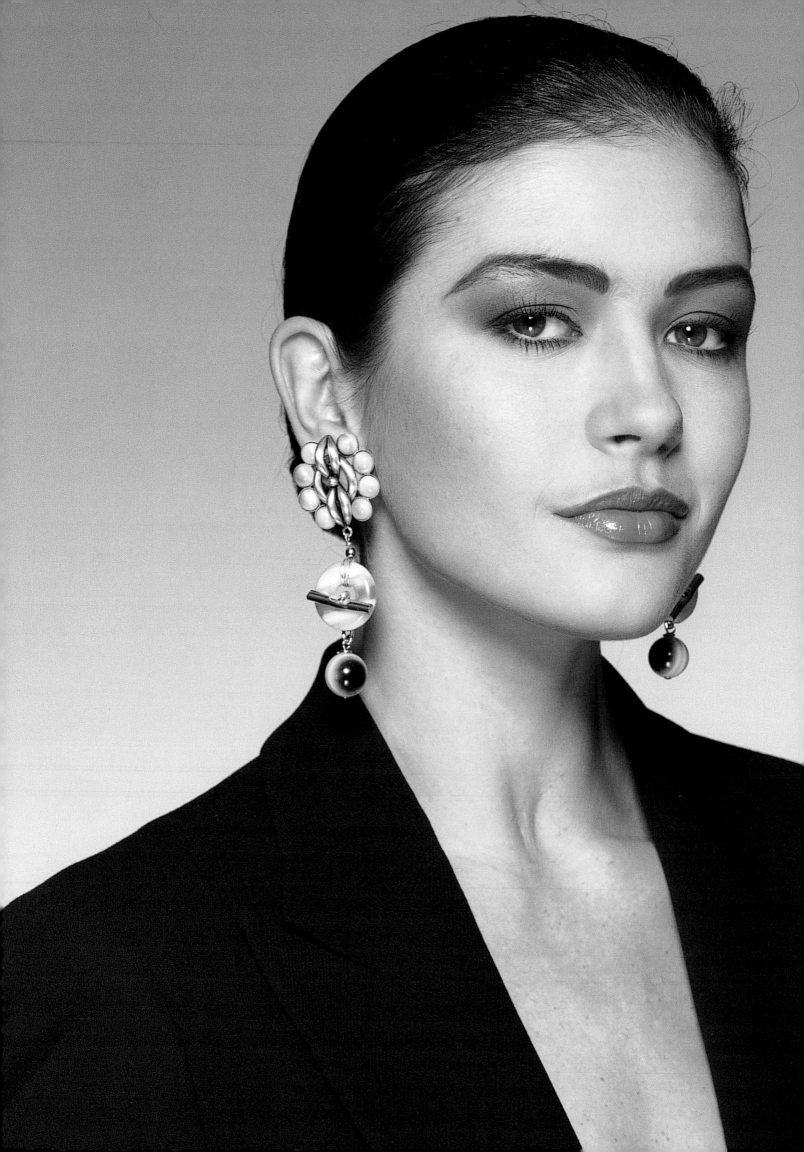

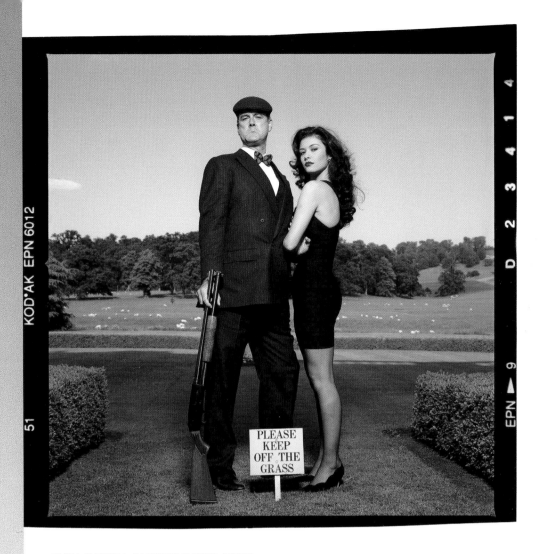

JOHN CLEESE & CATHERINE ZETA-JONES
England, 1993

*left,*
CATHERINE ZETA-JONES
London, 1997

GLENDA JACKSON
Shepperton Studios, England, 1971

*right,*
DAME EDNA EVERIDGE
London, 1990

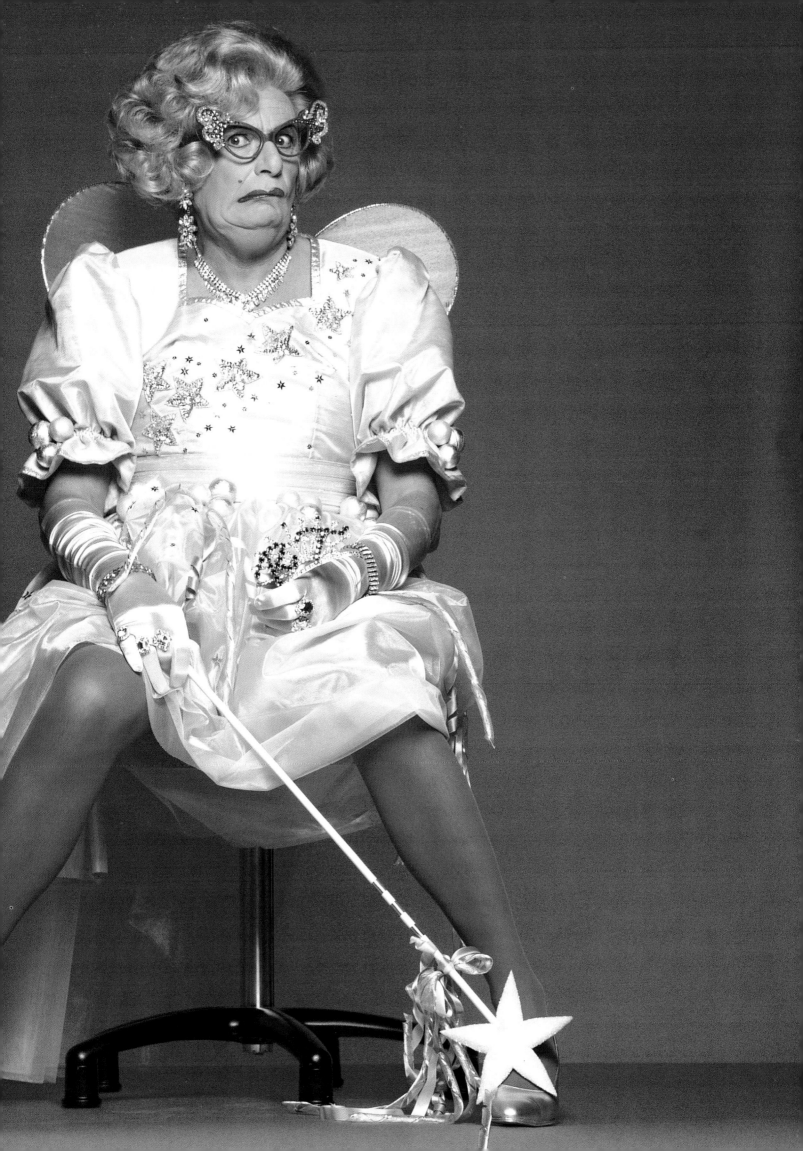

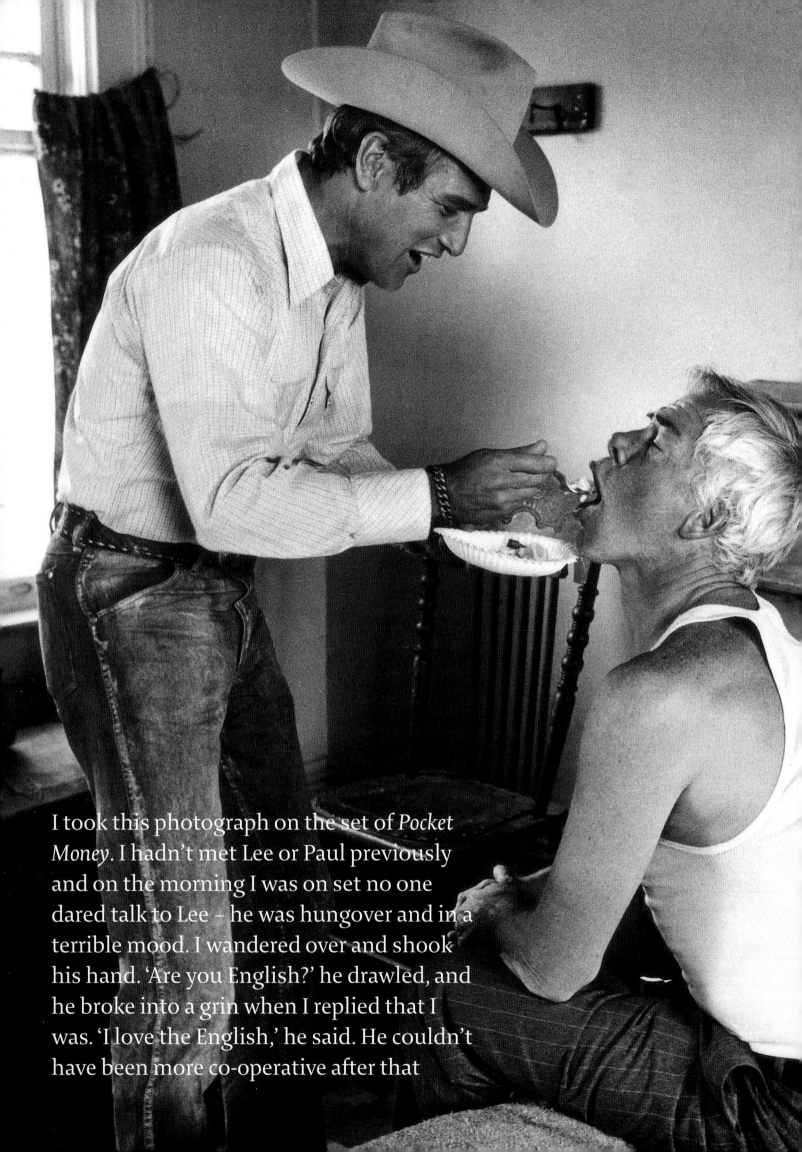

I took this photograph on the set of *Pocket Money*. I hadn't met Lee or Paul previously and on the morning I was on set no one dared talk to Lee – he was hungover and in a terrible mood. I wandered over and shook his hand. 'Are you English?' he drawled, and he broke into a grin when I replied that I was. 'I love the English,' he said. He couldn't have been more co-operative after that

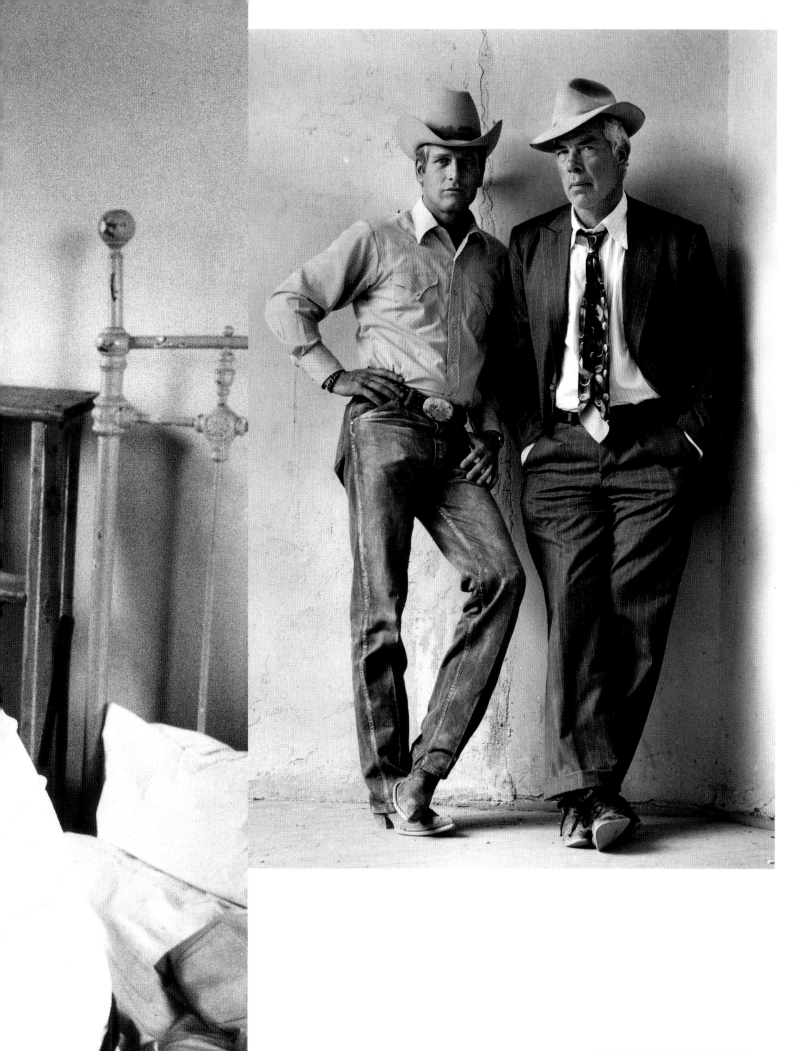

PAUL NEWMAN & LEE MARVIN
Denver, Colarado, 1971

127

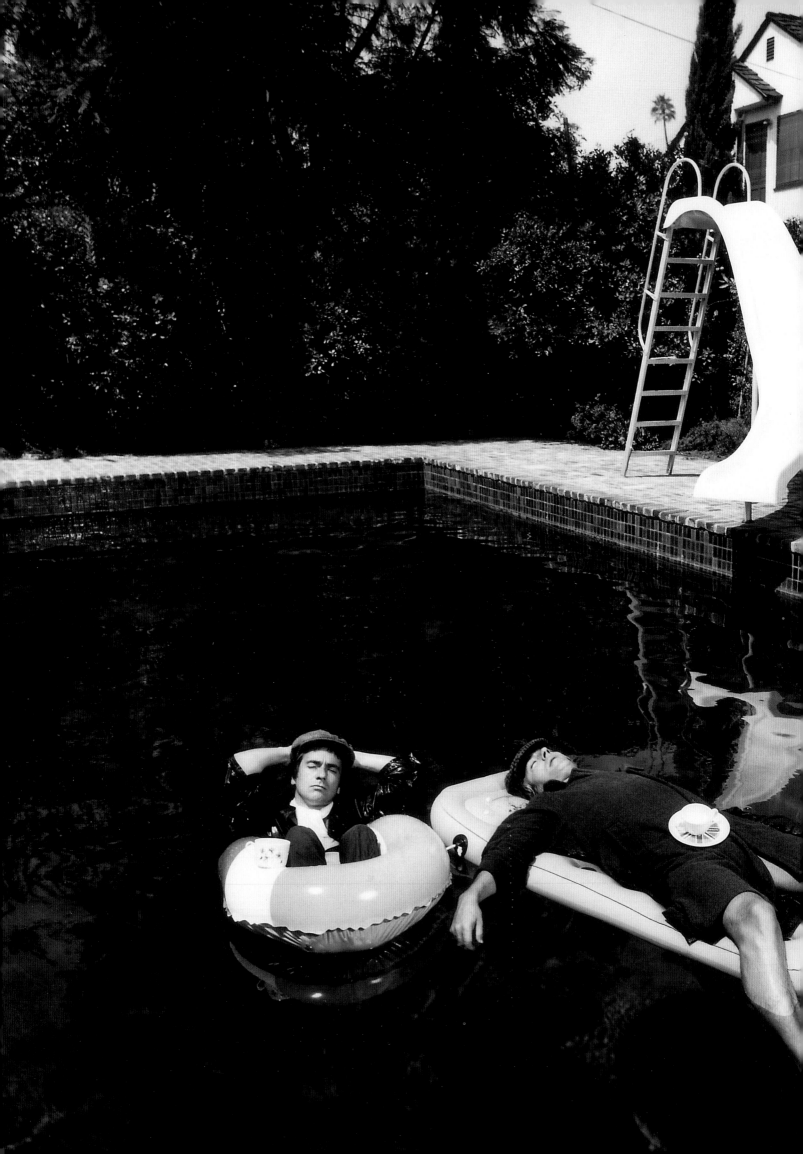

Peter Cook was renting this house with Keith Moon and they were in a hell of a state, doing cocktails of drugs all day. Dudley Moore was at the height of his fame at this point. He was living in the UK but he did Pete a great favour by coming over for a reunion. I told Pete he needed to get out of Hollywood and shortly afterwards he did indeed return home

PETER COOK & DUDLEY MOORE
Beverly Hills, 1975

I took this for the *Daily Sketch*. I'd just done a similar shoot with the Beatles and my editor's reaction to both was negative. He couldn't stand the way these bands looked. 'Go and shoot some pretty boys,' he told me

THE ROLLING STONES
London, 1963

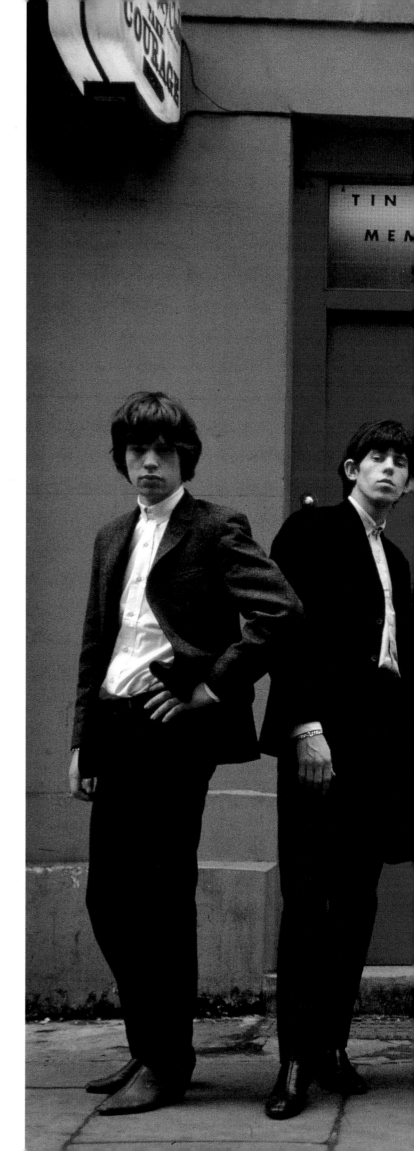

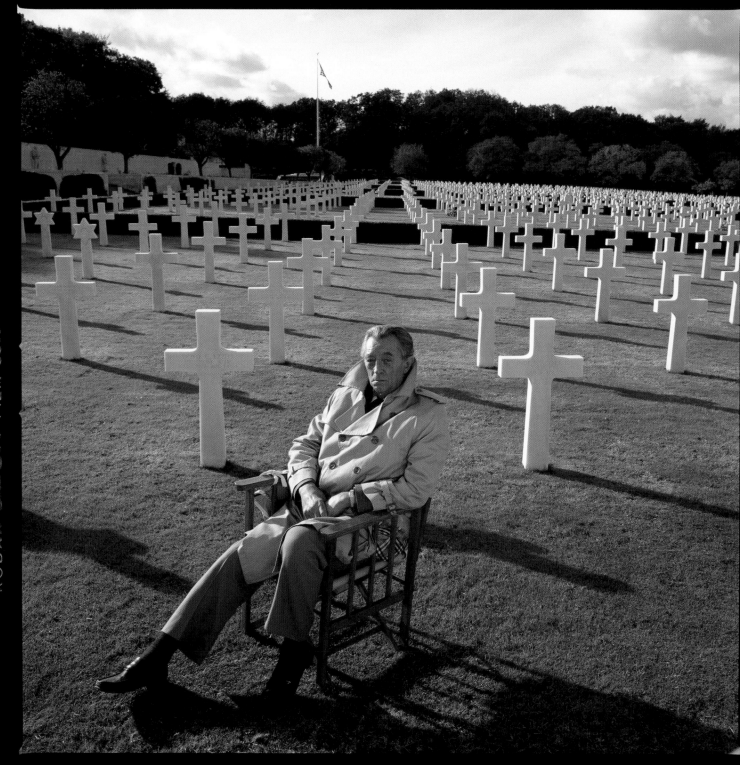

**ROBERT MITCHUM**
France, 1984

*right,*
RICHARD HELMS (the former CIA director, who was advising
Redford on his role in *Three Days Of The Condor*) & ROBERT REDFORD
Rikers Island, New York, 1975

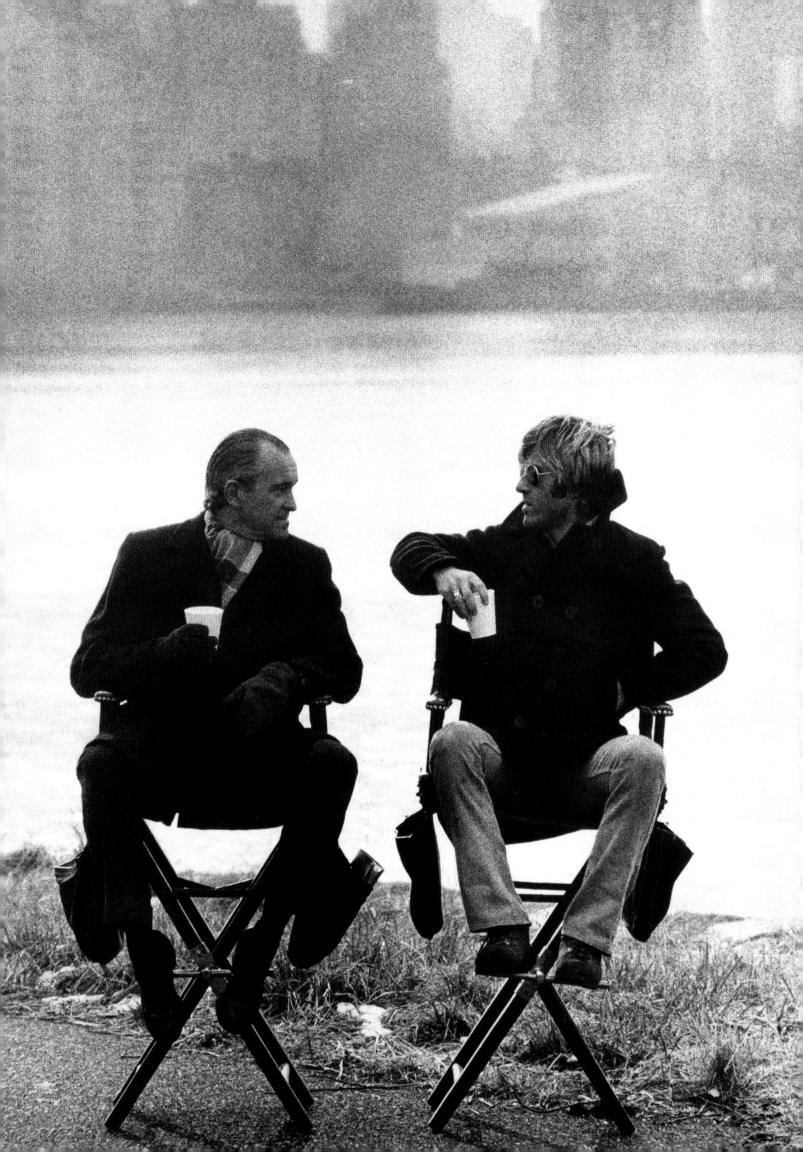

I call this picture 'The Morning After'. I wanted to get a different kind of 'Oscar' picture – one to illustrate what the award meant to actors and actresses. Faye had won Best Actress for *Network* the previous night and I made her meet me at the Beverly Hills Hotel at 6.30 a.m. for this shoot. She hadn't slept and the implications of a watershed event in her career were only just beginning to dawn on her

FAYE DUNAWAY
Los Angeles, 1976

134

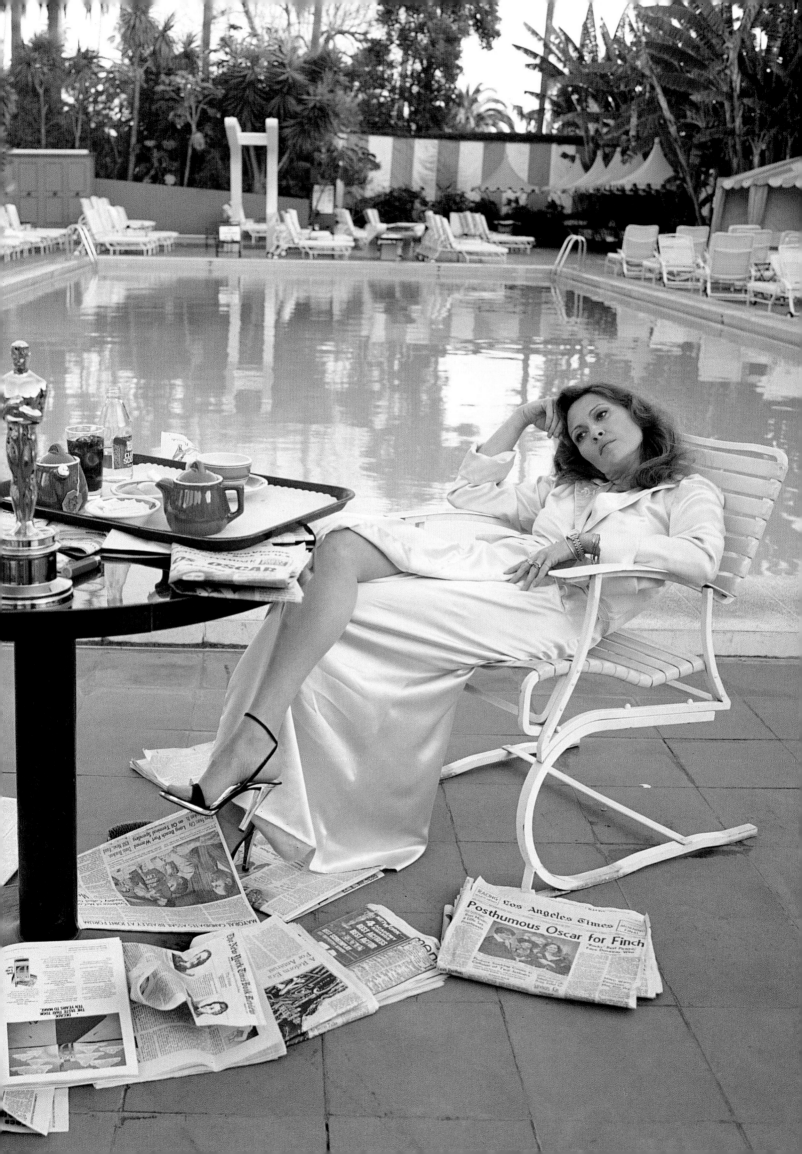

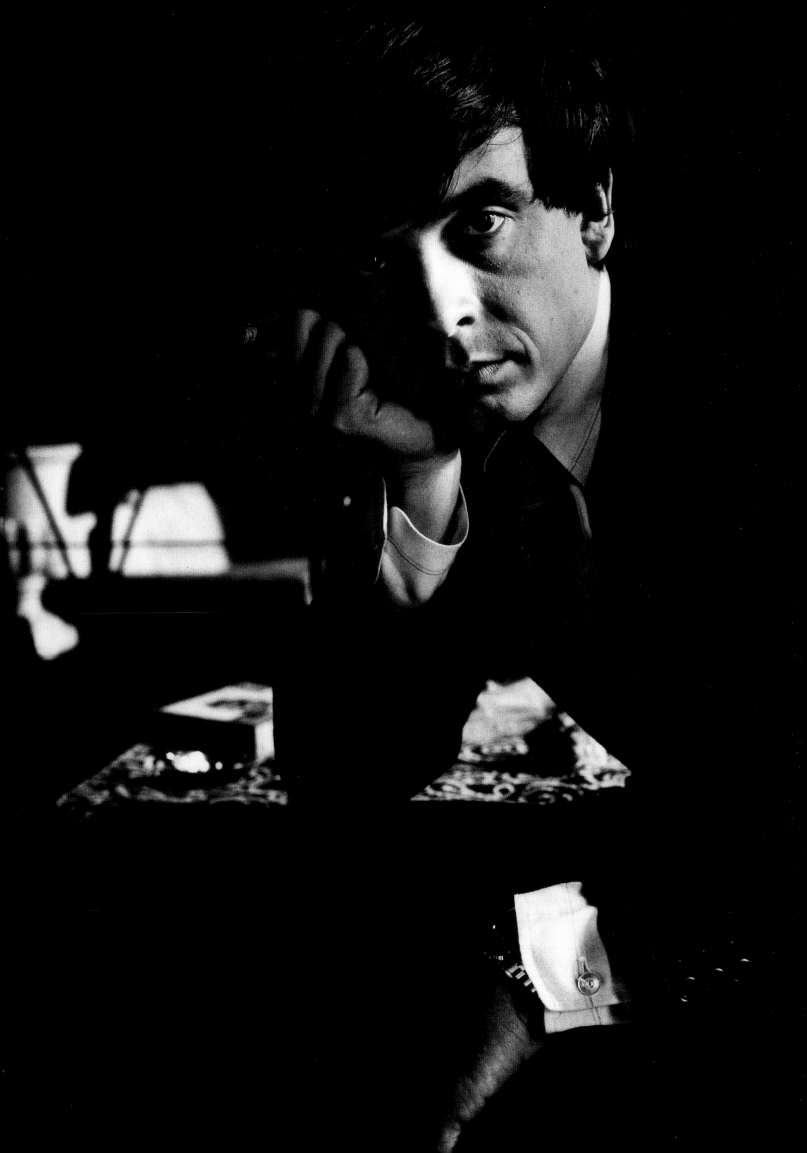

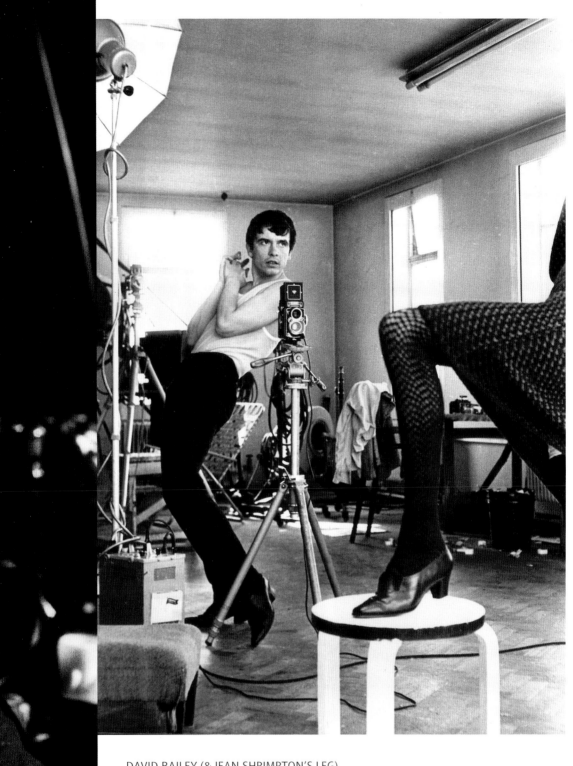

DAVID BAILEY (& JEAN SHRIMPTON'S LEG)
London, 1965

*left,*
DAVID BAILEY
London, 1965

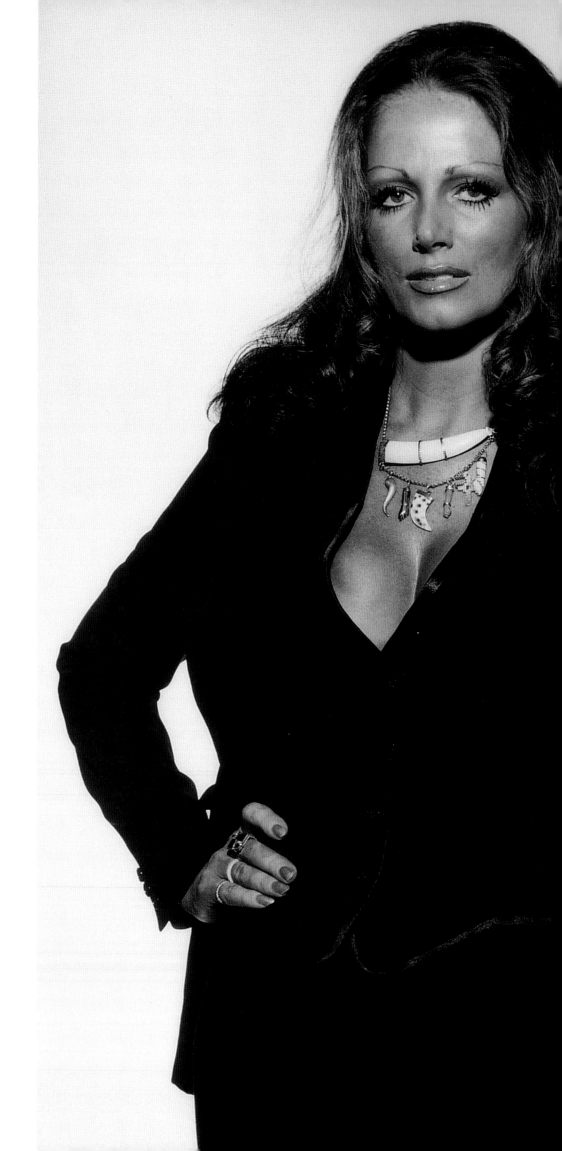

JACKIE & JOAN COLLINS
London, 1974

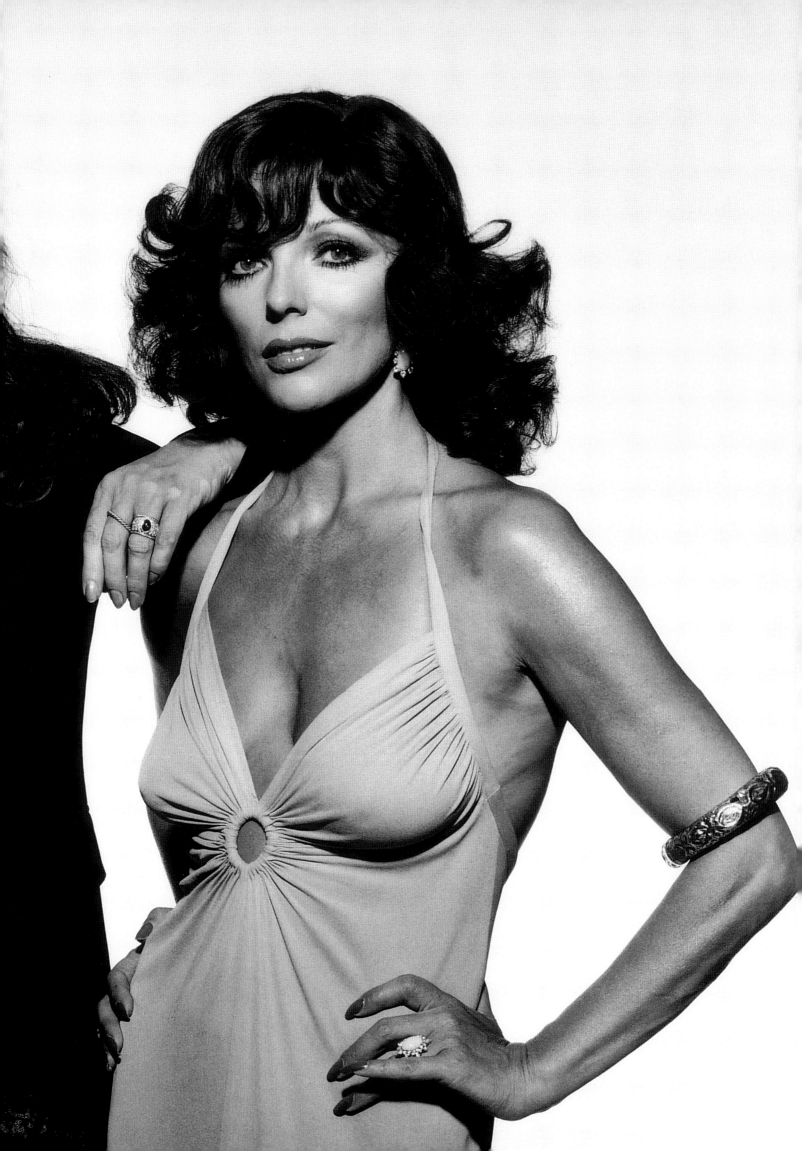

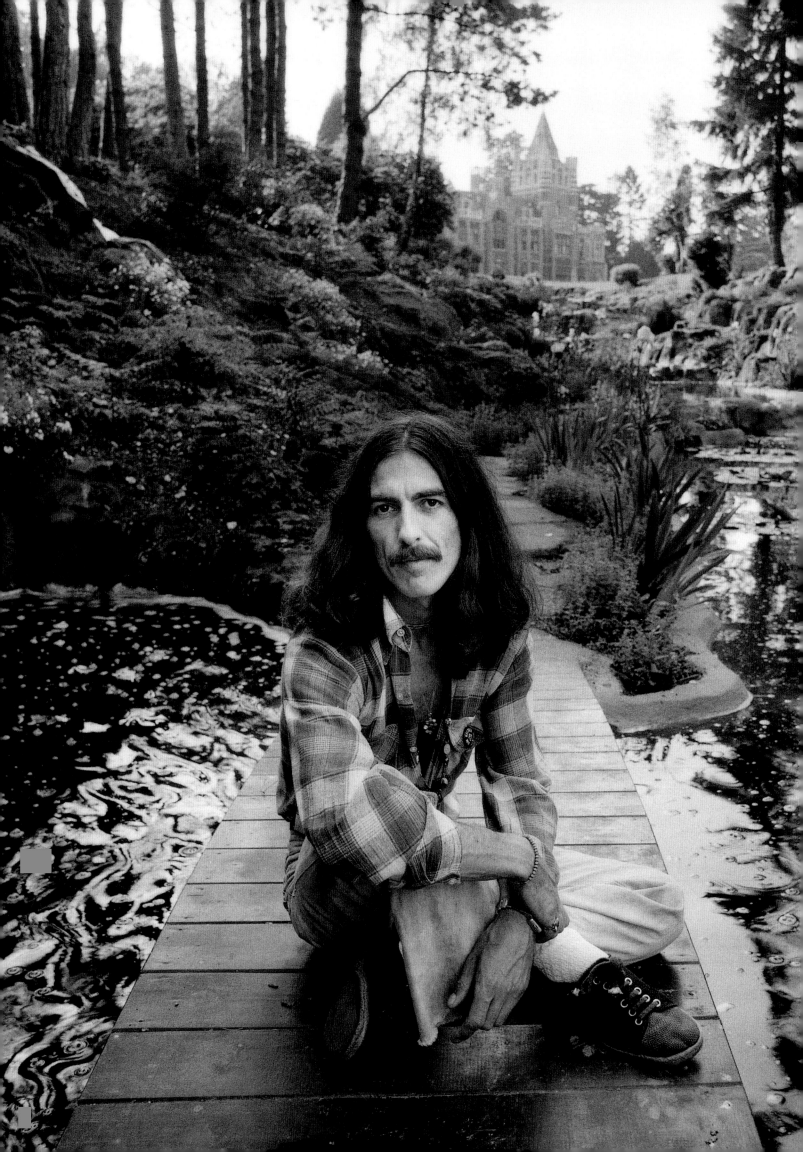

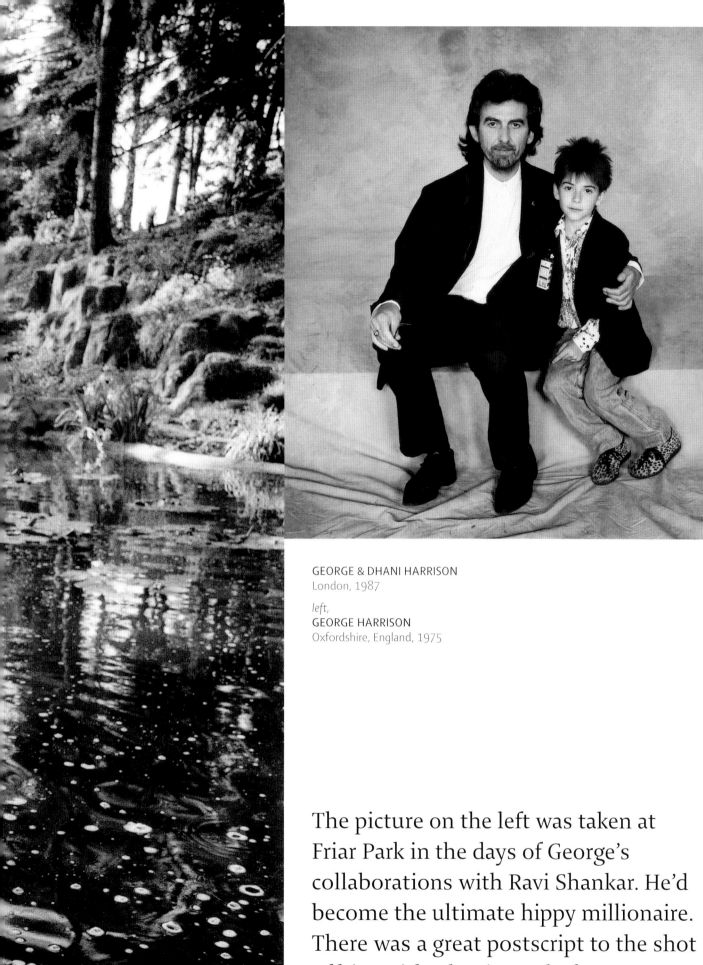

GEORGE & DHANI HARRISON
London, 1987

*left,*
GEORGE HARRISON
Oxfordshire, England, 1975

The picture on the left was taken at Friar Park in the days of George's collaborations with Ravi Shankar. He'd become the ultimate hippy millionaire. There was a great postscript to the shot of him with Dhani. Just before George died he wrote me a warm letter to say that it was the best picture he had of his son. That meant a lot to me

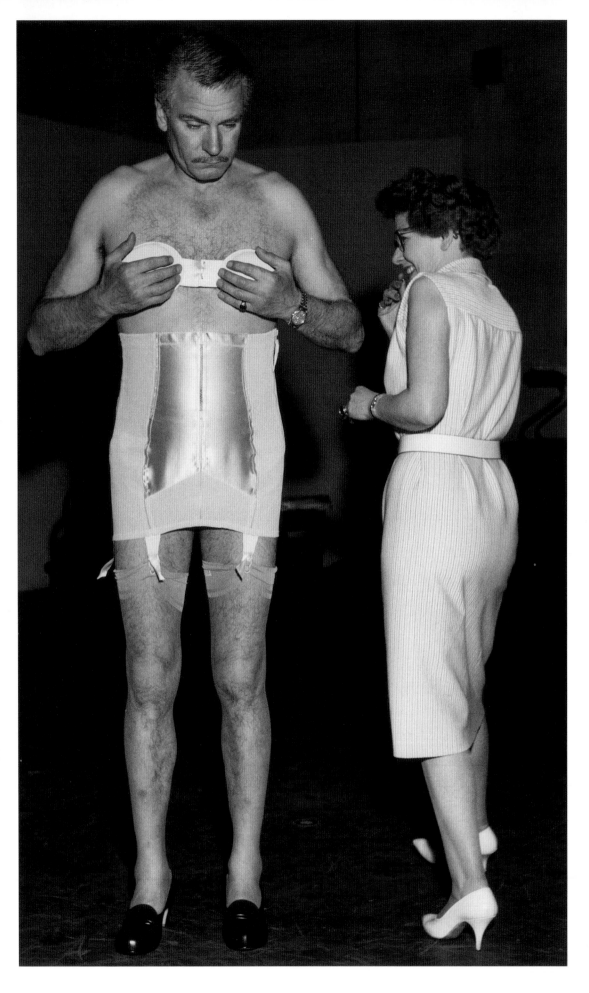

SIR LAURENCE OLIVIER
London, 1962

*right,*
PETER SELLERS & LORD SNOWDON
Beverly Hills, 1974

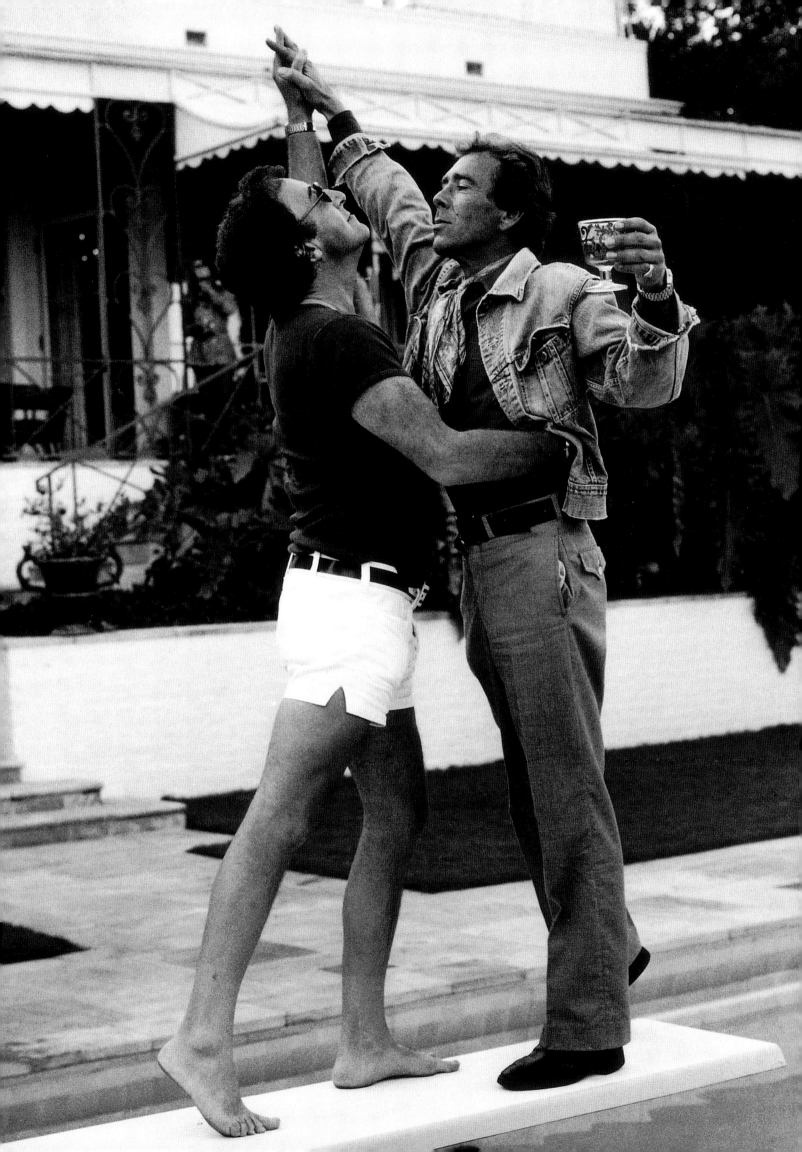

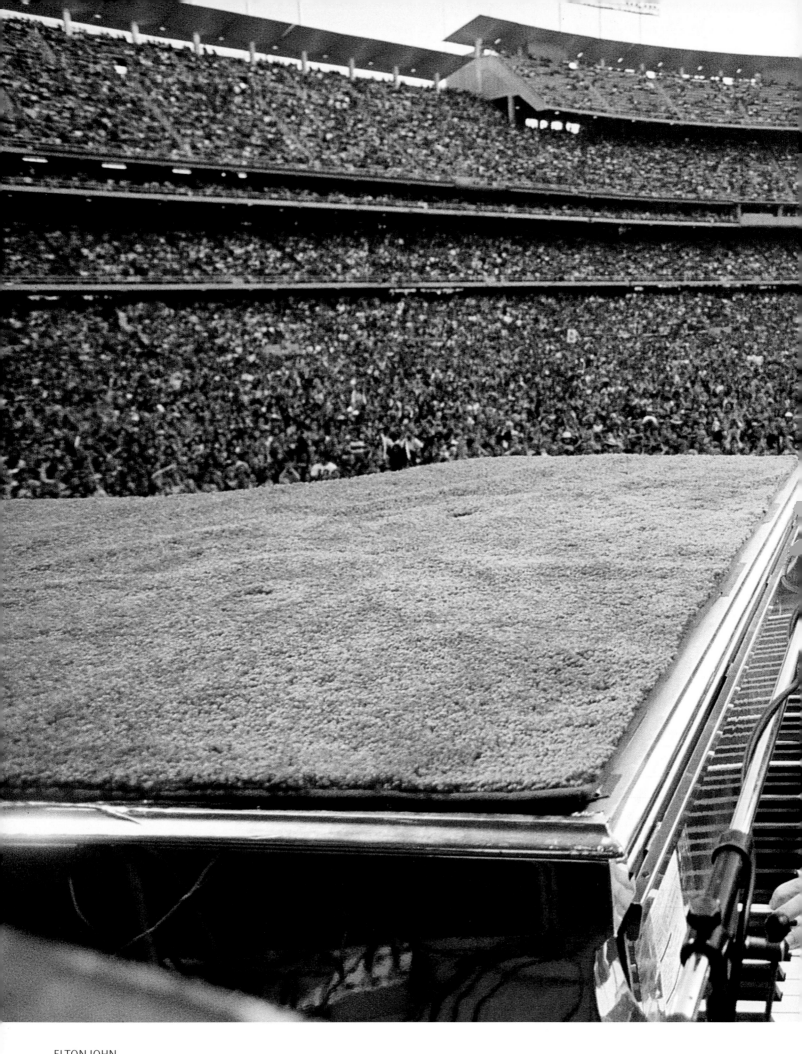

**ELTON JOHN**
Dodger Stadium, Los Angeles, 1975

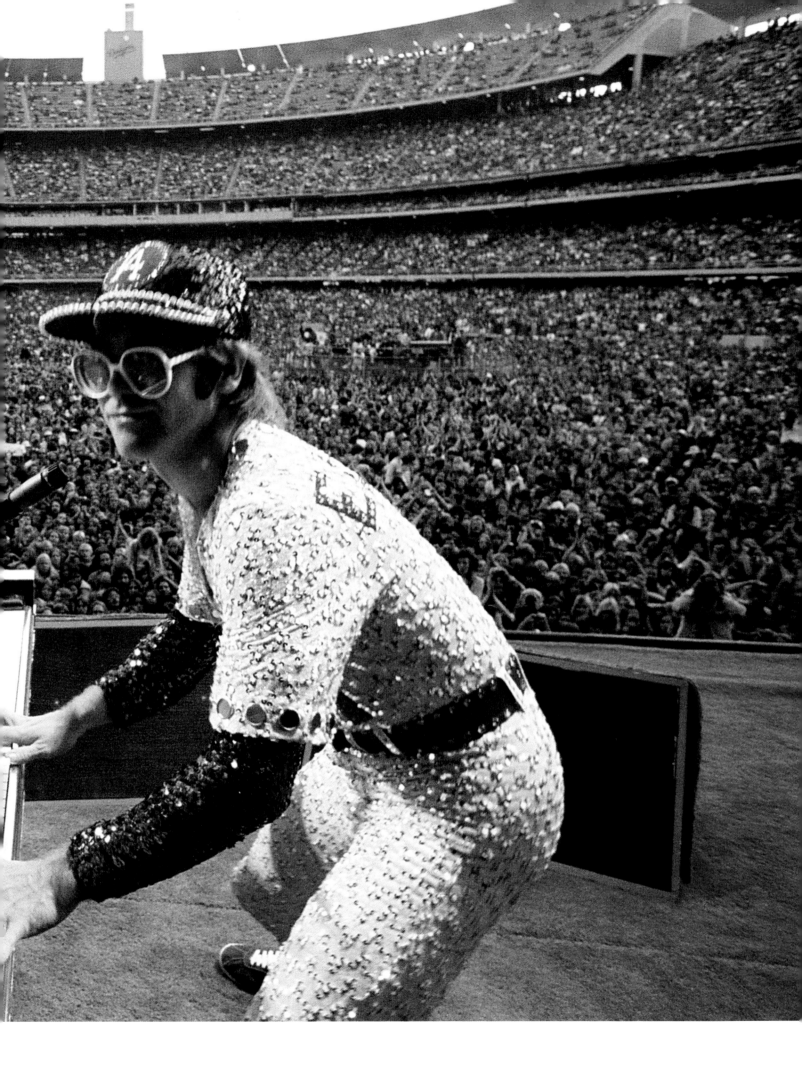

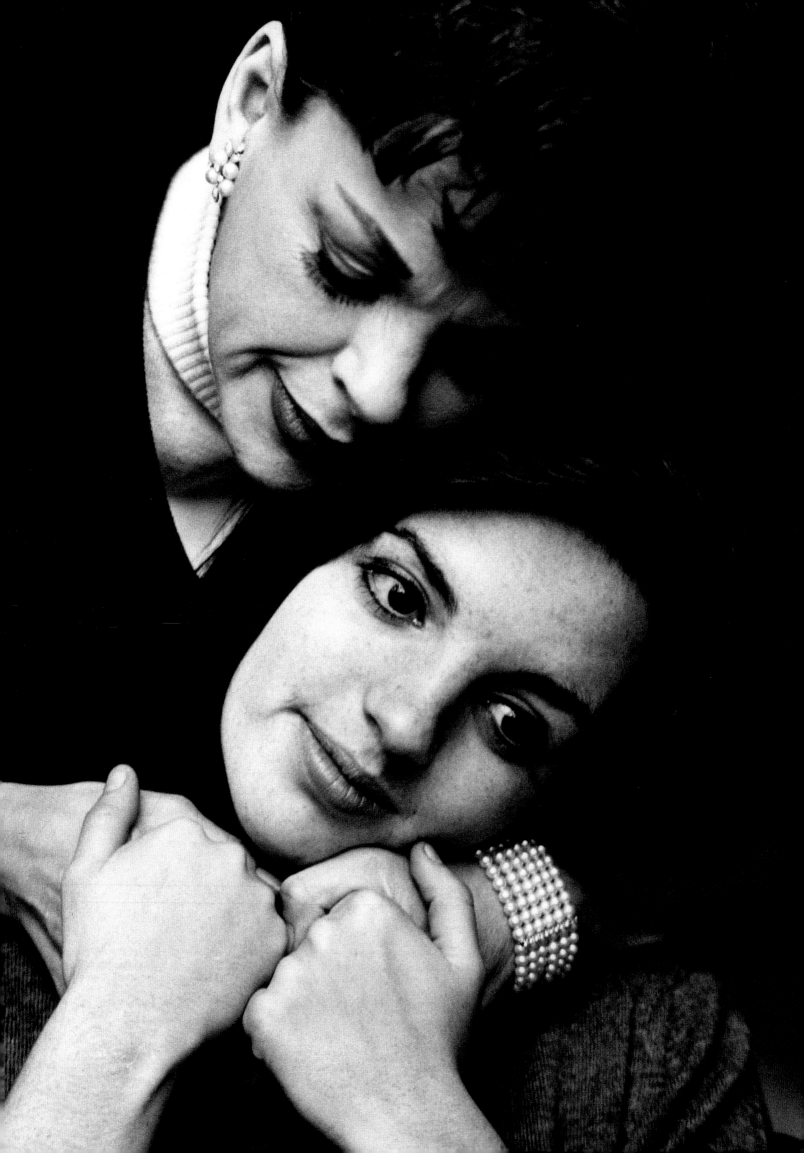

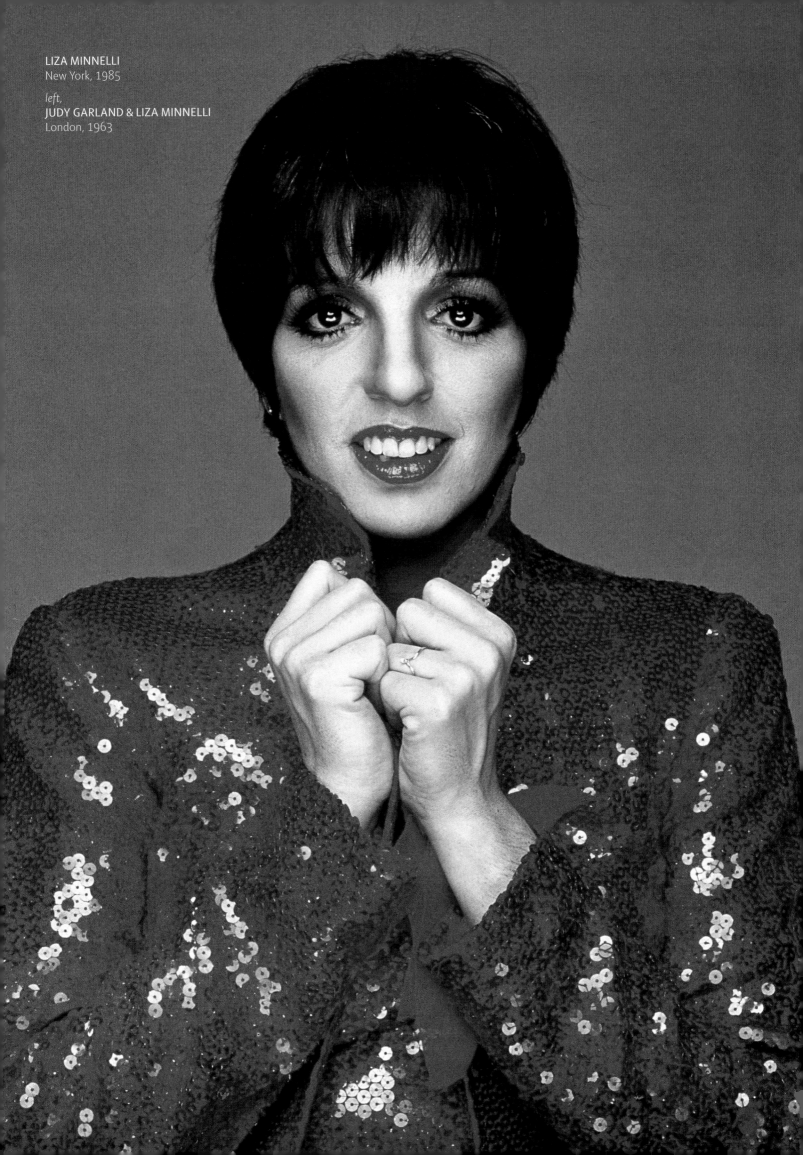

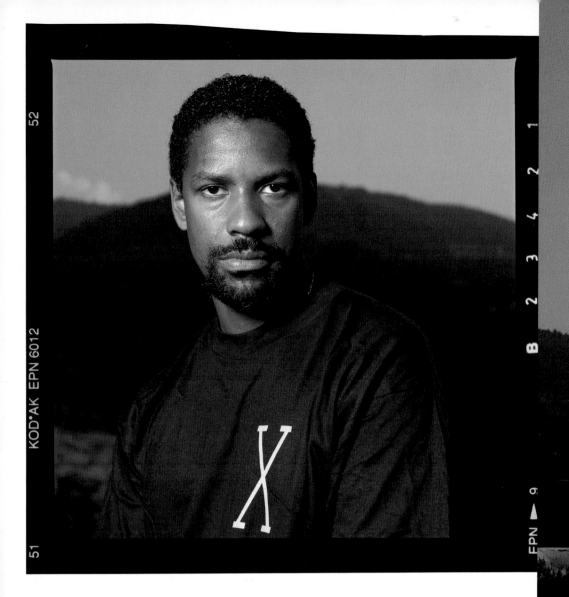

DENZEL WASHINGTON
Tuscany, 1993

*right,*
SPIKE LEE
Tuscany, 1993

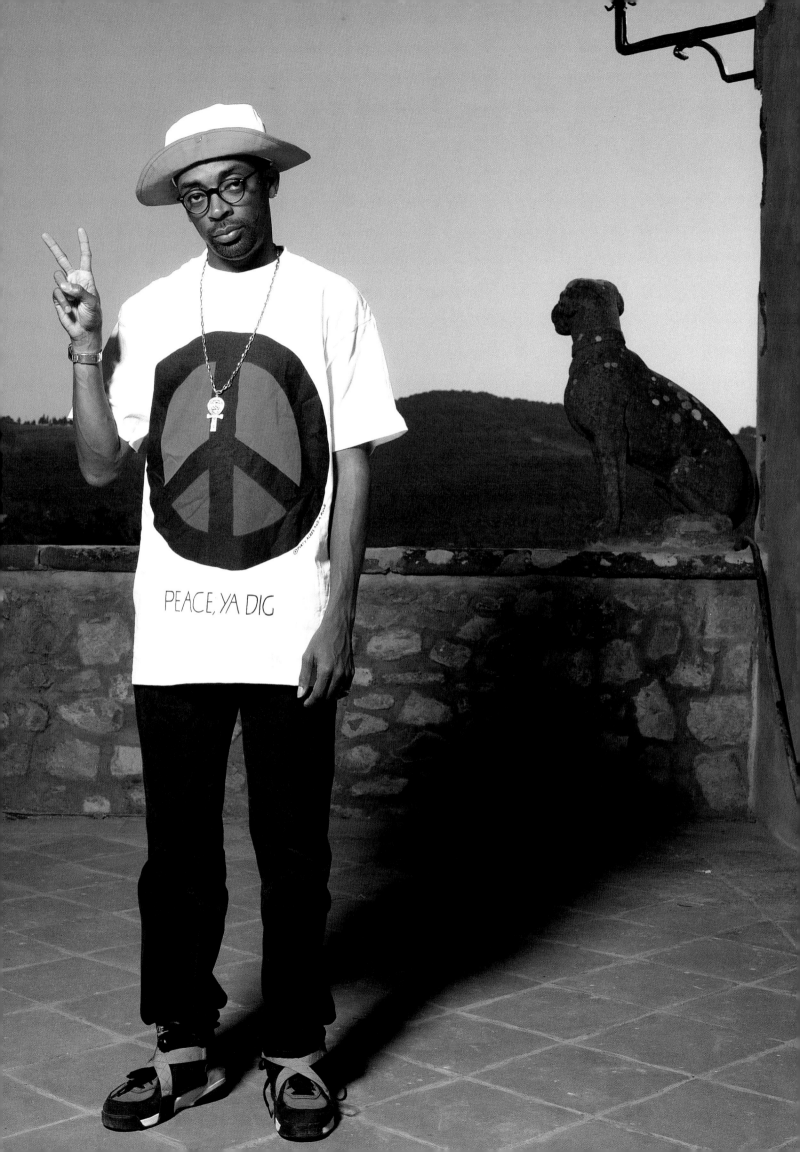

WALTER MATTHAU, JACK LEMMON & BILLY WILDER
Los Angeles, 1986

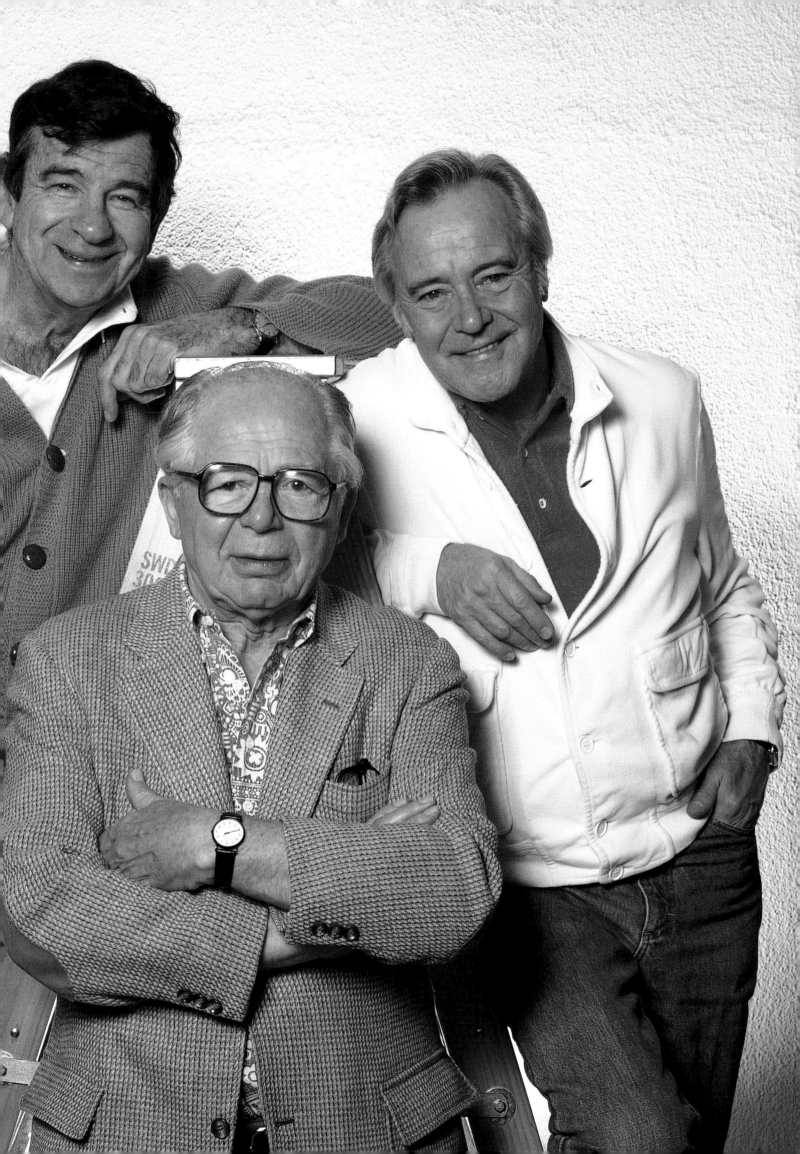

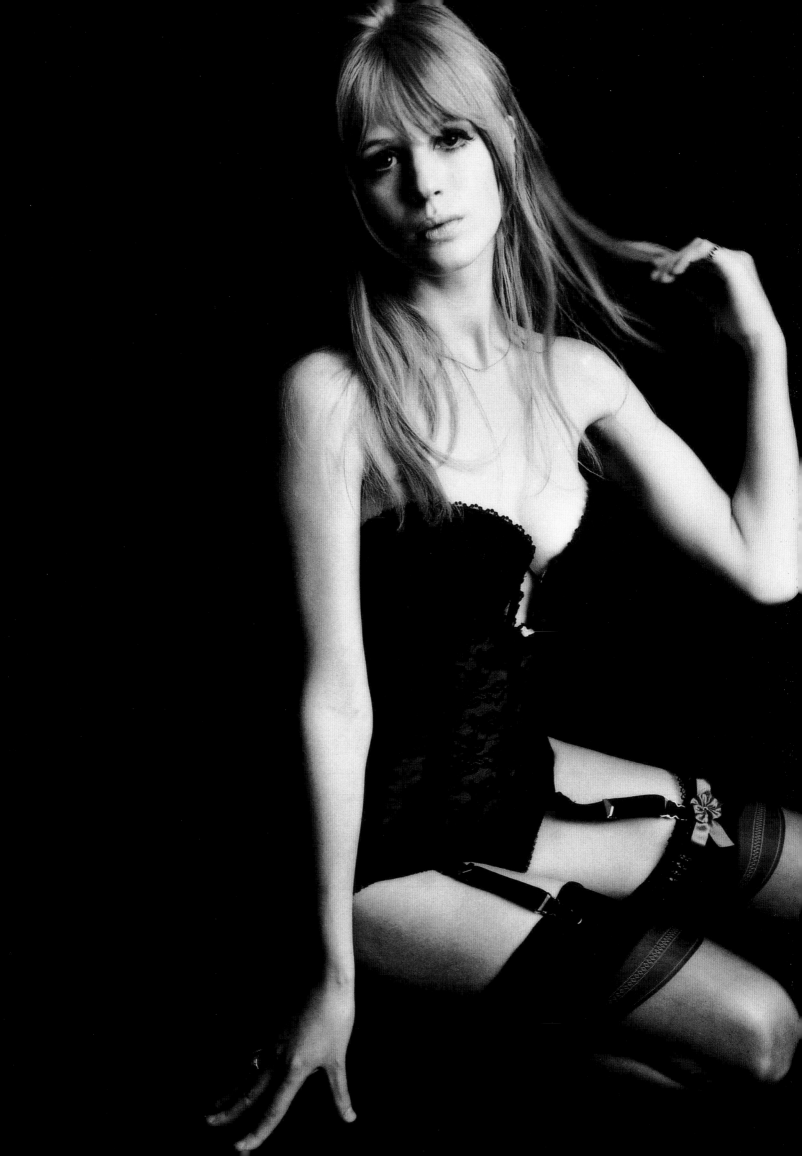

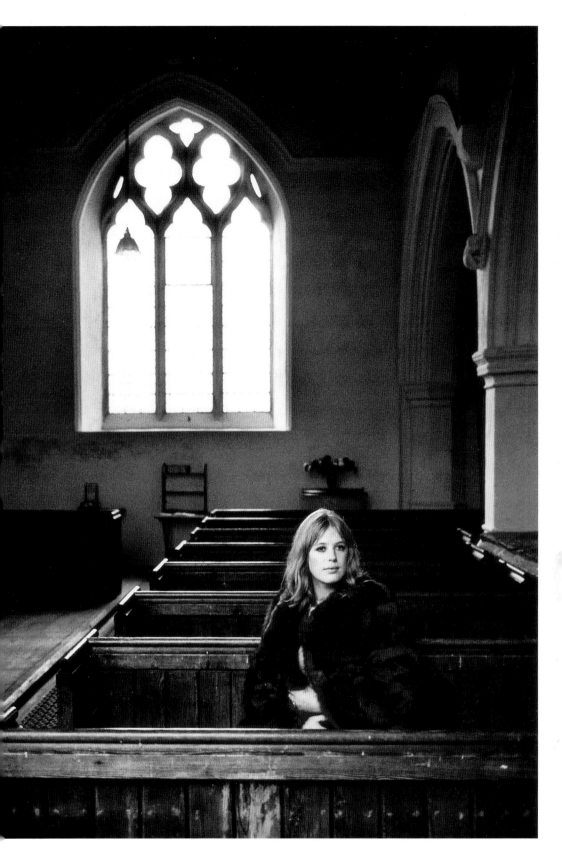

MARIANNF FAITHFULL
Oxfordshire, England, 1979

*left,*
MARIANNE FAITHFULL
London, 1964

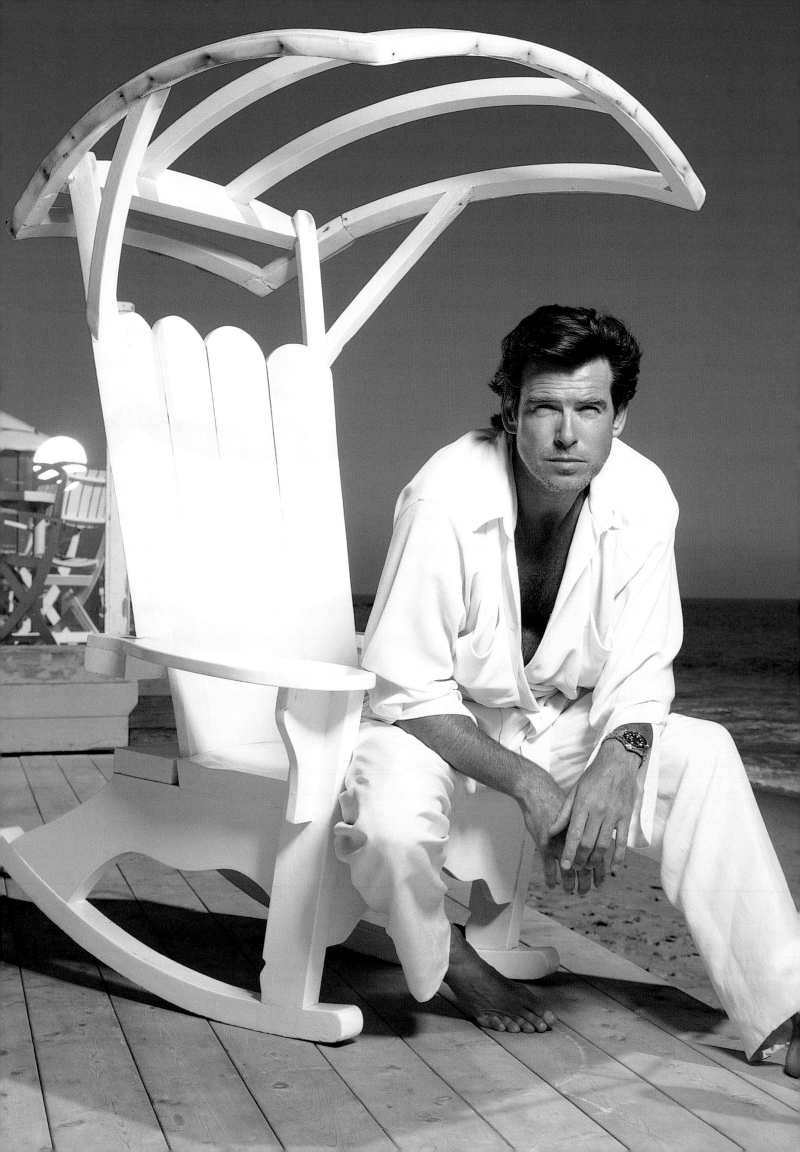

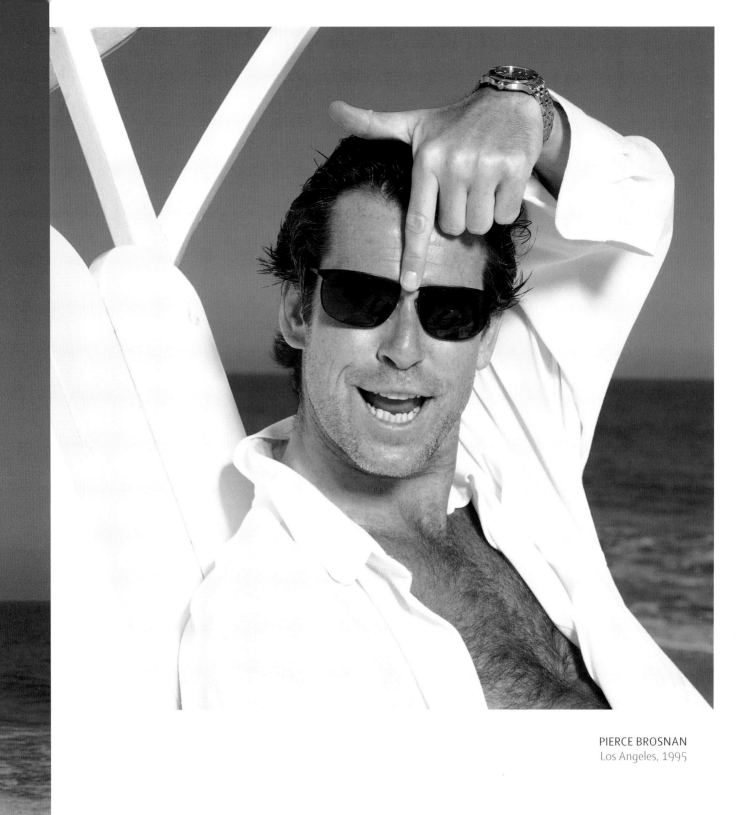

PIERCE BROSNAN
Los Angeles, 1995

155

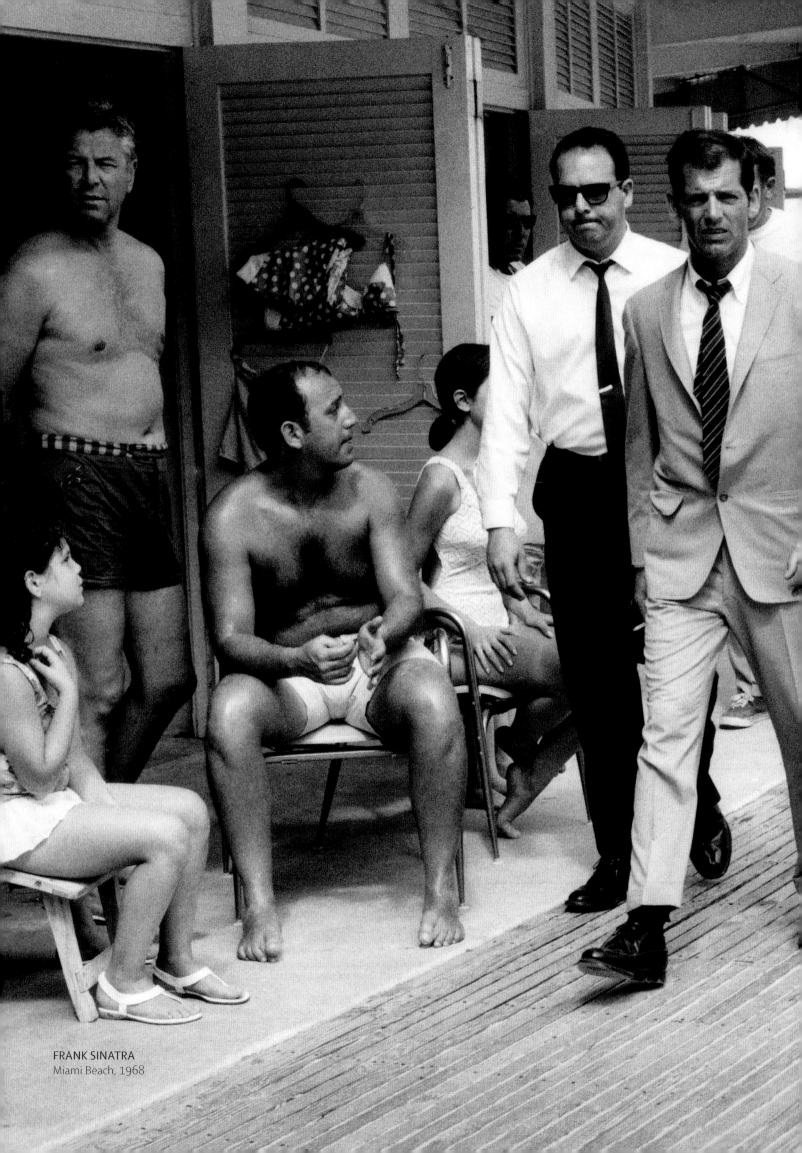

FRANK SINATRA
Miami Beach, 1968

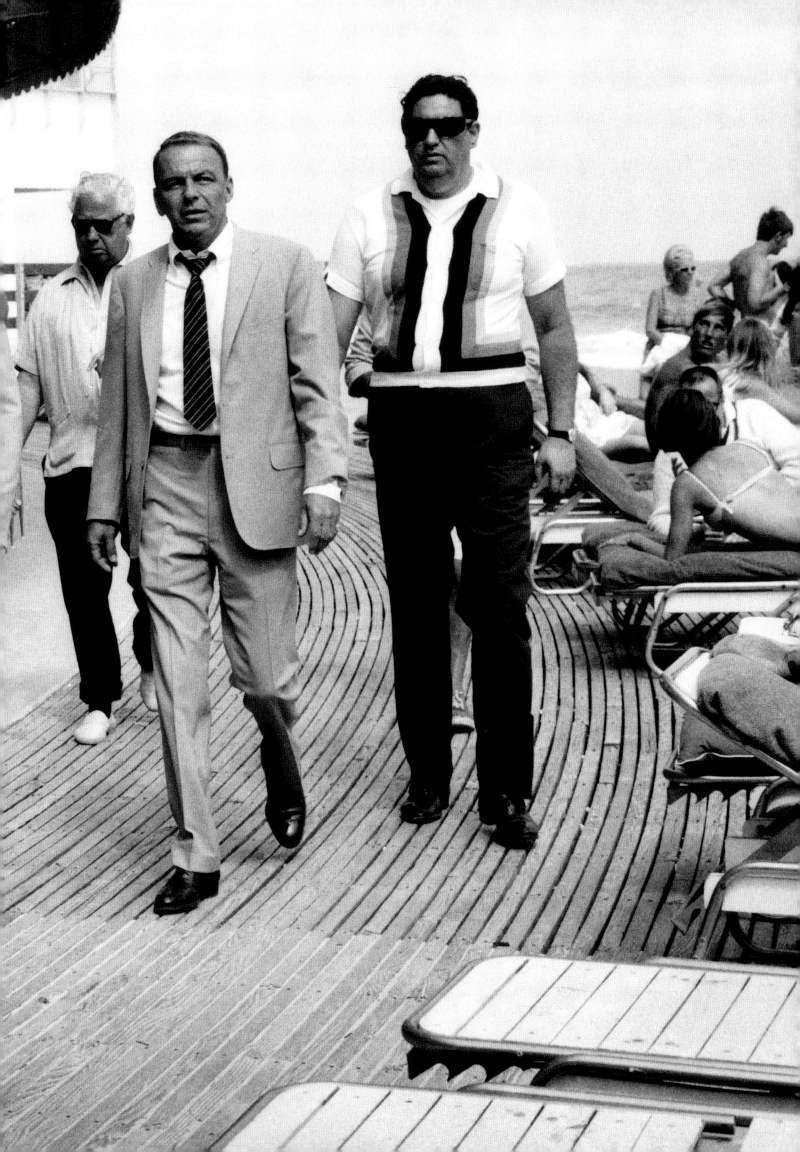

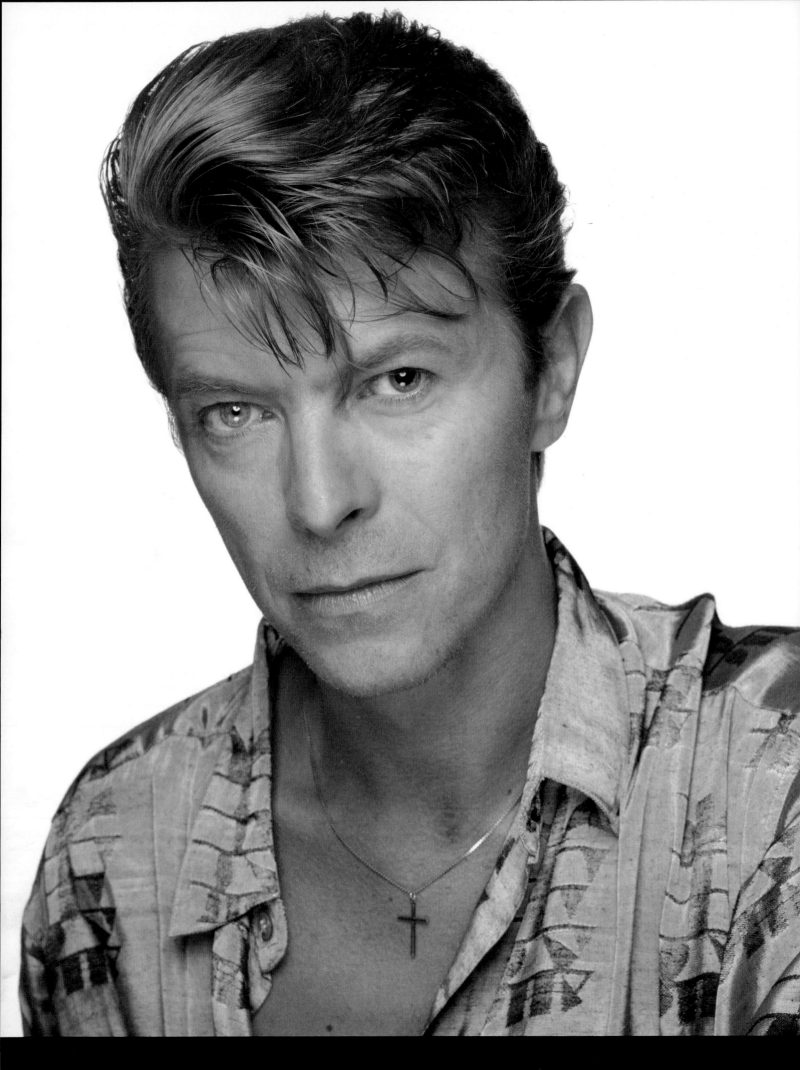

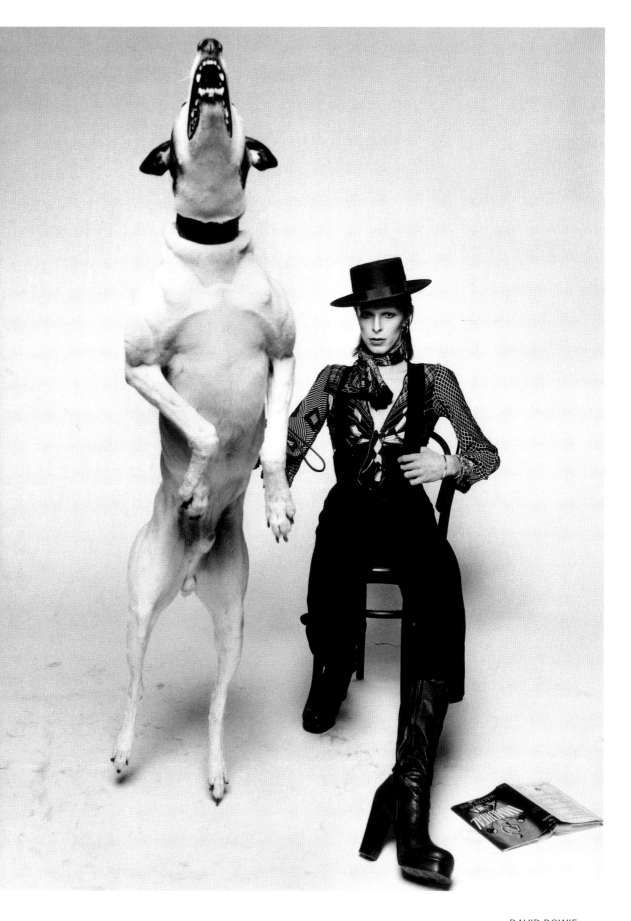

DAVID BOWIE
London, 1975

*left,*
DAVID BOWIE
London, 1992

159

I took a lot of publicity shots of Mae during the filming of *Myra Breckinridge* and I'd send the negs over to her every night. I later found out that Mae would examine her face in each photo with a magnifying glass, to check for any blemishes I might have caught on film. She'd then select the best images for herself and return the second-rate ones to me

MAE WEST
Hollywood, 1970

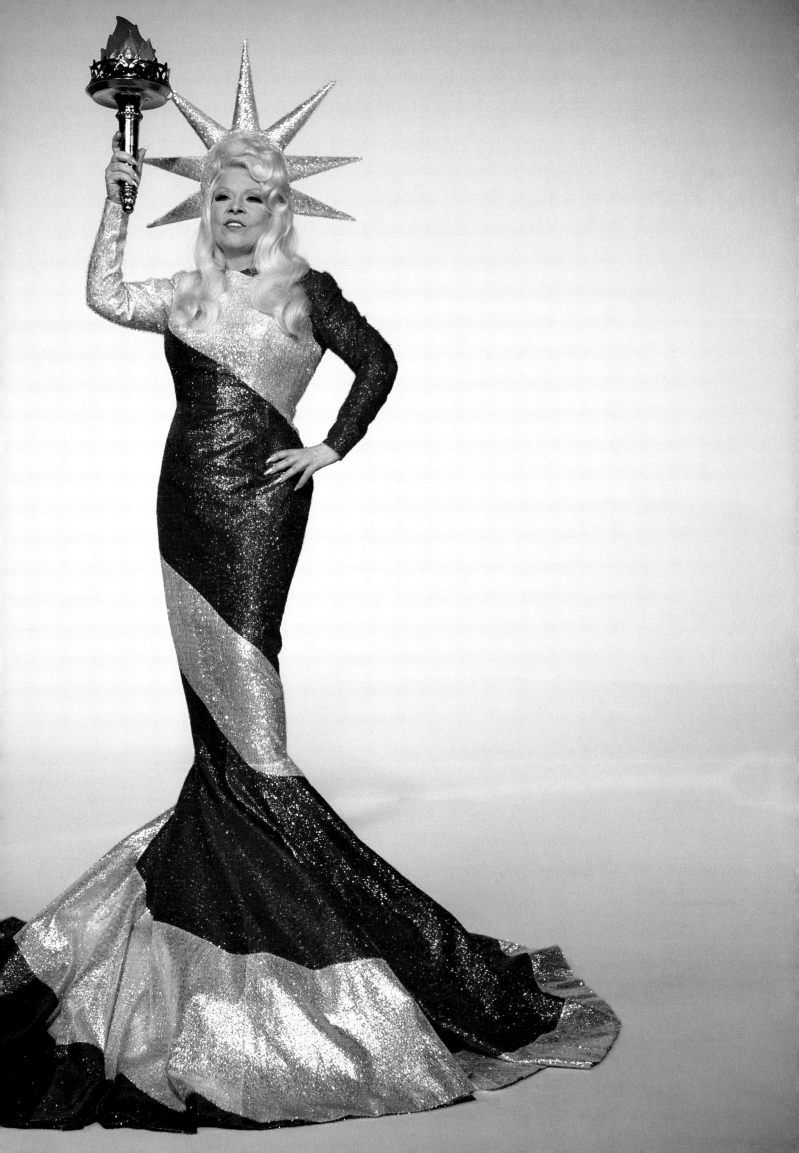

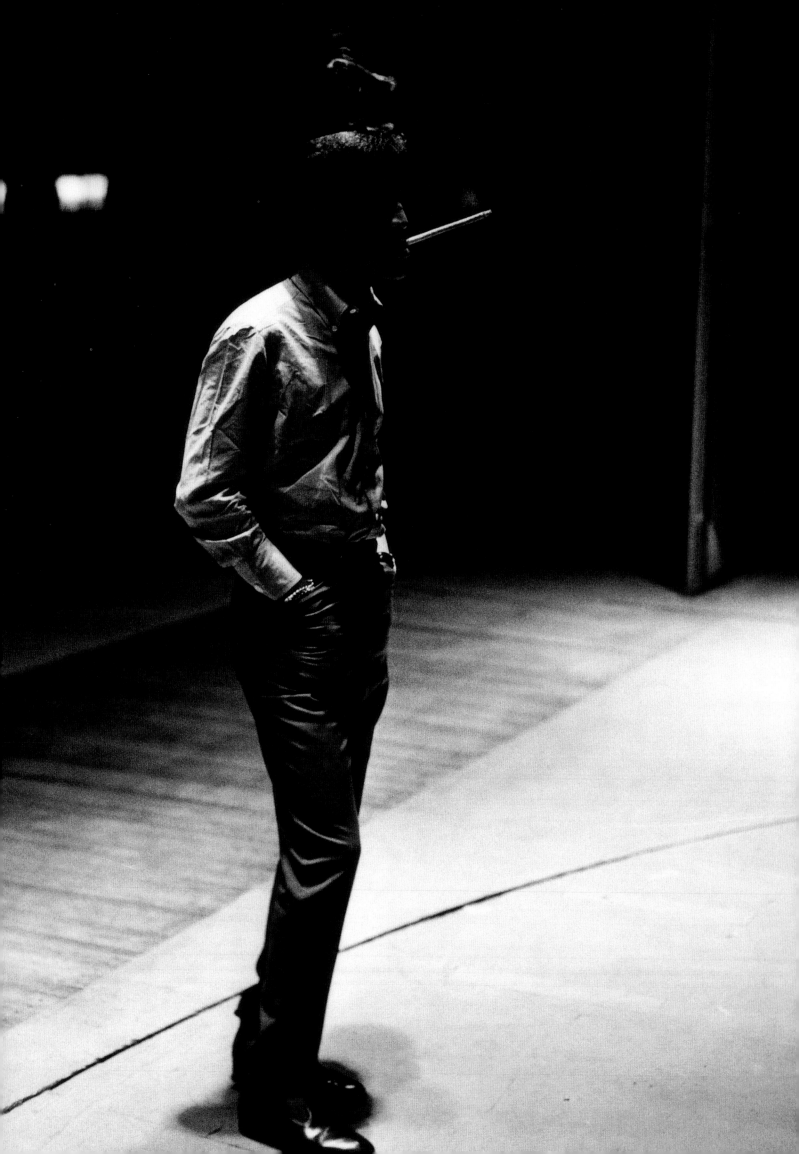

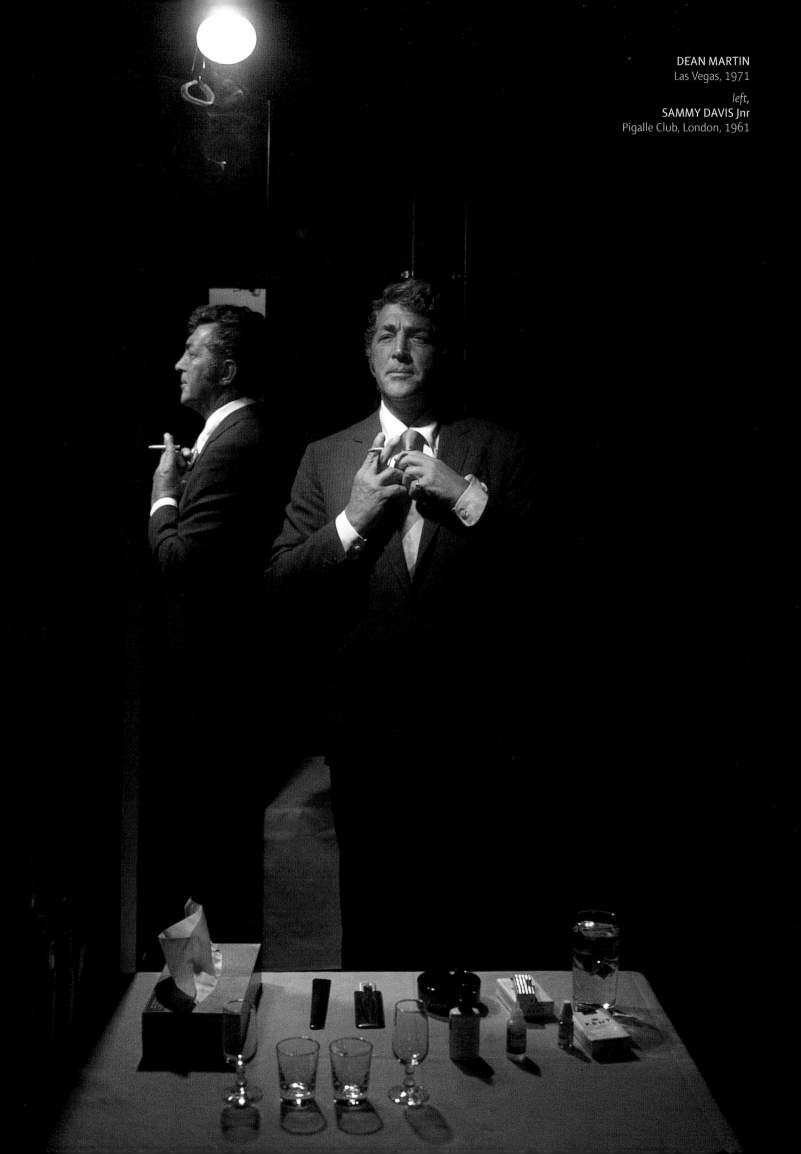

**DEAN MARTIN**
Las Vegas, 1971

*left*,
**SAMMY DAVIS** Jnr
Pigalle Club, London, 1961

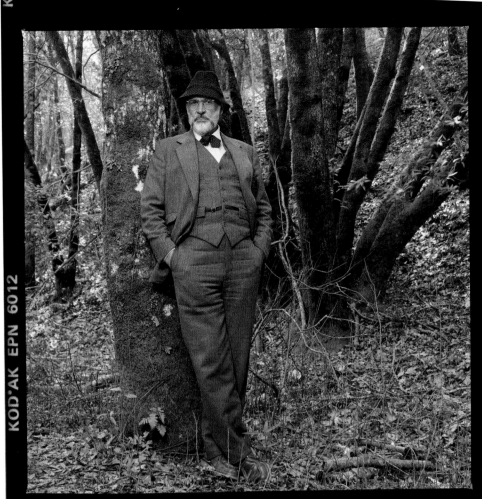

**SEAN CONNERY**
California, 1981

*right,*
**SEAN CONNERY**
Marbella, 1990

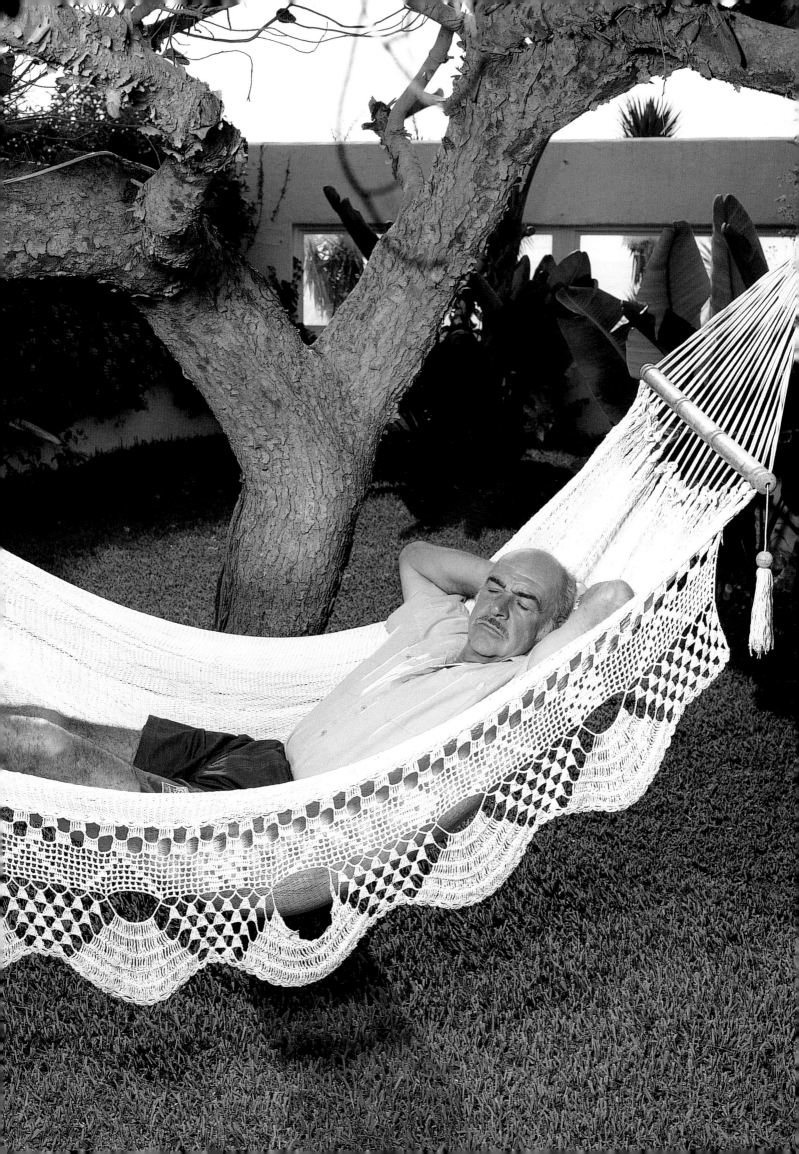

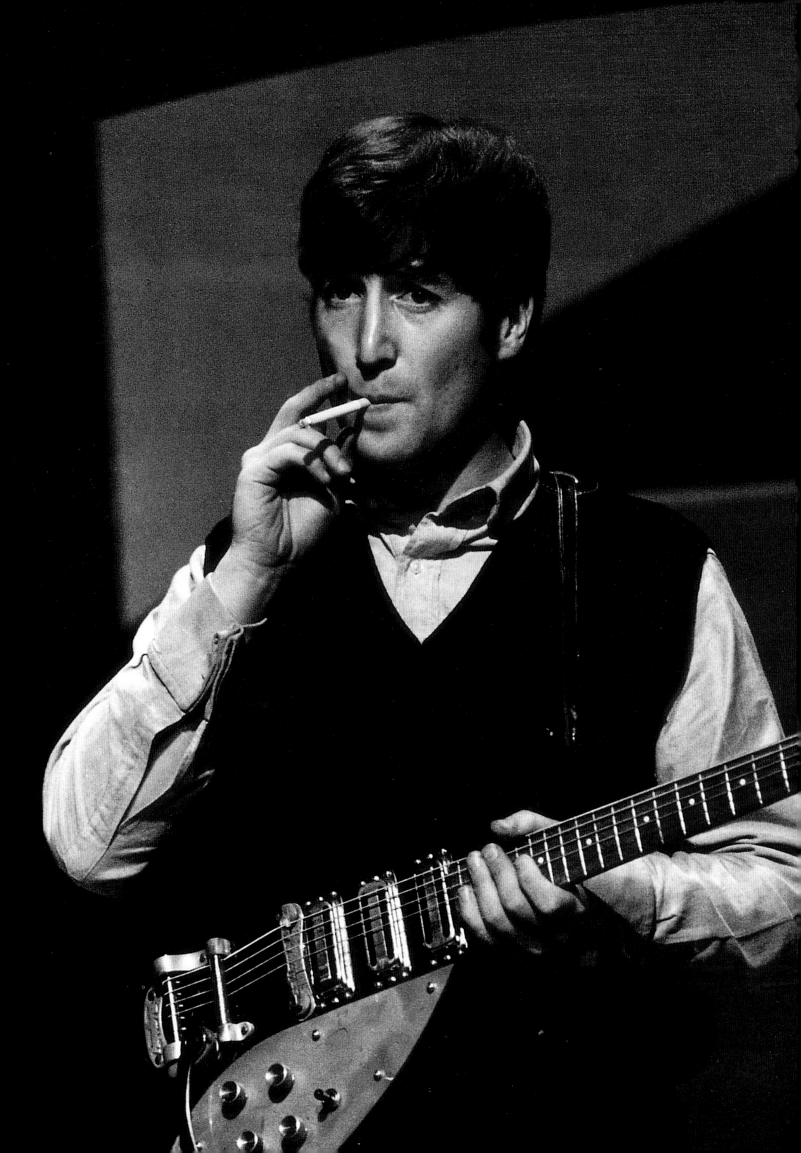

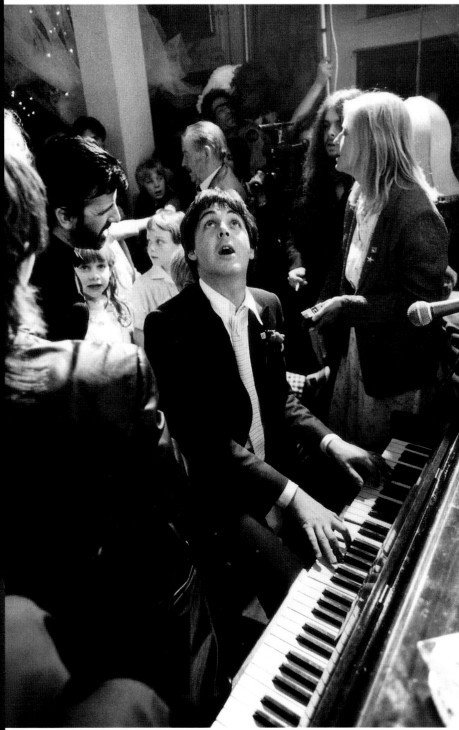

A fun shot of Paul rocking 'n' rolling at Ringo Starr's wedding party. It was Ringo's second marriage, to American model and actress Barbara Bach

PAUL McCARTNEY
London, 1981

*left,*
JOHN LENNON
Twickenham Film Studios, London, 1963

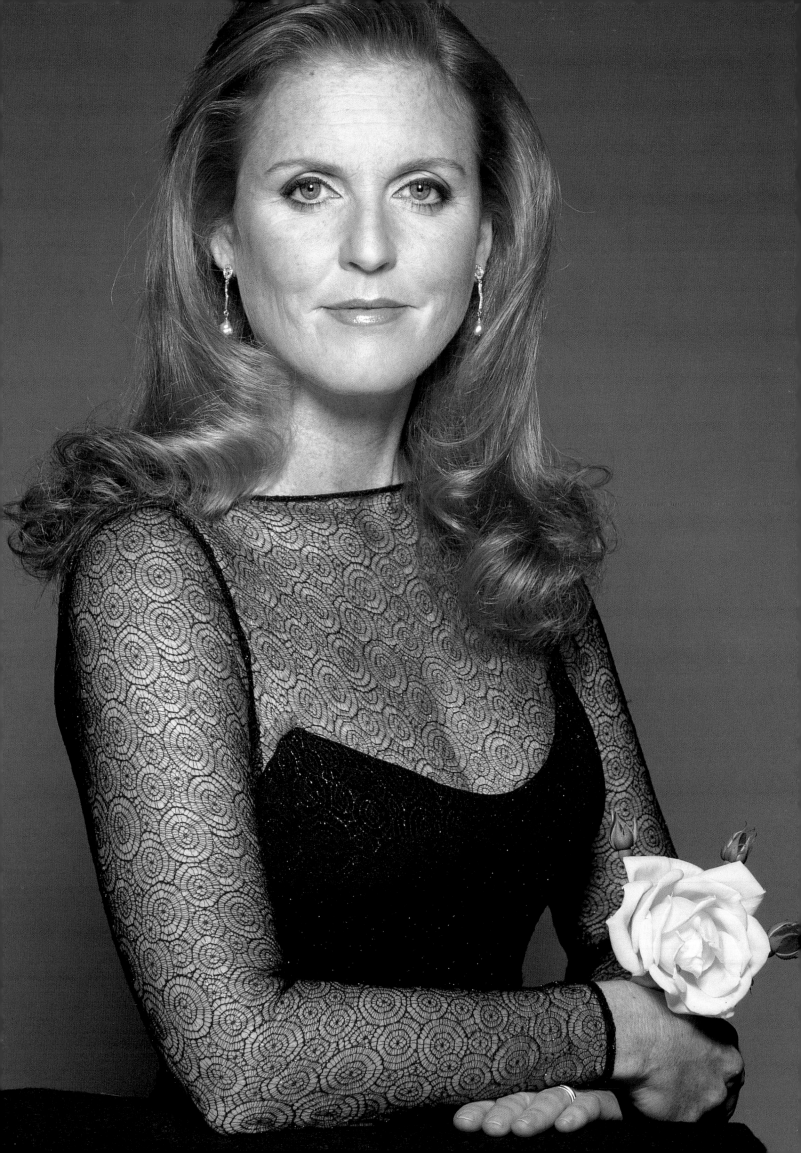

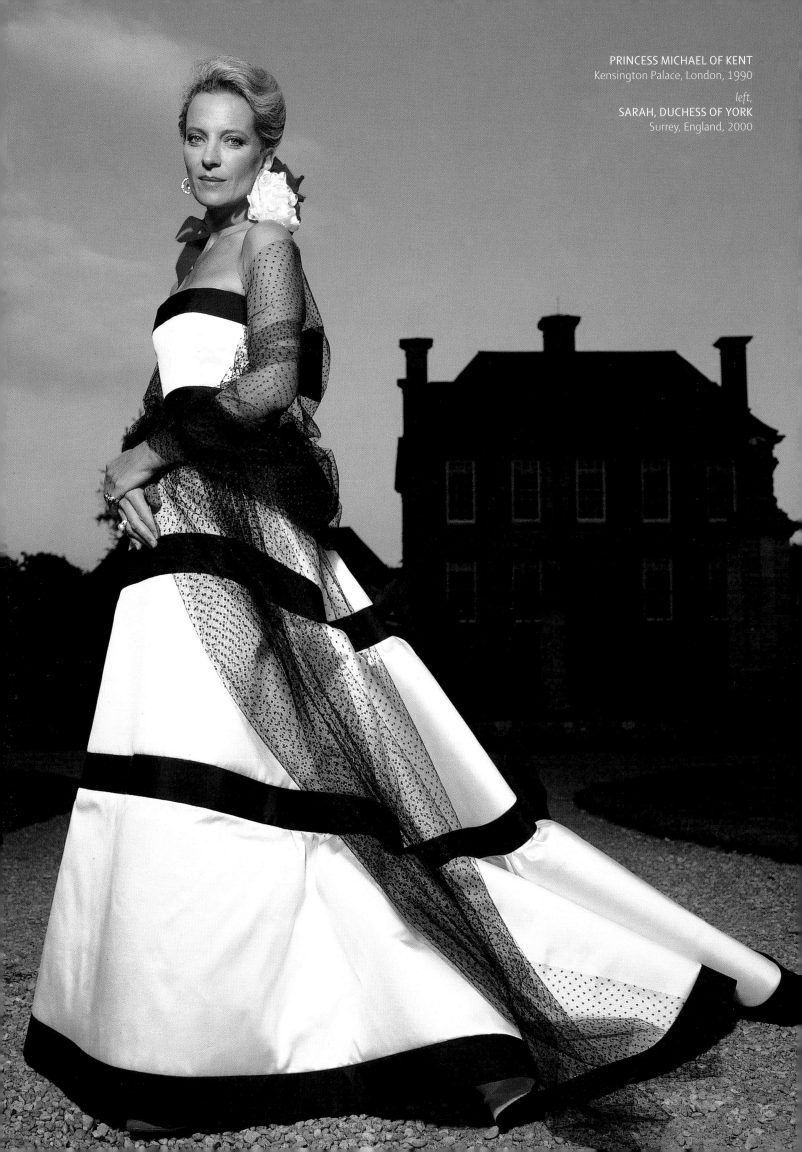

MARTIN AMIS
Highgate Cemetry, London, 1991

*right,*
SALMAN RUSHDIE
London, 1993

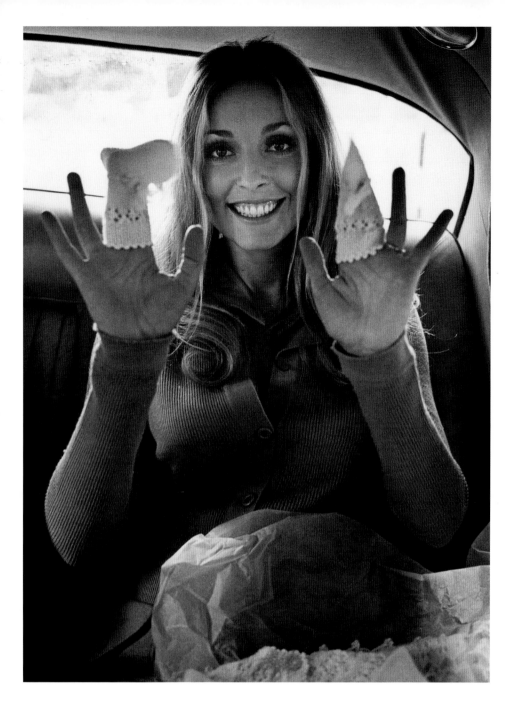

SHARON TATE
London, 1969

*right,*
JANIS JOPLIN
Hollywood, 1972

I took this shot of Sharon two days before her
murder. She was in London at the time; she flew
back to LA the following day. I remember her
asking me along to a small house party being
held at her home in the States, but I was
too busy to accept. The memory of the invitation
always makes me shiver now, with sadness
as much as horror

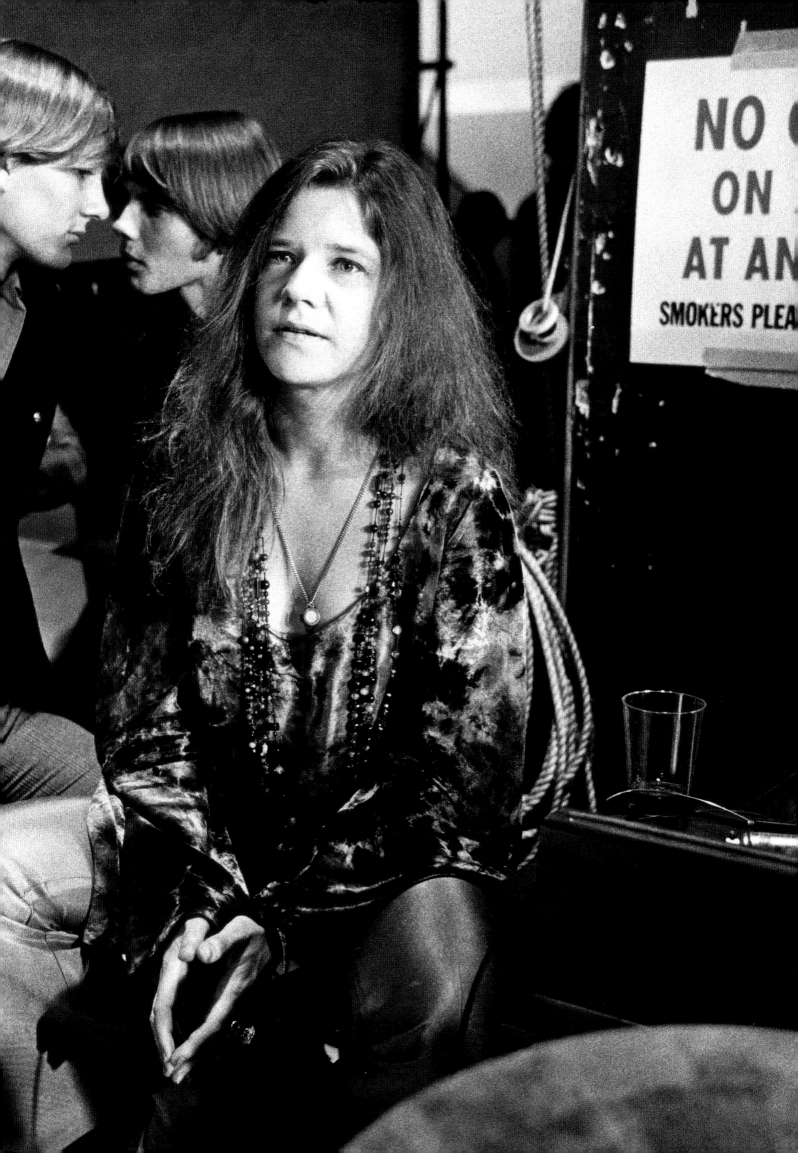

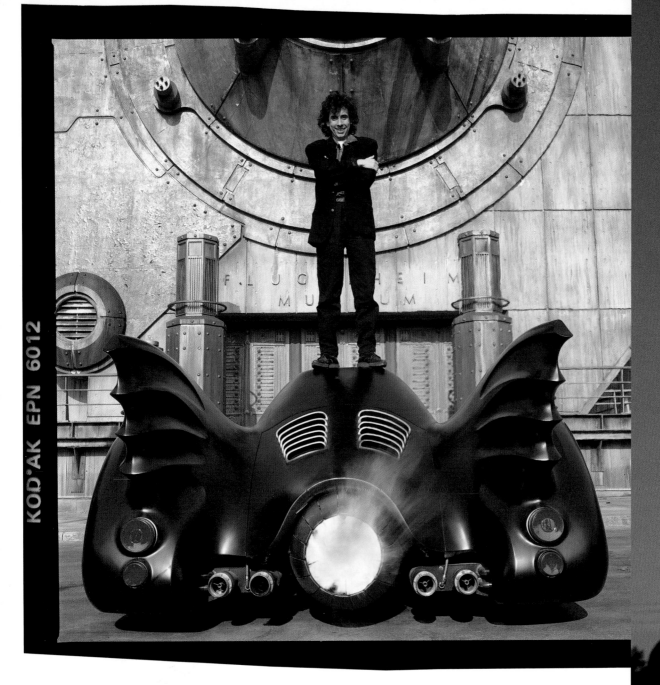

KOD'AK EPN 6012

**TIM BURTON**
Pinewood Studios, Buckinghamshire, England, 1989

*right,*
**MICKEY ROURKE**
Los Angeles, 1989

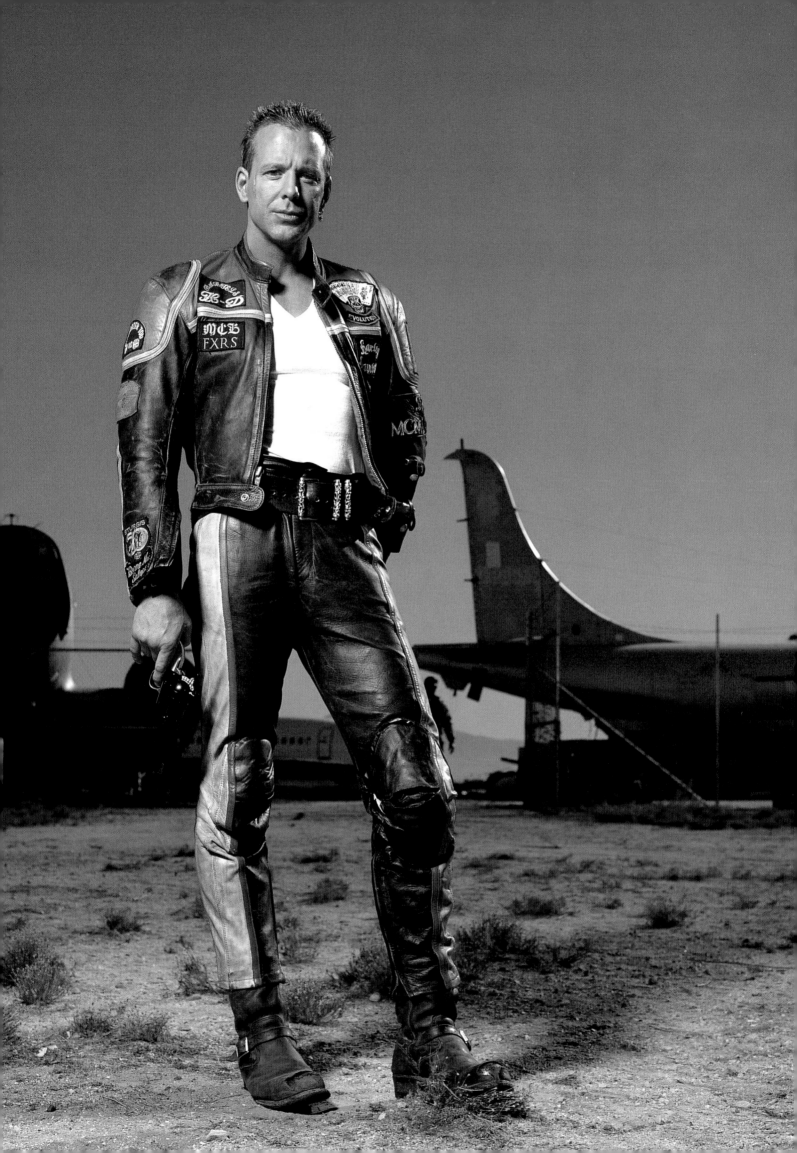

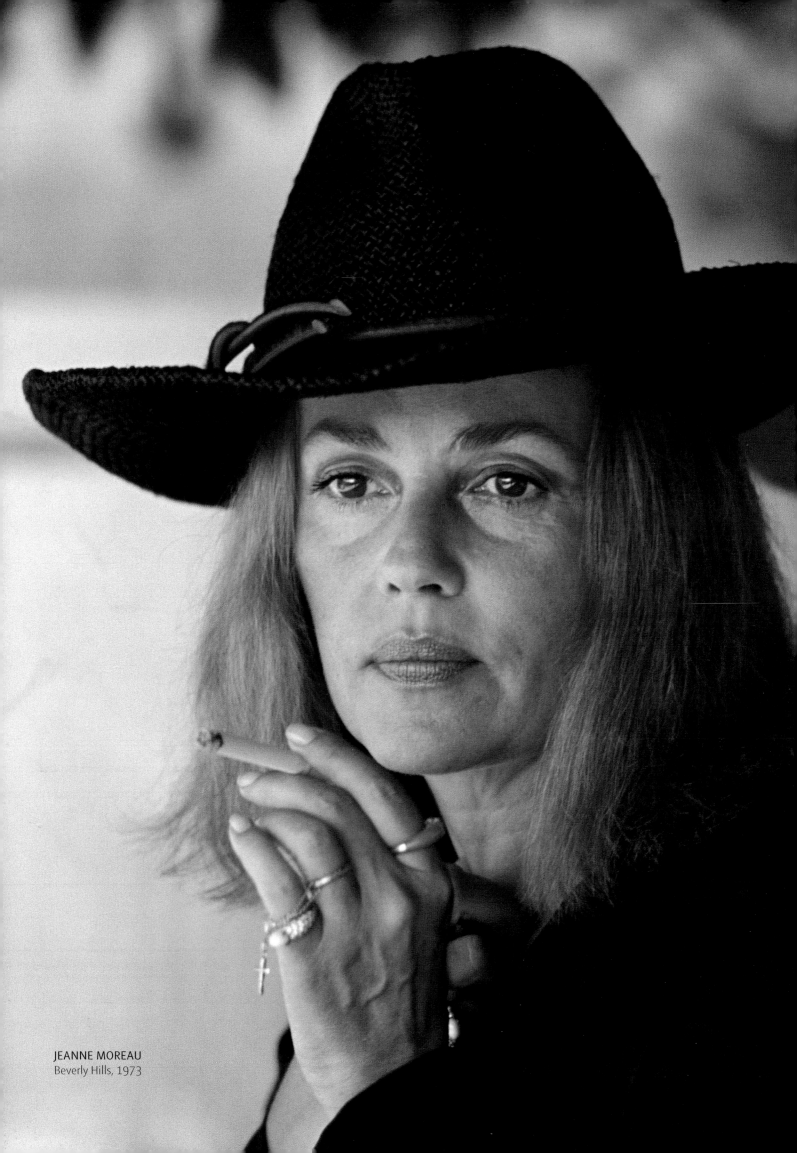

JEANNE MOREAU
Beverly Hills, 1973

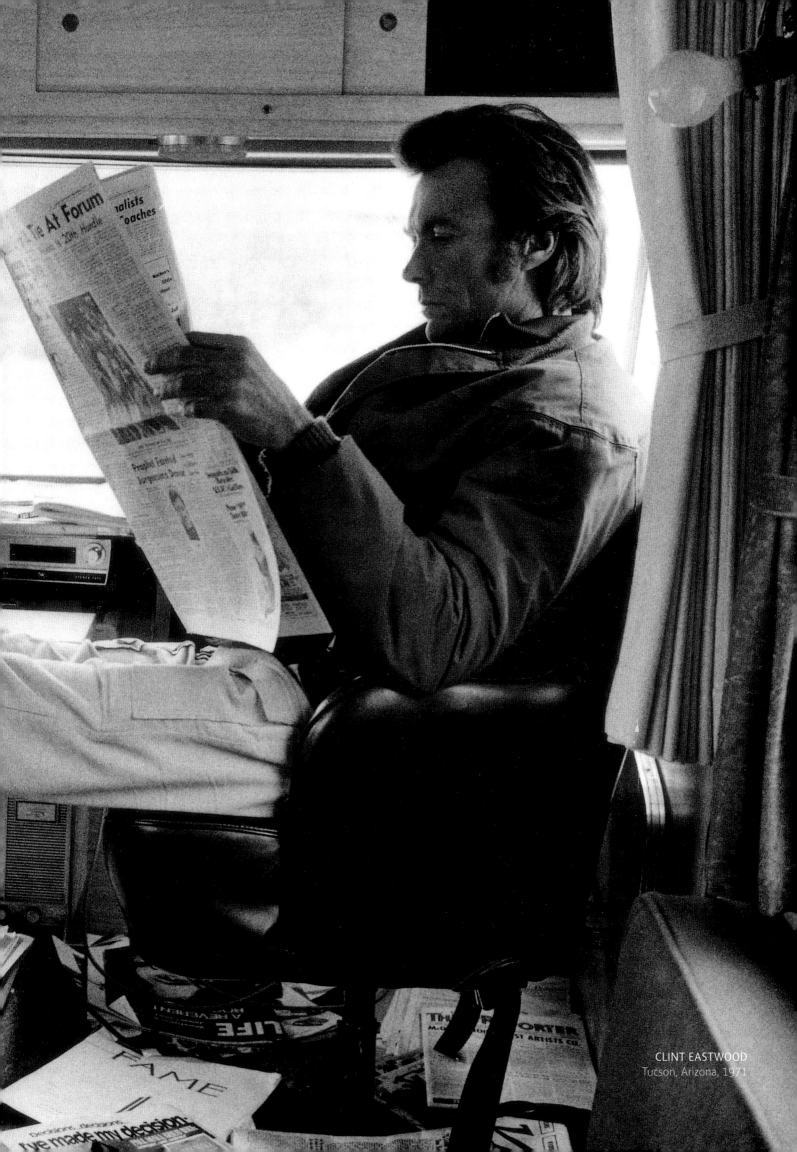

CLINT EASTWOOD
Tucson, Arizona, 1971

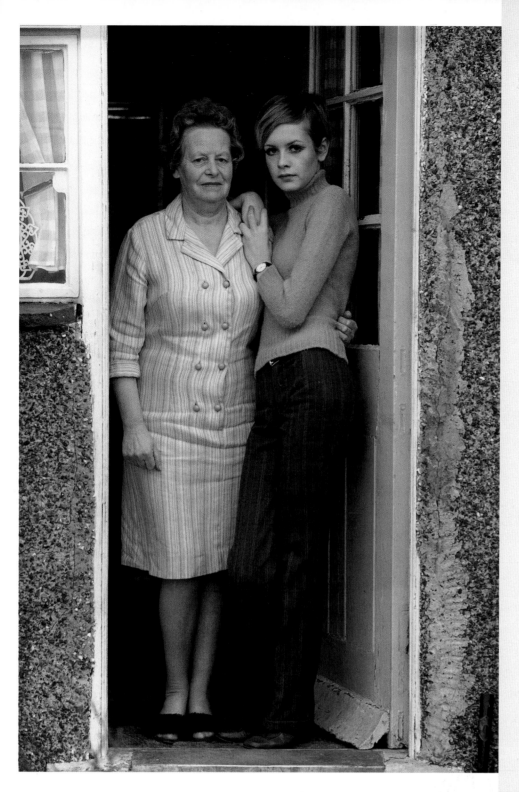

TWIGGY & HER MOTHER
London, 1965

*right,*
JODIE KIDD
London, 1989

I shot this portrait of Jodie as a surprise
for her father. She was twelve years old

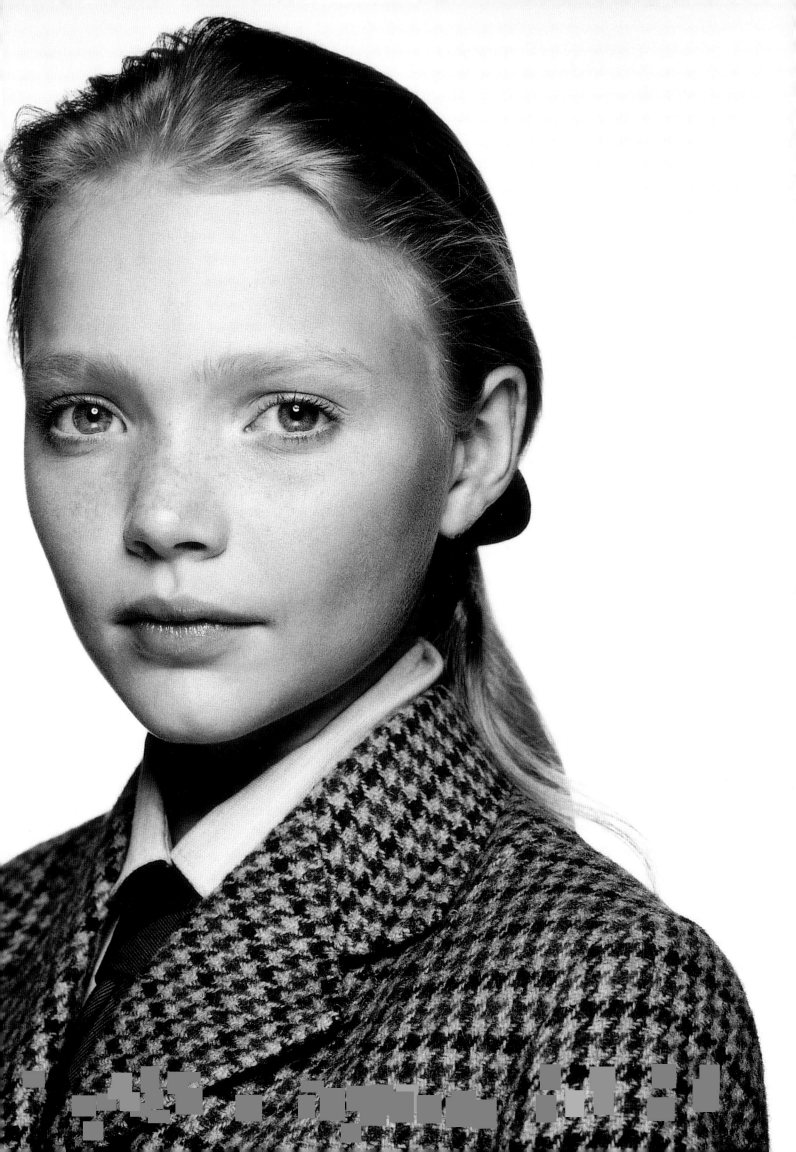

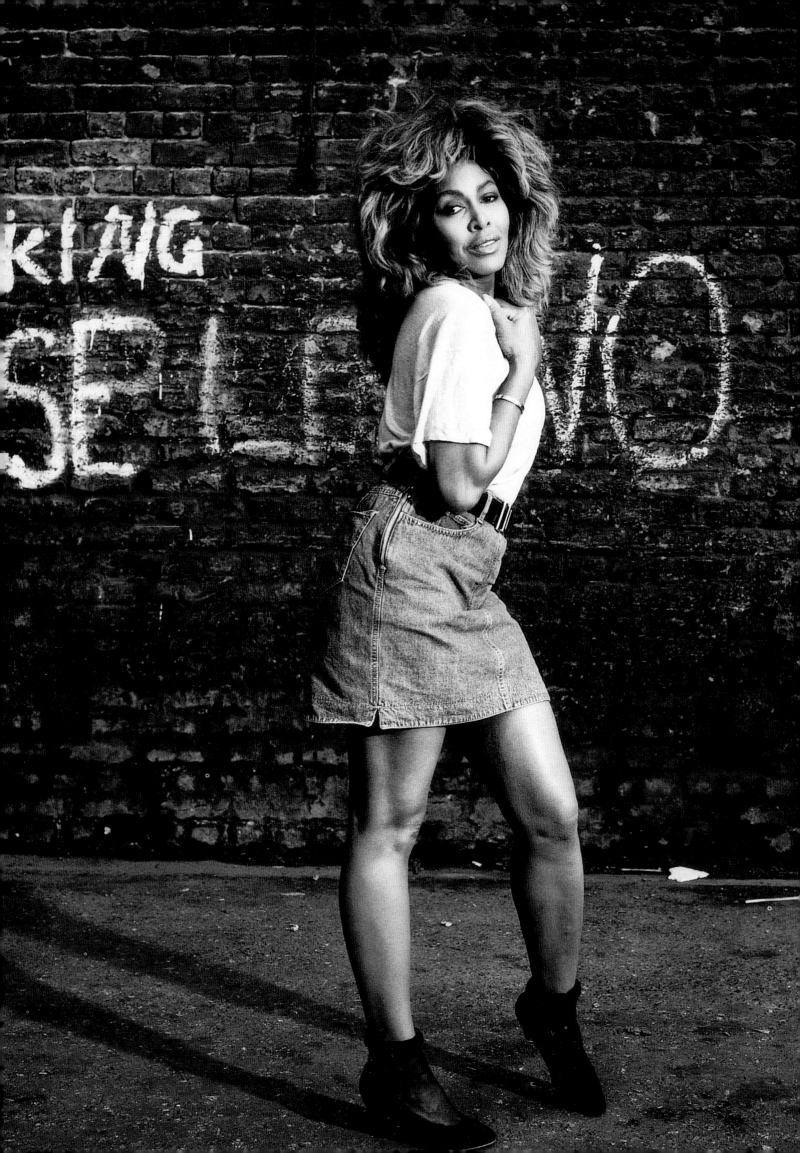

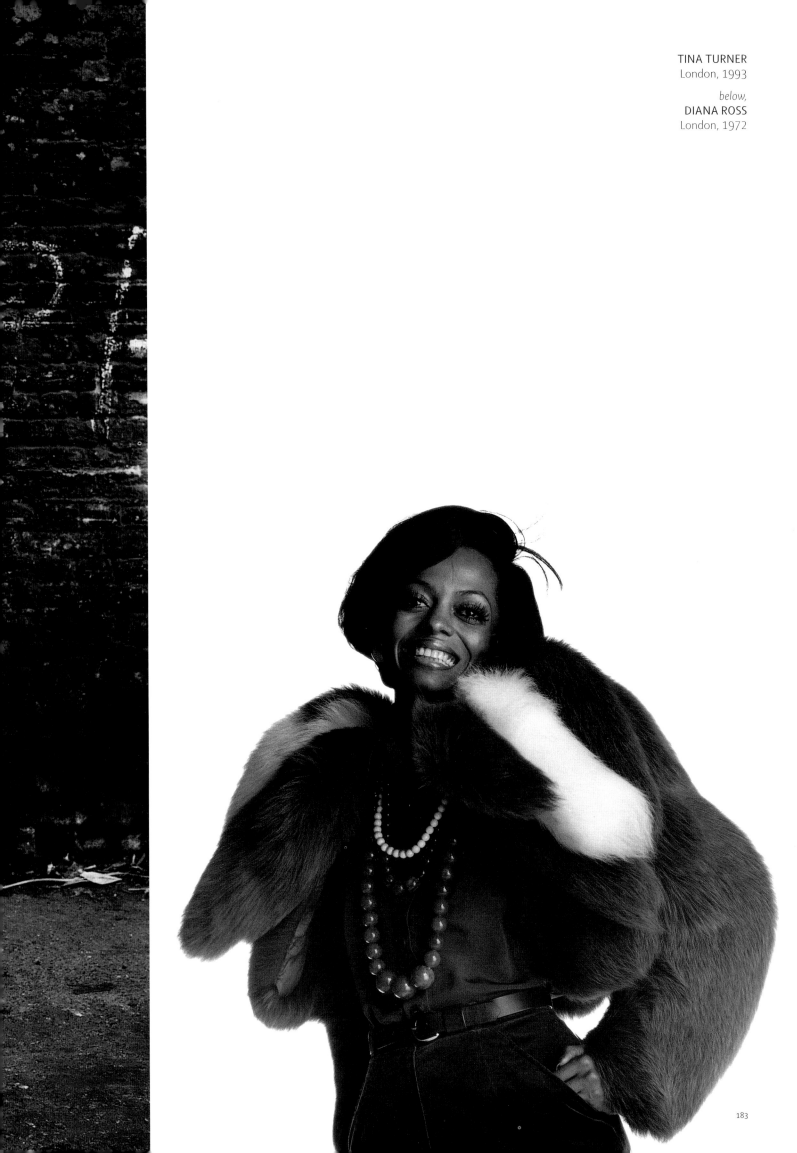

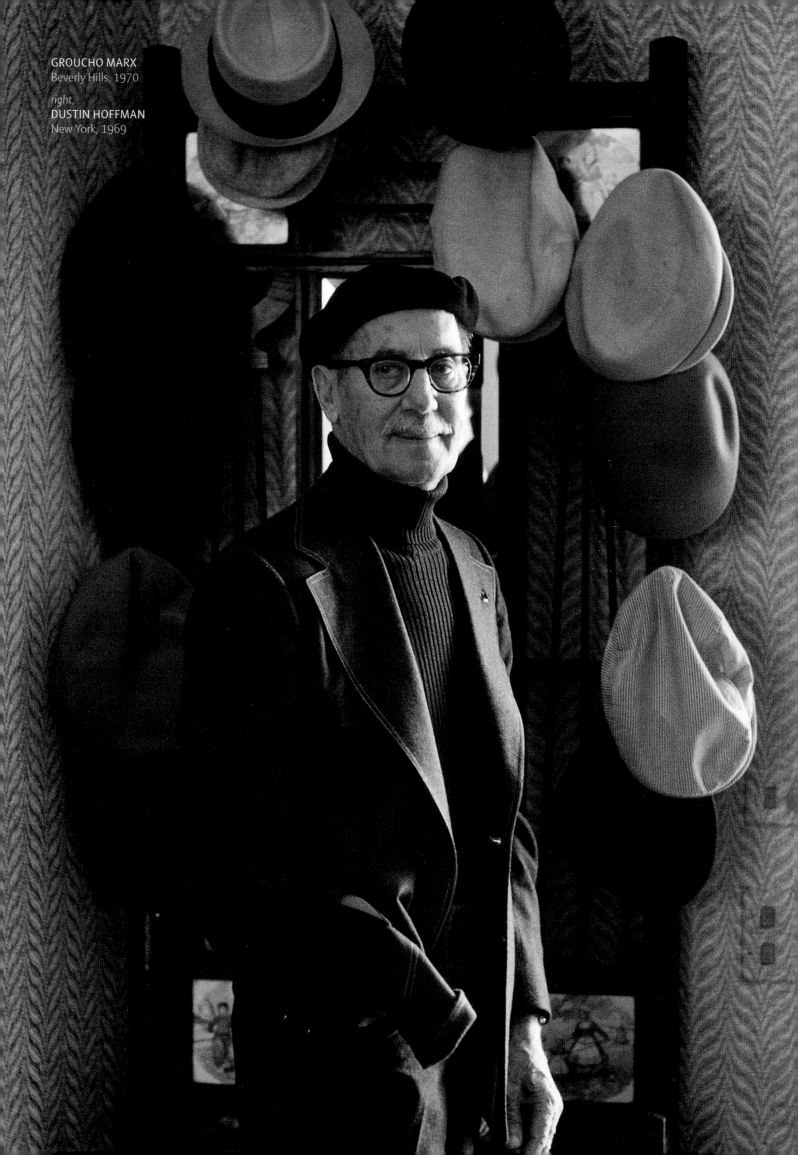

GROUCHO MARX
Beverly Hills, 1970

*right,*
**DUSTIN HOFFMAN**
New York, 1969

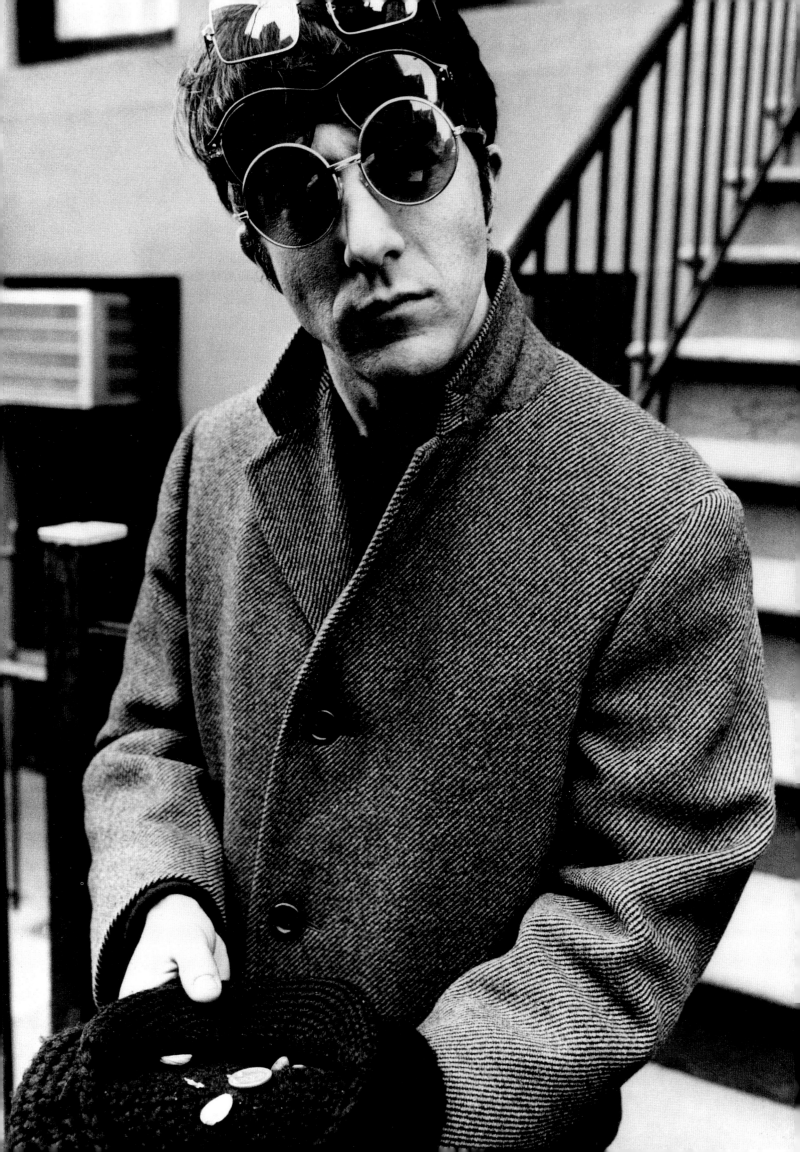

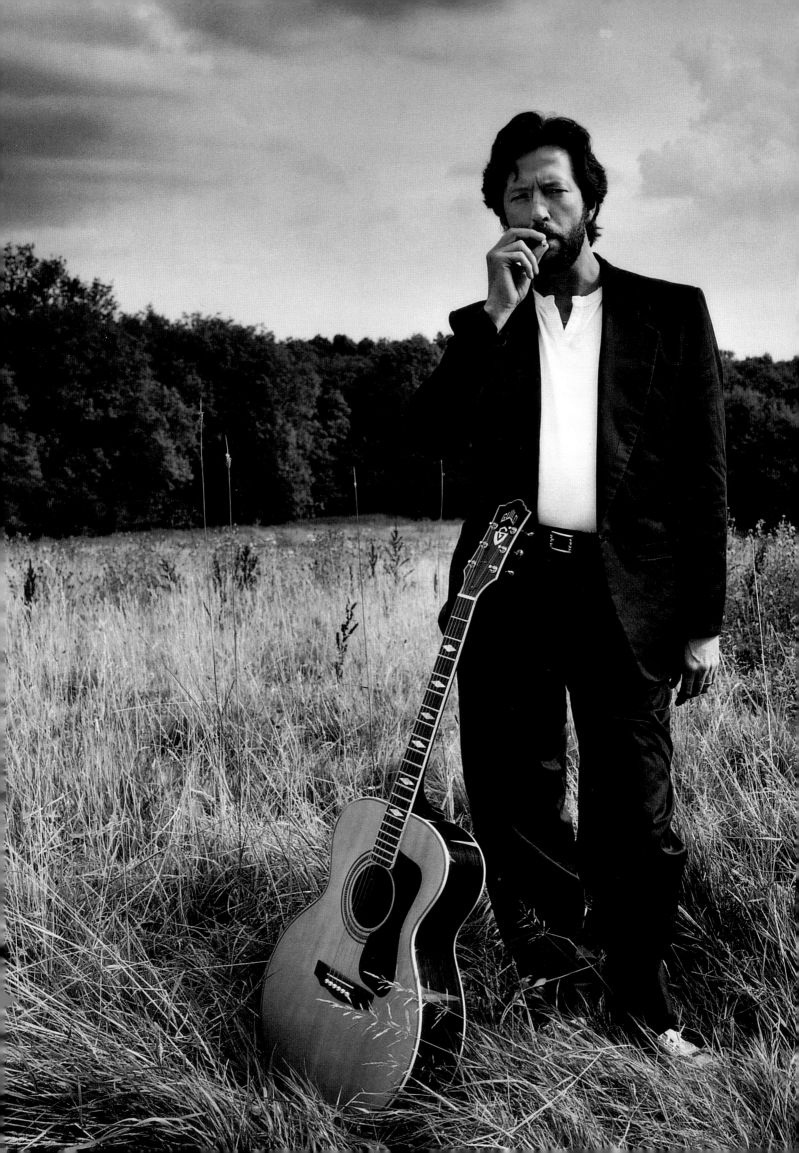

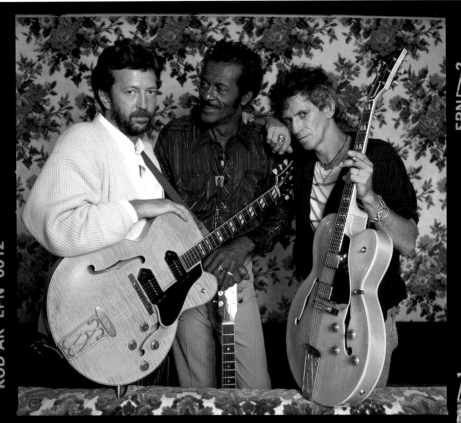

A trinity of guitar legends, shot in Chuck Berry's front room during the shooting of *Hail! Hail! Rock 'n' Roll*

ERIC CLAPTON, CHUCK BERRY & KEITH RICHARDS
Los Angeles, 1986

*left,*
ERIC CLAPTON
Surrey, England, 1993

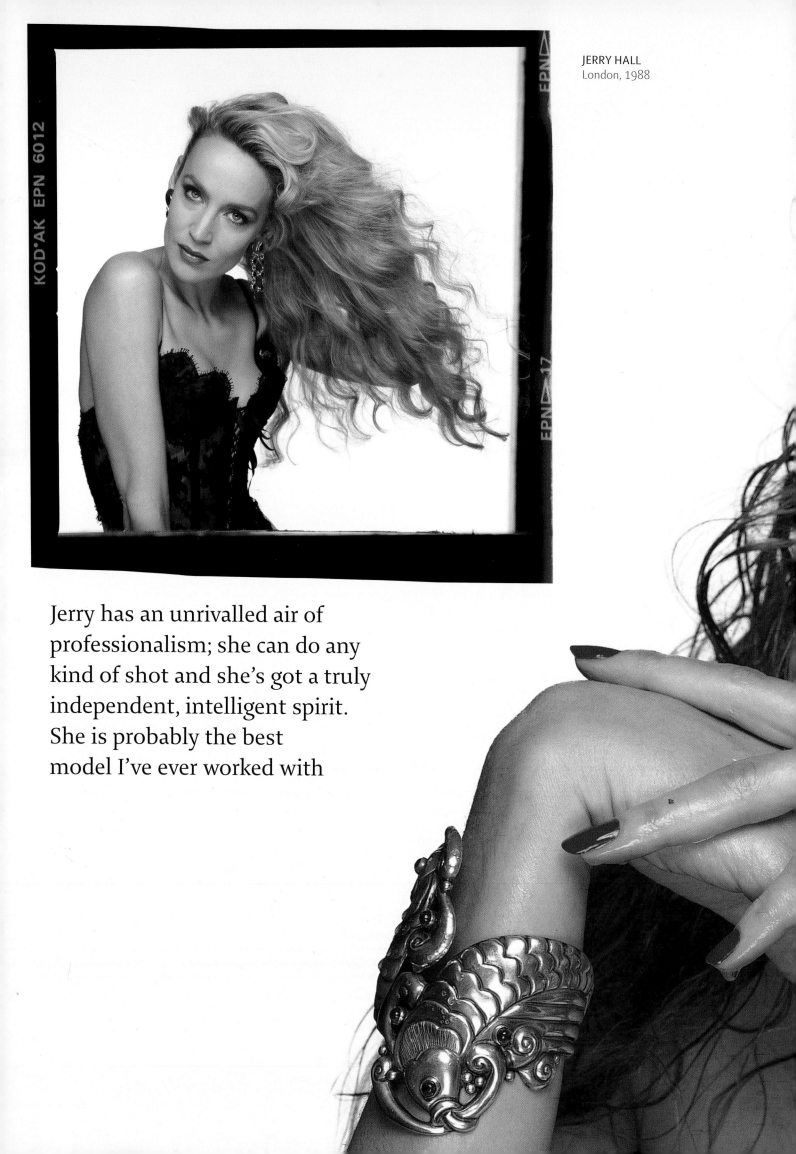

Jerry has an unrivalled air of
professionalism; she can do any
kind of shot and she's got a truly
independent, intelligent spirit.
She is probably the best
model I've ever worked with

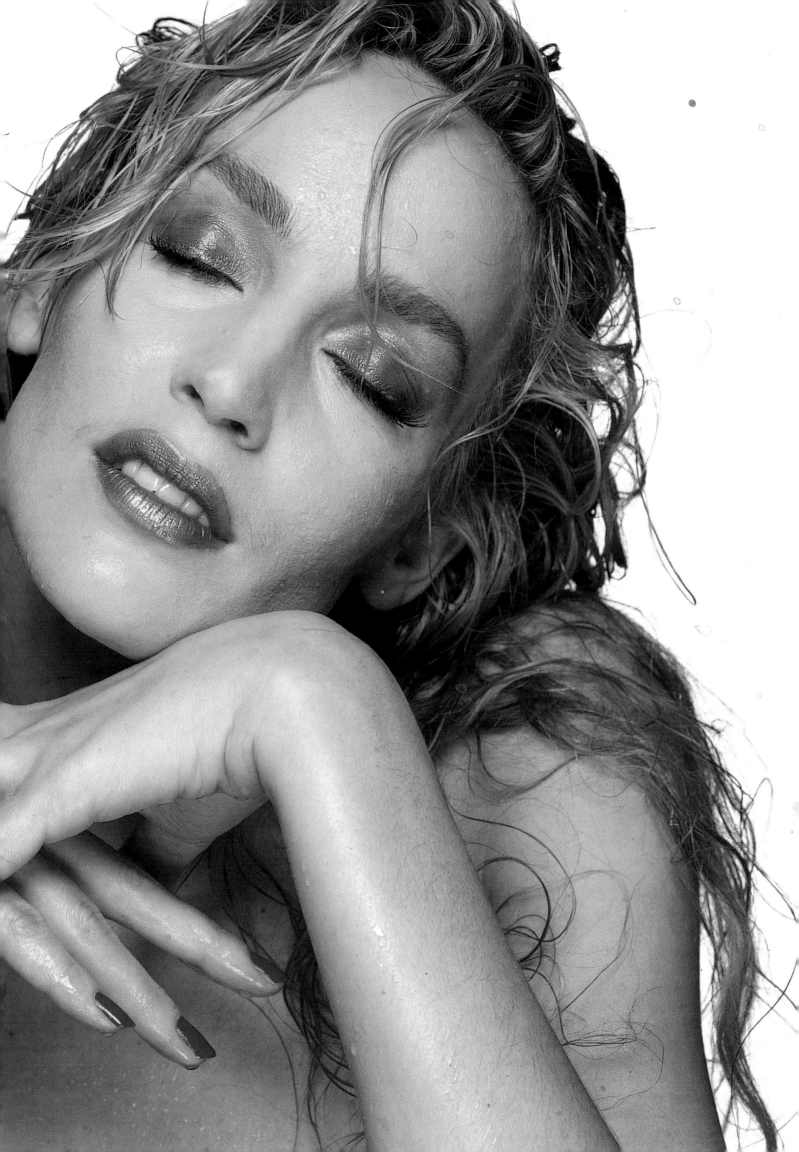

JOHN WAYNE'S CHAIR
London, 1975